BEAUTIFUL ONTARIO

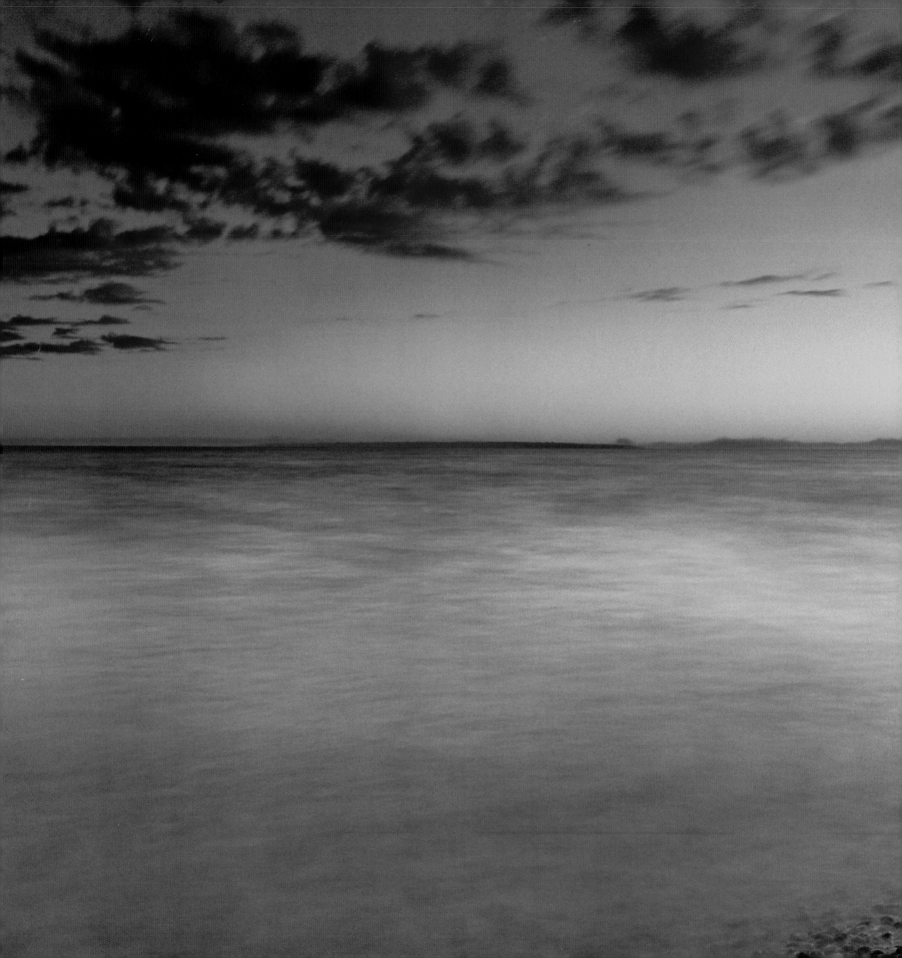

BEAUTIFUL ONTARIO

J. A. KRAULIS

FIREFLY BOOKS

A FIREFLY BOOK

Published by Firefly Books Ltd. 2020
Copyright © 2020 Firefly Books Ltd.
Text and photographs © J. A. Kraulis

First printing

Library of Congress Control Number: 2020933524

Library and Archives Canada Cataloguing in Publication
Title: Beautiful Ontario / J.A. Kraulis.
Names: Kraulis, J. A., author, photographer.
Description: Includes index.
Identifiers: Canadiana 20200198203 | ISBN 9780228103097 (hardcover)
Subjects: LCSH: Ontario—Pictorial works. | LCGFT: Illustrated works.
Classification: LCC FC3062 .K73 2020 | DDC 971.30022/2—dc23

Published in Canada by
Firefly Books Ltd.
50 Staples Avenue, Unit 1
Richmond Hill, Ontario
L4B 0A7

Published in the United States by
Firefly Books (U.S.) Inc.
P.O. Box 1338, Ellicott Station
Buffalo, New York
14205

Designed by: Noor Majeed

Printed in Korea

We acknowledge the financial support of the Government of Canada.

Acknowledgements

I owe my first thanks to Lionel Koffler for offering me the opportunity to work on this book and to see it appear in print. There has been an explosion of outstanding photography since the medium became mostly digital and having one's work appear in hard copy form is a privilege not to be taken for granted. Others at Firefly Books who have been instrumental in shaping it include Michael Worek, who edited and polished the text, and Noor Majeed, whose excellent design will be evident in the pages that follow.

Many of the photos herein resulted from magazine work and previous book contracts. For the latter, I am particularly indebted to the late Mel Hurtig, Anna Porter, Michael Burch and Frank Edwards. For the former, the staff at *Equinox* and at *Canadian Geographic*, who sent me on numerous assignments across the province and it has been my good fortune to work with Bart Robinson, Barry Estabrook, James Lawrence and Ian Darragh, among others.

Without the assistance of friends this book would have been much poorer, if possible at all. George Stimpson, Bernice Slotnick and Ian Watts accompanied me on several paddles in Georgian Bay, Quetico Provincial Park and Lake Superior. Meanwhile, half the credit at least for the aerial images belongs to Bo Curtis and Catherine Young. Bo piloted the plane for the photos on pages 18, 19, 26, 58, 59, 76, 77, 78, 79, 84, 85, 143, 163, 179, 184, 185, 188, 189, 192, 193, 196, 197, 204, 205, 208.

For their support and encouragement at all stages of my work on this book I owe my greatest thanks to my family, to Anna, Kalyaan, Theo, Ilze and above all and always, my late wife, Linda.

In memory of my wife, Linda Kuttis, and her beautiful life,
with gratitude boundless and love unending

Introduction

To understand what makes Ontario unique it helps, as with many complex stories, to start in the middle, in this case the geographic middle, of the province. Take a map of Ontario and locate its centre, midway between its north and south, east and west peripheries. There you will find a coastline where the land bellies into Lake Superior. And on this coastline is the ideal place from which to begin to grasp the essence and the substance of this great province, its landscape and history, its economy and culture and its unique beauty.

Within this rugged, roadless terrain lies Pukaskwa, the largest, wildest and most impressive of Ontario's six national parks. Here the Coastal Hiking Trail follows the longest section of wilderness shoreline anywhere along the Great Lakes, traversing country similar to what most of the province was like before its transformation into the vast mosaic of farm, city and industry over the last two dozen decades. It takes several days to walk this challenging trail and, at first, the scenery seems unremarkable. The trees are modest compared to, say, the giant conifers in the Pacific coast rainforests. There is no Grand Canyon grandeur or Himalayan hugeness to seize the eye and stagger the mind.

However, with deep beauty in smaller features, the Pukaskwa coast is one of the most extraordinary places on earth. Science tells us that it is both among the very oldest and the very youngest of all landscapes, born out of ancient fire and recent ice, an enthralling first and last chapter in the geological story of our planet. Incredibly old bedrock, exquisitely veined and striated, steel hard and polished porcelain smooth by the glaciers, slides into crystalline emerald waters that emerged from the last Ice Age a mere seven thousand years ago.

The rock, a tangled complex of ancient granites and gneisses, melted and molded in subterranean heat, twisted, broken, and reshaped by the hammering of tectonic collisions billions of years ago, was forged in another world, when the present continents did not exist, there was almost no oxygen in the air and no life on land. It is a particularly beautiful exposure of the Canadian Shield, the craton, the original base of what is now North America before continental bumps and grinds added the west and eons of erosion buried much of the rest.

The Canadian Shield covers more than half of the province. Richly endowed in nickel, gold, copper, zinc and platinum, the area supports an extensive mining industry that makes Northern Ontario a major player in the economy of the province. Meanwhile vast tracts of boreal forest, mostly spruce, fir, poplar and birch, supply a large pulp and paper industry, while rivers cascading through the rugged terrain are tapped for hydroelectric power. Remote and little known, this region supplies much of the wealth of the province.

The Shield underlies the glacial basins which contains the superabundance of lakes that blanket, patch and speckle so much of Ontario, a province which is even more defined and shaped by its fresh water than by its primordial stone. In Pukaswka one looks across the most expansive body of fresh water on earth. Here, in this relatively untouched landscape, one can perhaps imagine what the earliest French explorers, Étienne Brûlé and Samuel de Champlain, must have felt when they first came upon the Great Lakes, oceanic in size, but with refreshingly drinkable water. Ontario is a veritable empire of fresh water, with statistics and superlatives second to no other region in the world.

Fifteen percent of the inland surface of Ontario is water. That water covers an area larger than that of England, or Greece, or

Pennsylvania, or New York State. Ontario has thousands of waterfalls including Niagara Falls, one of the most powerful and famous in the world. Downstream from Kingston in the St. Lawrence River are the Thousand Islands, a number that sounds impressive until compared to the more than 14,000 islands in Lake of the Woods or the Thirty Thousand Islands in Georgian Bay, the largest freshwater archipelago on earth. Meanwhile at the north end of Georgian Bay, Manitoulin Island is the largest freshwater island in the world, in turn home to several lakes, some with islands of their own.

The whole province comes close to being an island itself. In the north, Ontario has a 1,200-kilometre saltwater coastline on Hudson Bay and James Bay, while three-fourths of its boundary with two other provinces and five American states runs down rivers or across lakes. In fact, except for a single kilometre of portages, the entire 2,700-kilometre long border between Ontario and the United States is water.

Meanwhile, the navigability of its waterways has governed the founding of its cities and shaped the economic and human destiny of the industrial heartland of Canada. This history has not been without drama and tragedy. Several thousand ships have gone down on the Great Lakes. Among the most famous is that of the Edmund Fitzgerald in 1975, immortalized in song by Gordon Lightfoot a year later. Most catastrophic was the Great Lakes Storm of 1913 which destroyed 19 ships and stranded 19 more all with the loss of over 250 lives.

Today, Ontario has more ports than British Columbia or Newfoundland, and about the same number as Nova Scotia. Seagoing vessels can pass through the St. Lawrence Seaway and the Welland Canal to reach Thunder Bay, fifteen hundred crow-flight kilometres from the Atlantic but a mere eight hundred from the exact geographic centre of the continent. Lake freighters haul grain, oil seeds and potash from the Prairie Provinces eastward, iron ore from Quebec and Labrador southwards to the steel mills of Hamilton, salt from the largest underground salt mine in the world under Lake Huron at Goderich, along with the sand, cement and limestone used to build the cities and the roads across the land

These great bulk carriers trace a loop of commerce around Southern Ontario, home to more than one-third of the population of Canada but occupying less than two percent of the area of the nation. Cradled by three of the Great Lakes and Georgian Bay and bounded further by major rivers, Southern Ontario is peninsular but, in fact, the southwestern portion with most of the major towns and cities is technically an island. The 386-kilometre long Trent-Severn waterway connects a series of lakes and rivers with canals so that it is eminently possible to circumnavigate this part of the province by boat.

Southern Ontario is far from the shield country of Lake Superior, not only in distance but in character and culture, geology and ecology. The great Laurentide Ice Sheet pushed furthest south at the Great Lakes, reaching at Point Pelee and Pelee Island the latitude of northern California. The deciduous trees of the Carolinian forest in this southernmost region is a very different environment from the boreal forest in the north, and distinct from the mixed forest in between. The rural landscape is dominated by some fifty thousand farms interspersed here and there with woodlots. Sprawling cities rise over the horizon, culminating in the ten-million-population urban agglomeration known as the Golden Horseshoe, centred on Toronto and curled around Lake Ontario from Hamilton to Oshawa.

Underlying the south is a different, much younger geology of sedimentary rock only a few hundred million years old, with loose glacial deposits mere thousands of years old. Quarries here have supplied the building materials for the brick and stone architecture of hundreds of communities and towns, the limestone in many of the institutional buildings in Kingston and the sandstone in the Parliament Buildings in Ottawa and the Legislative Building in Queen's Park, Toronto. One can imagine the cities of Southern Ontario literally growing out of its own bedrock, climaxing, perhaps, in the tremendous concrete trunk of the CN Tower.

Meanwhile, in the north the calls of loons and howls of wolves hang in the lonely distance across silent waters in wilderness such as that in Quetico Provincial Park. In this and many ways, the contrast between the regions of this enormous province could hardly be more marked.

But, no matter where you go in Ontario, there is the water. Water in every direction, in every corner, water which gives this great land its commonality and its identity. The very name of the province comes from a Huron or Iroquoian term variously interpreted as meaning "great lake," "beautiful water," "lake of shining waters" or "sparkling waters." Along its splendid waterways, in its spectacular waterfalls and across its sky-reflecting and shining water spaces, Ontario spreads its extravagant beauty, a modest amount of which is presented in the pages that follow.

J. A. Kraulis
February, 2020

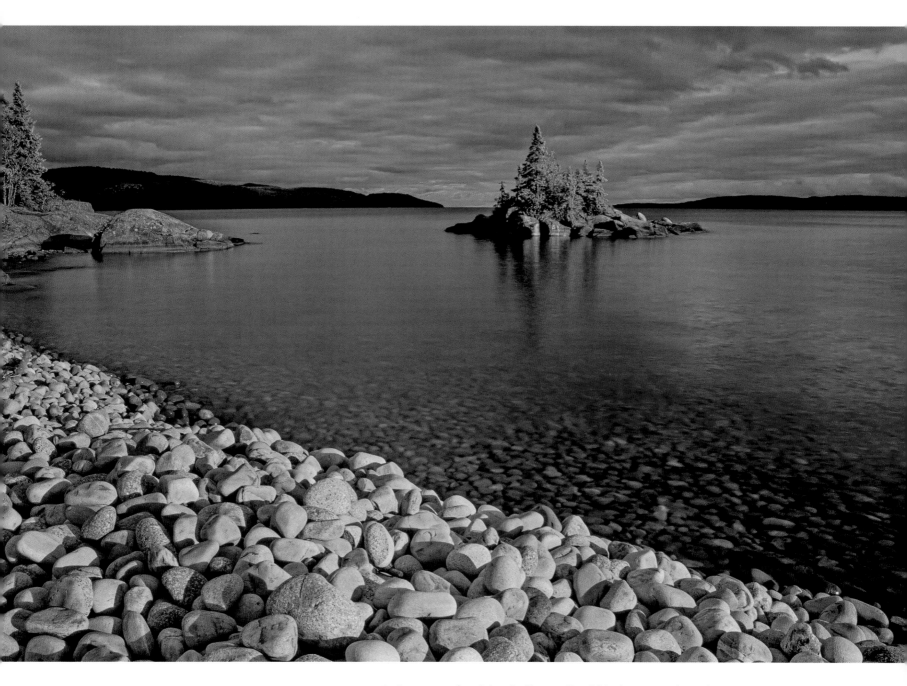

A picture-perfect island off a small cobbled cove on the Lake Superior coast along the Trans-Canada Highway east of Rossport.

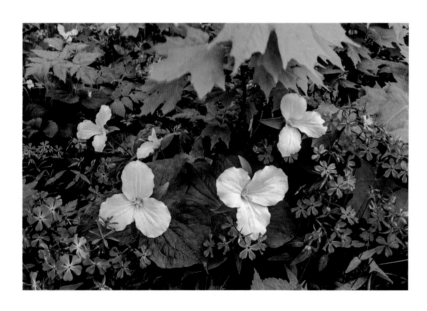

The trillium, here with phlox, is the official flower of Ontario.

A fallen birch tree among trilliums in the spring in Bronte Creek Provincial Park.

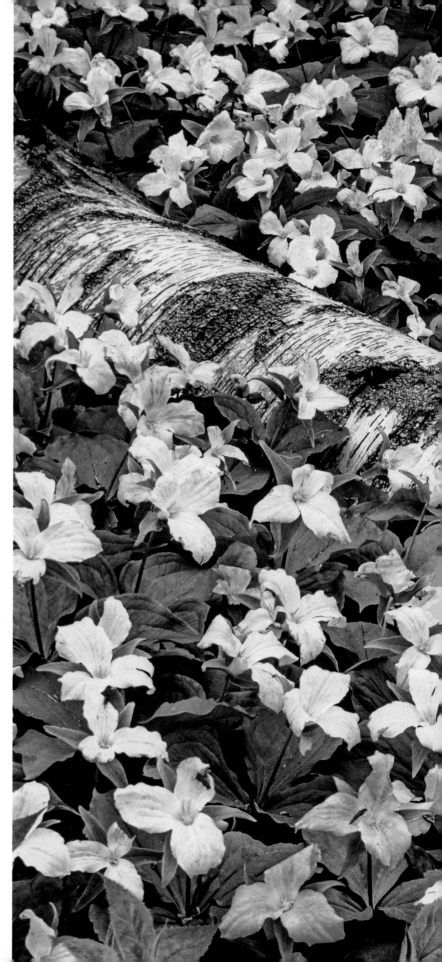

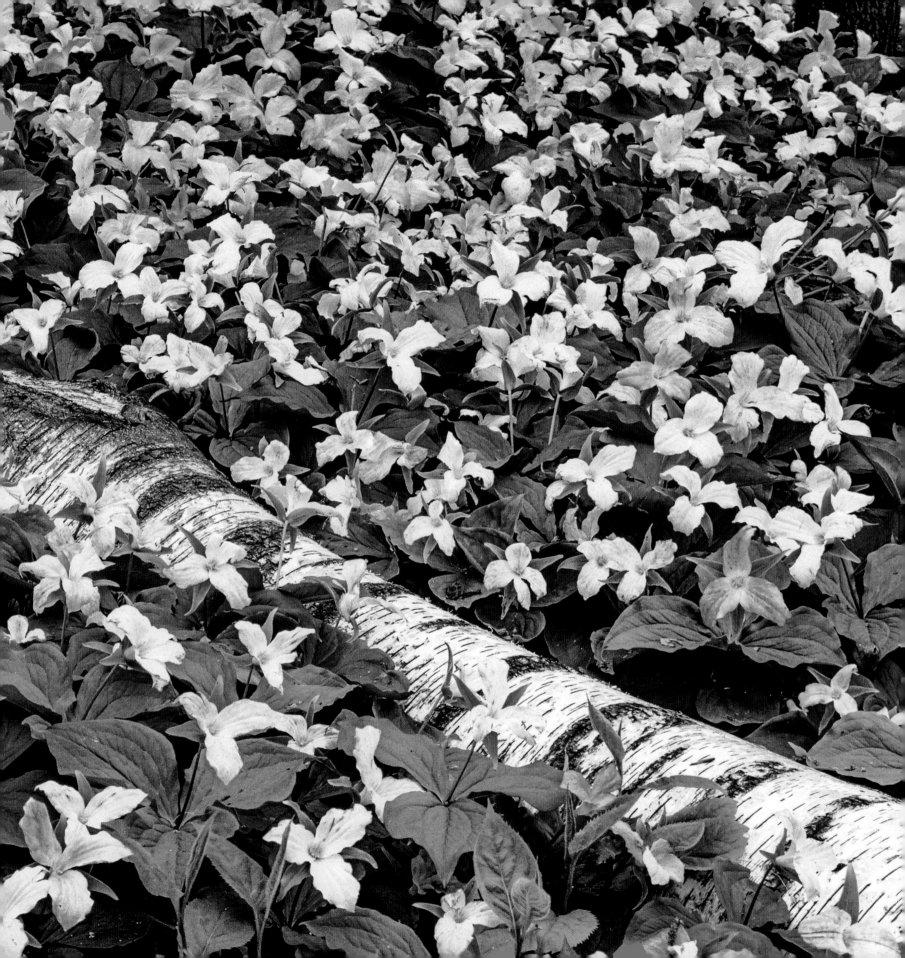

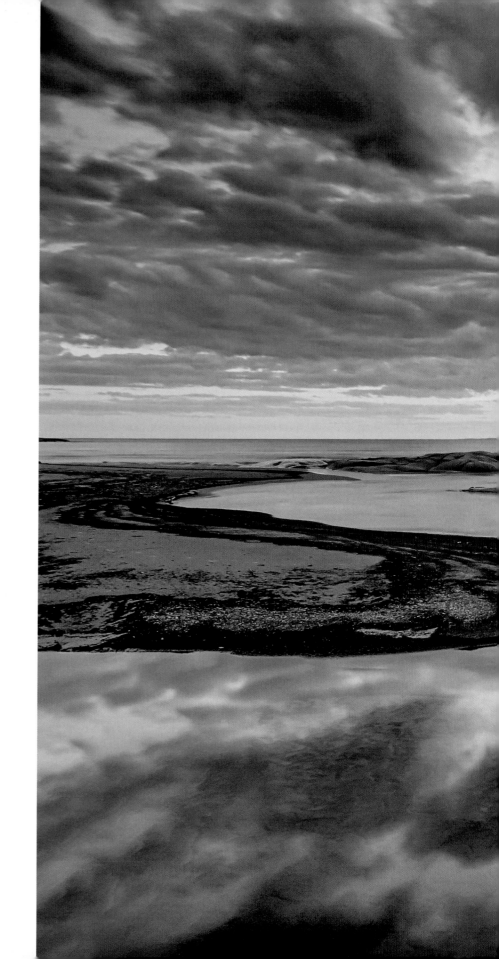

Along the coast of Lake Superior at dusk in Neys
Provincial Park.

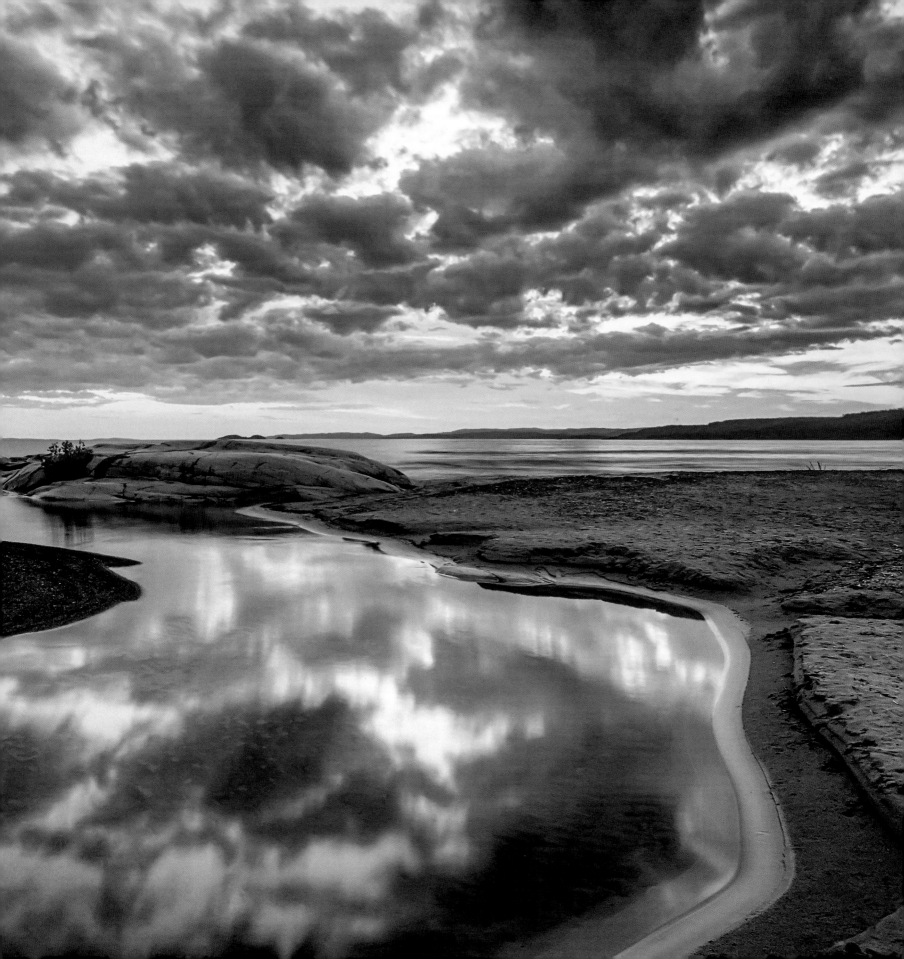

Autumn at Rosseau Falls in Muskoka.

A November snowfall turns Toronto's High Park into a winter wonderland.

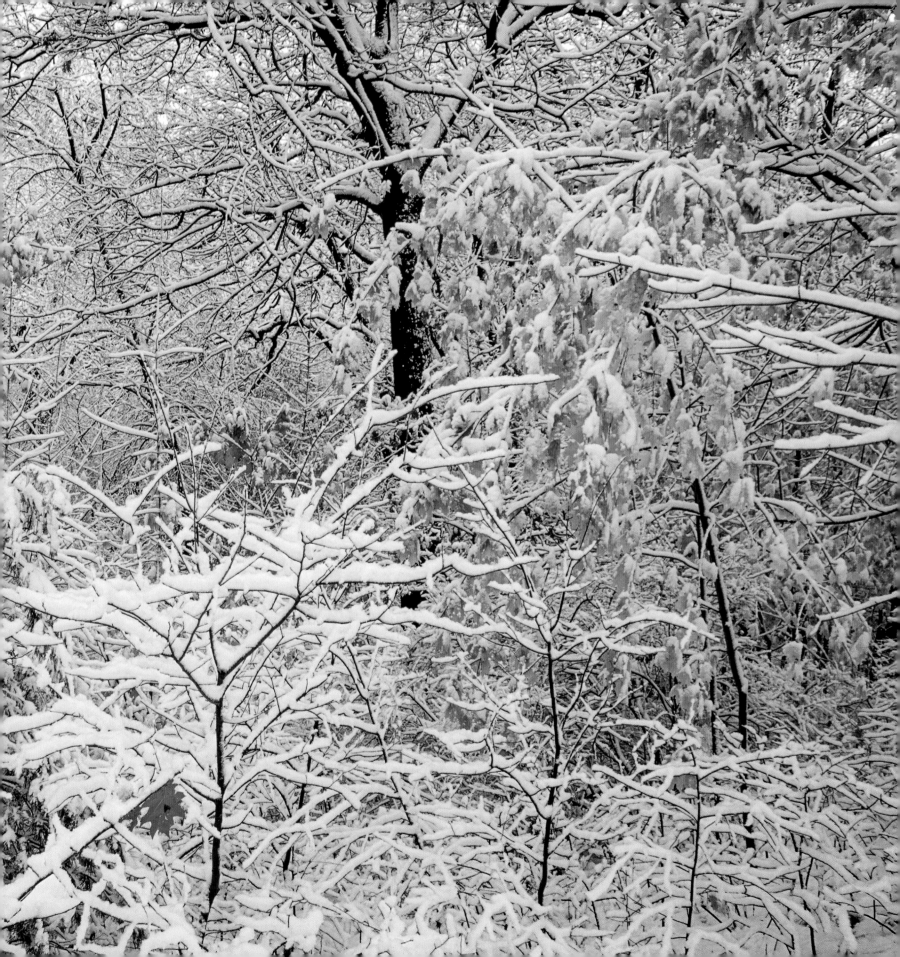

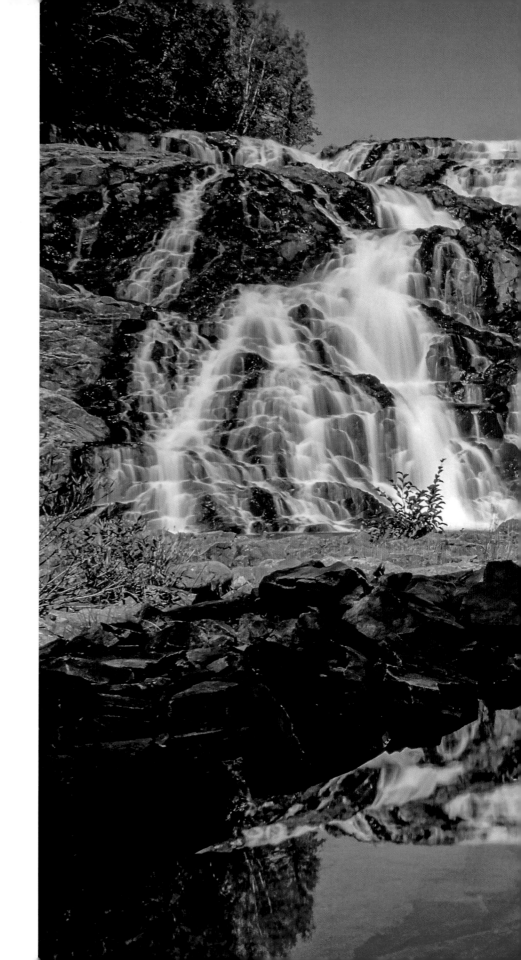

High Falls on the Magpie River near Wawa.

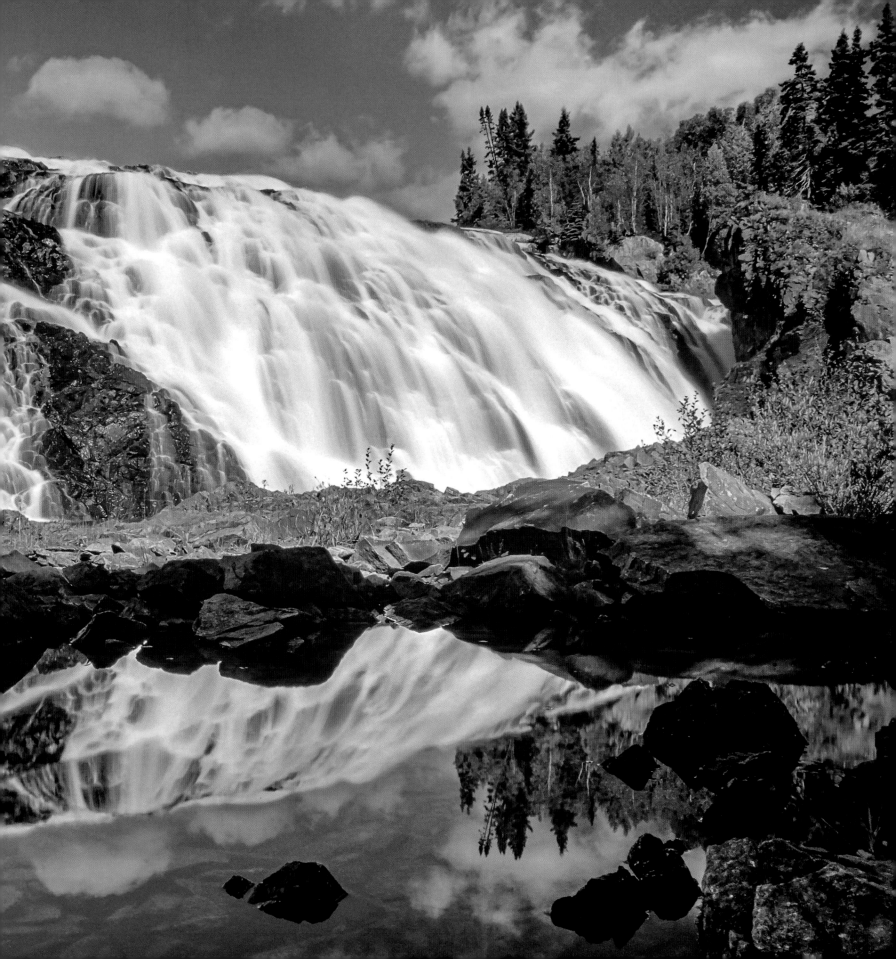

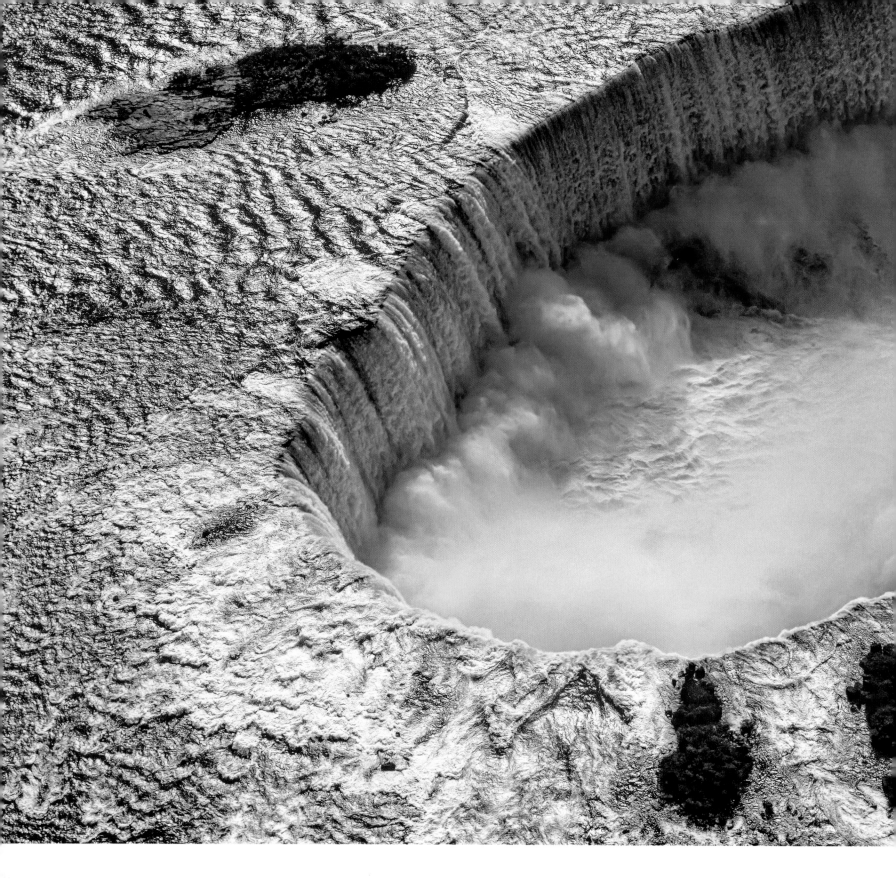

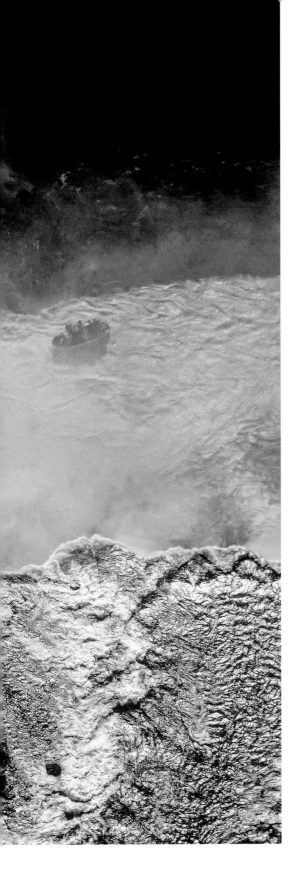

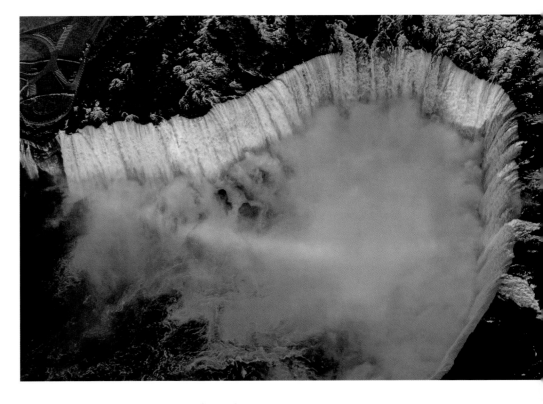

Horseshoe Falls at Niagara Falls from the air.

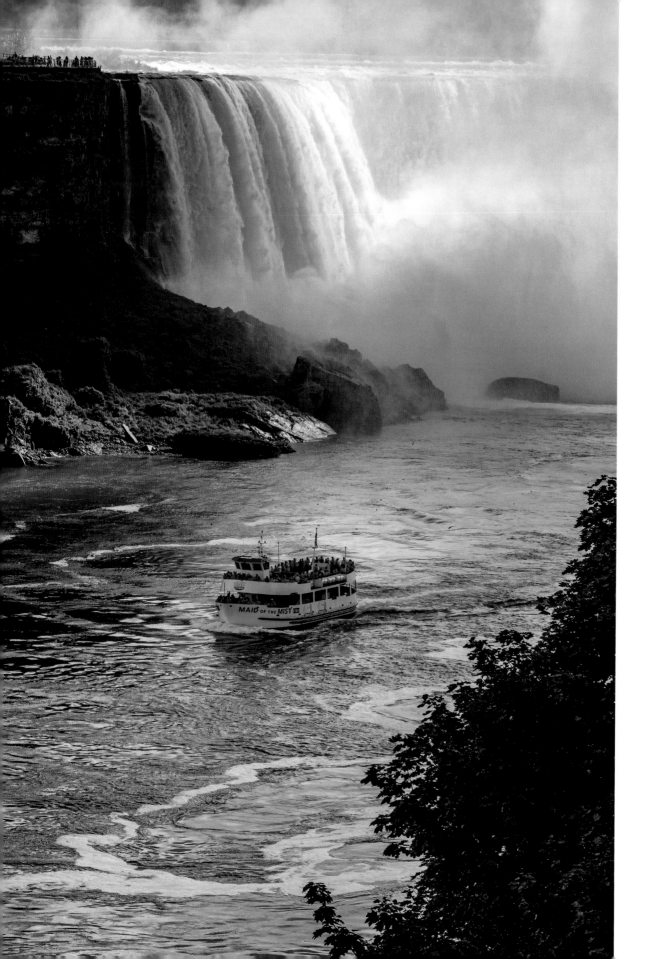
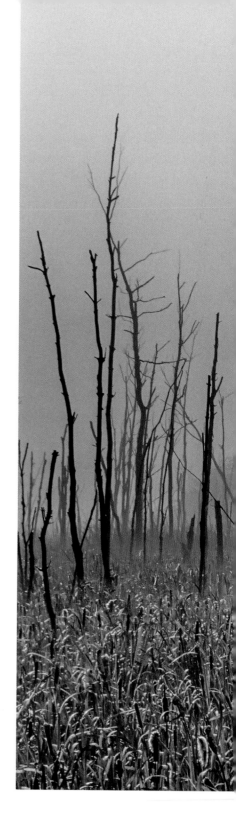

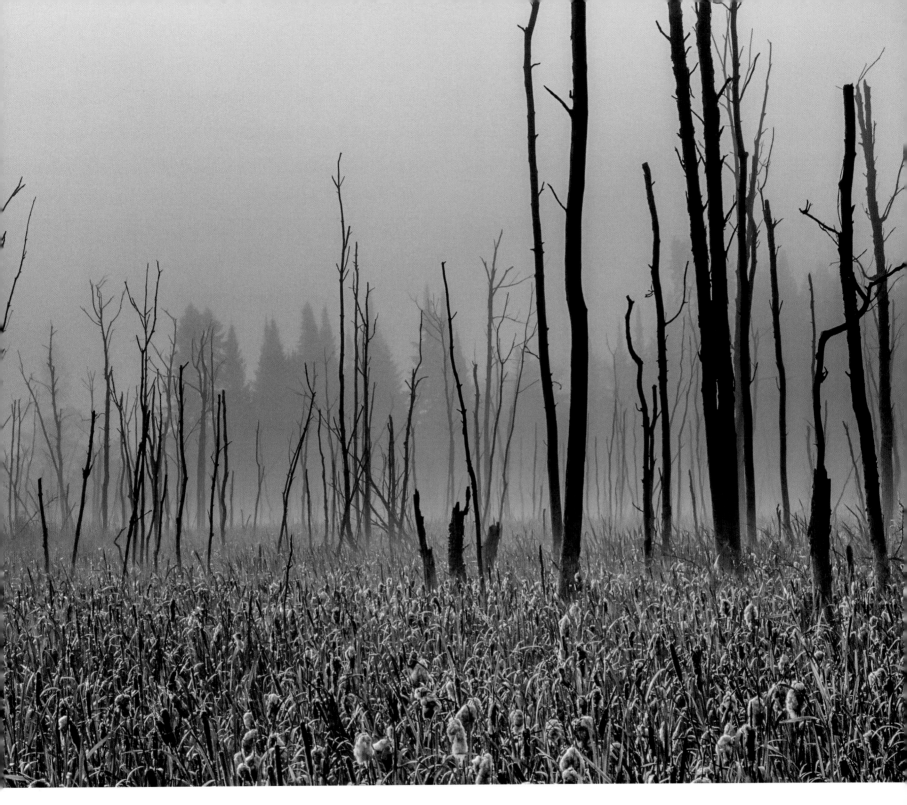

Horseshoe Falls and the Niagara River, Niagara Falls.
The falls, among the most powerful on earth, are the
most visited natural spectacle in the world.

Tree snags and bulrushes on a
misty morning near Mattawa.

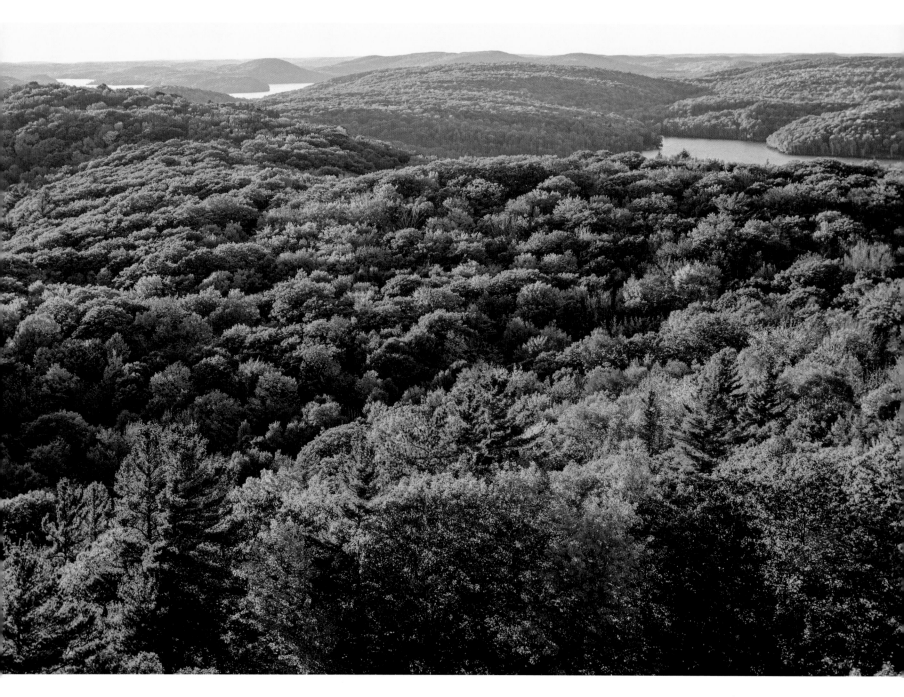

Autumn view from the Dorset Lookout Tower in the Township of Algonquin Highlands.

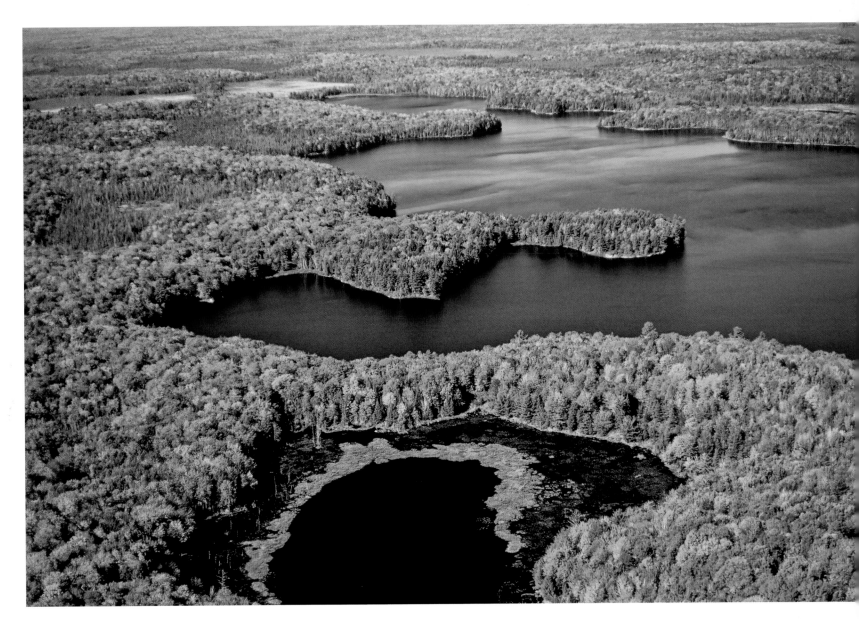

An aerial view of Muskoka in autumn.

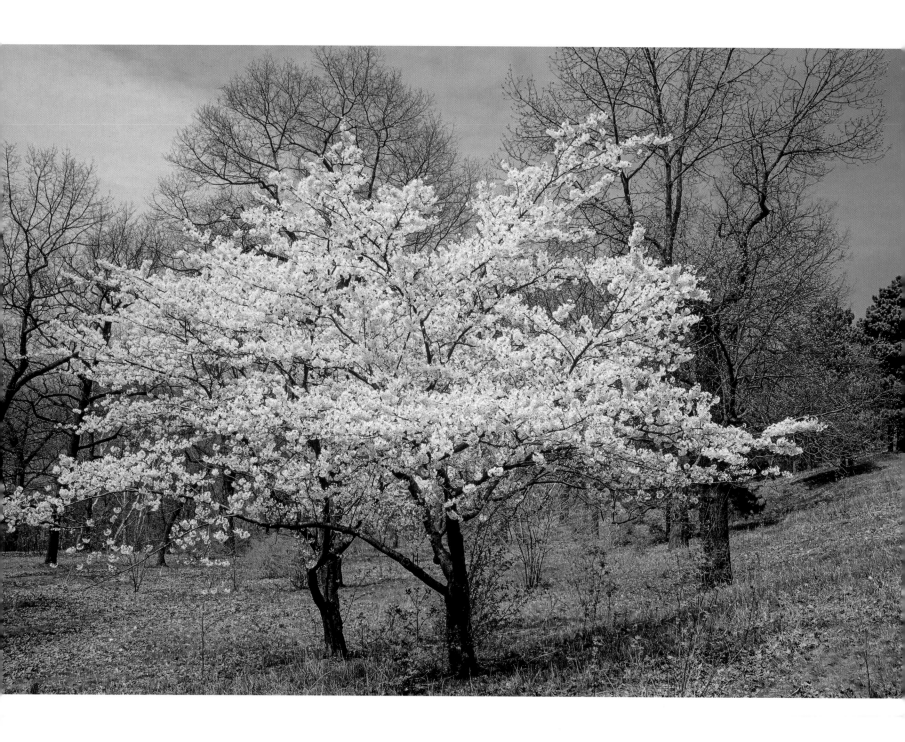

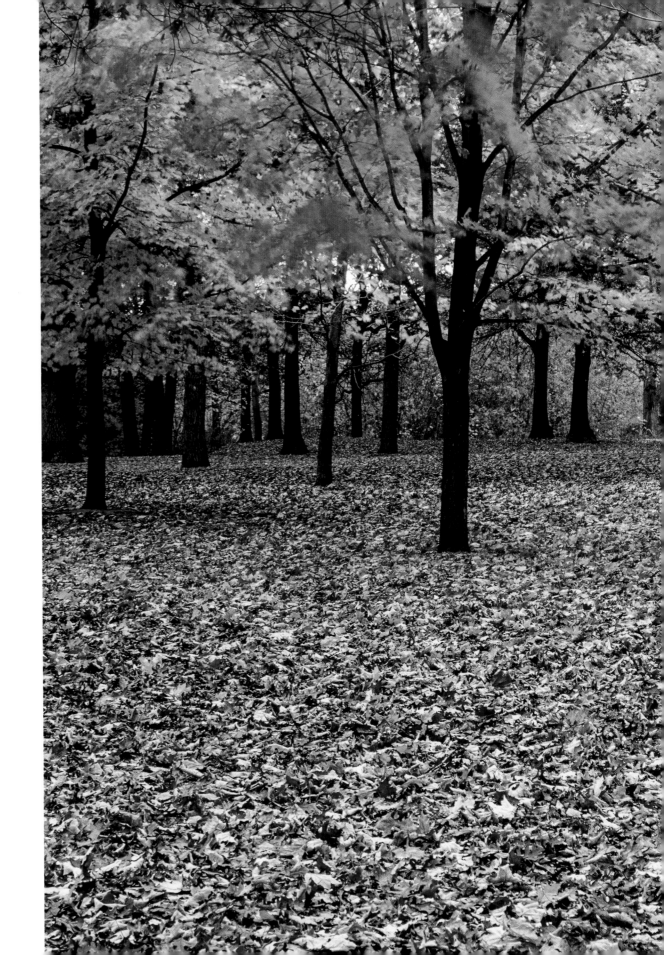

Cherry blossoms in spring (left) and maple trees and leaves in autumn, High Park, Toronto.

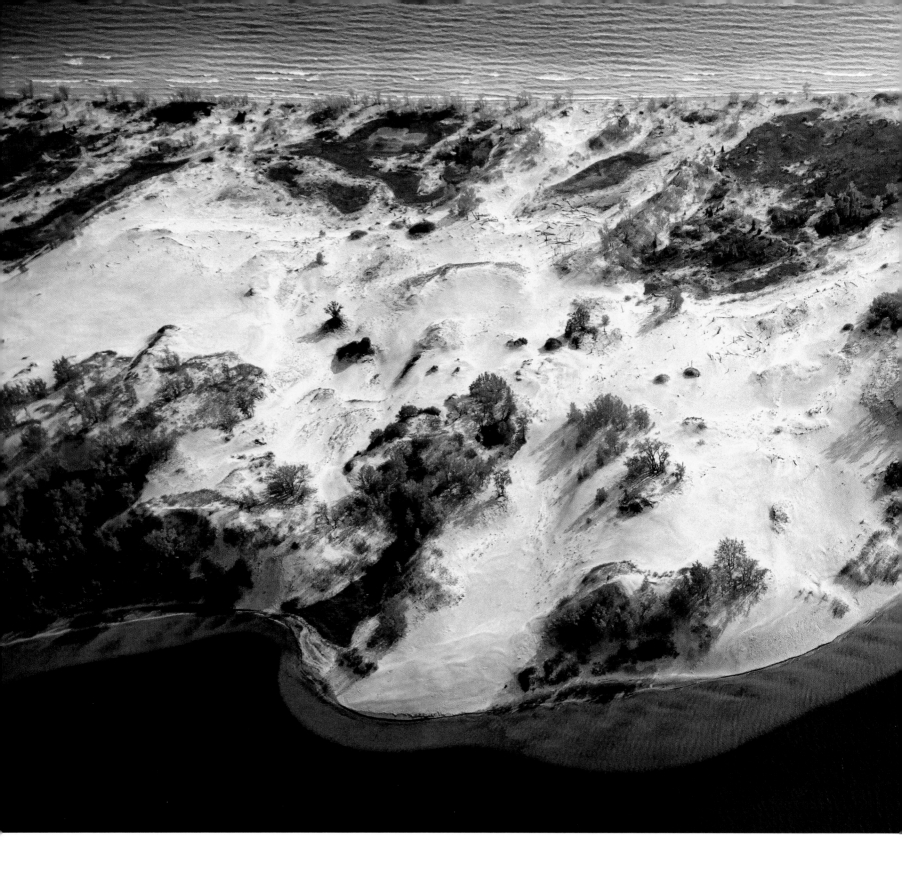

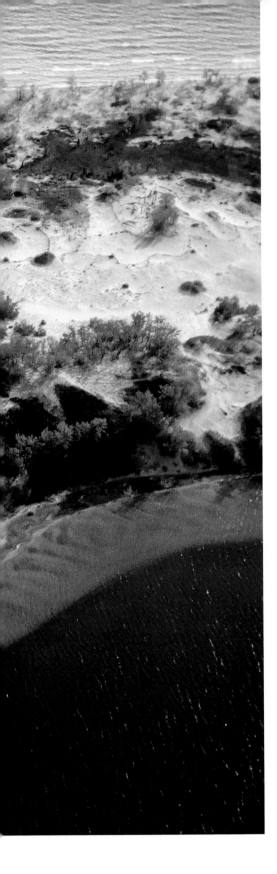

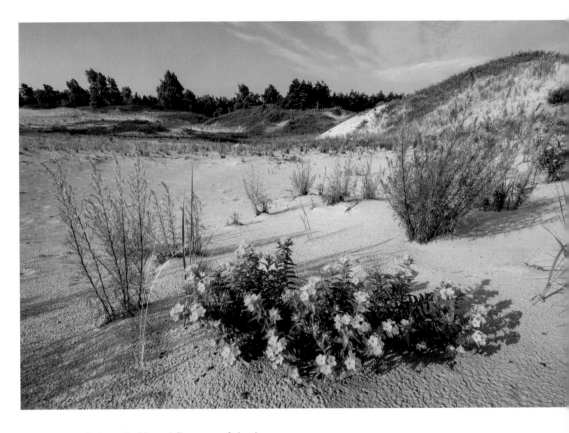

An aerial view (left) and flowers of the hoary puccoon at Sandbanks Provincial Park, site of the world's largest fresh water sand bar and dune system.

NEXT SPREAD: Cherry trees in Toronto's High Park, in spring, summer, autumn and winter.

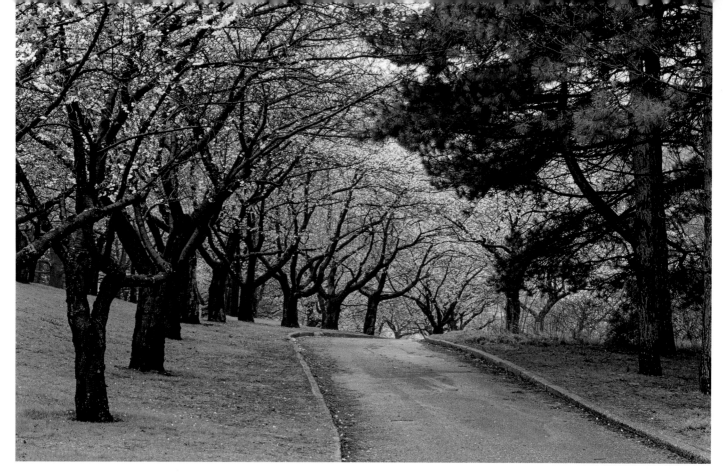

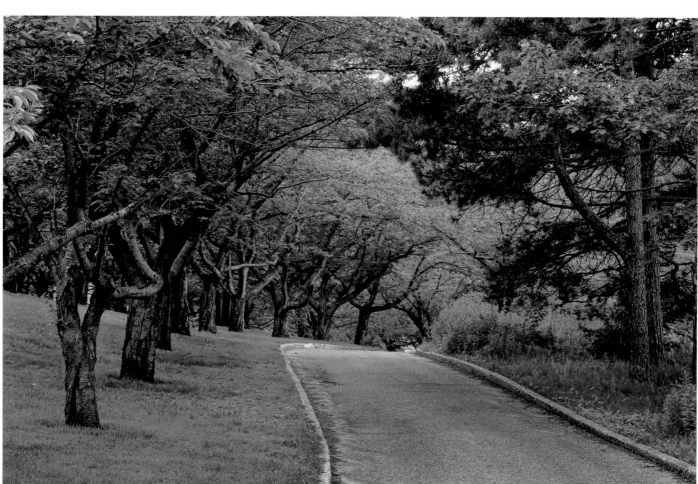

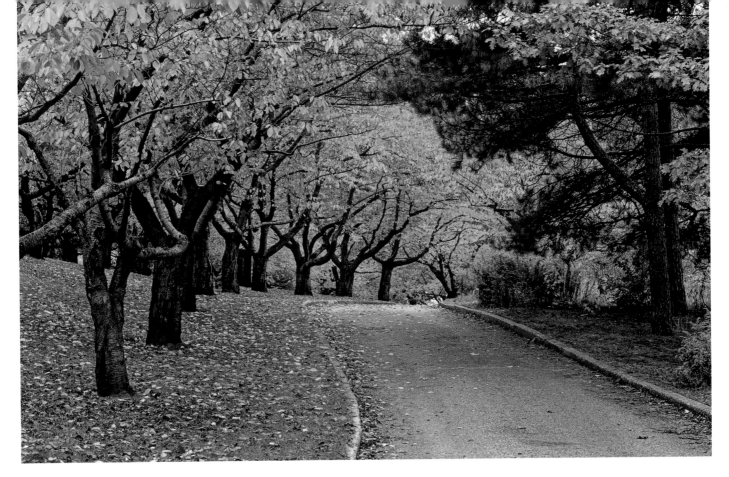

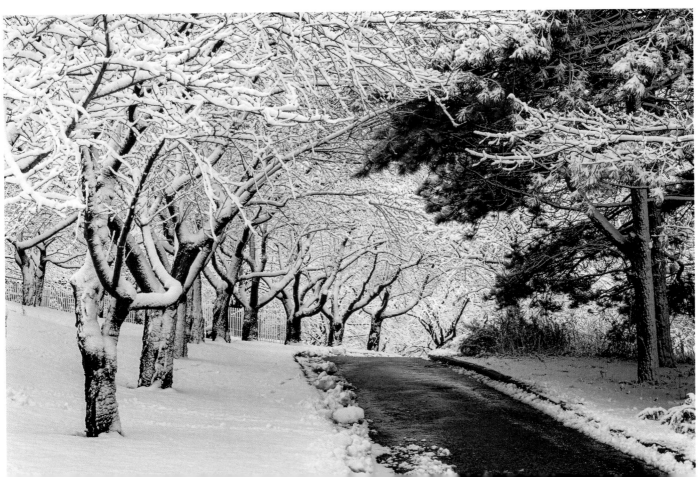

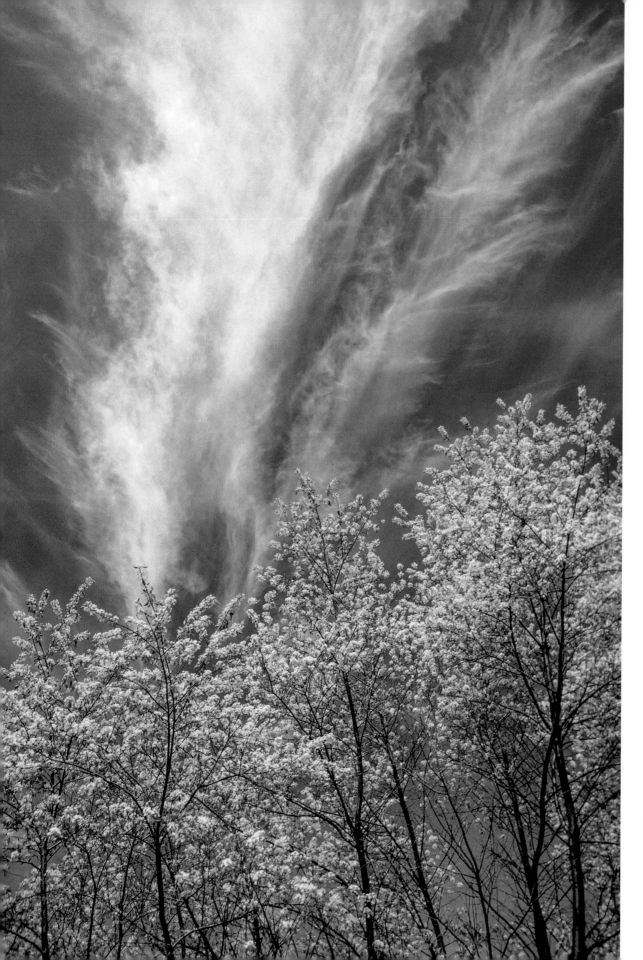

Wild cherry trees bloom in spring near Denbigh.

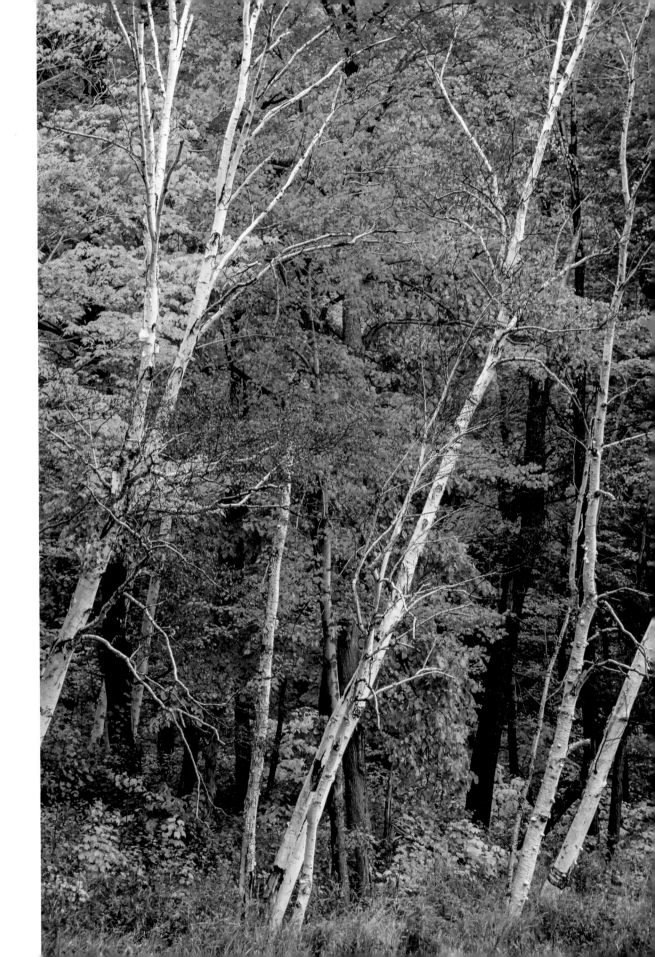

Autumn colours on Beausoleil
Island in Georgian Bay Islands
National Park.

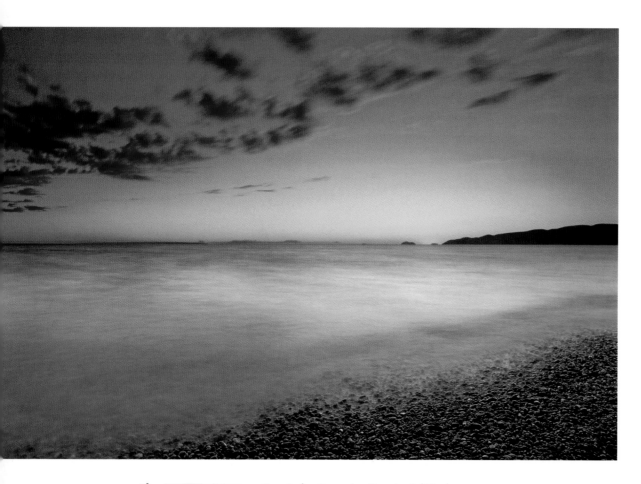

After sunset at Agawa Bay, Lake Superior Provincial Park.

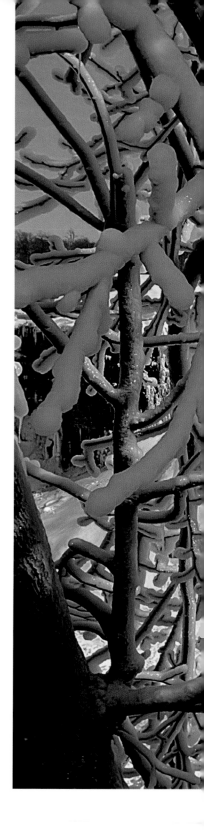

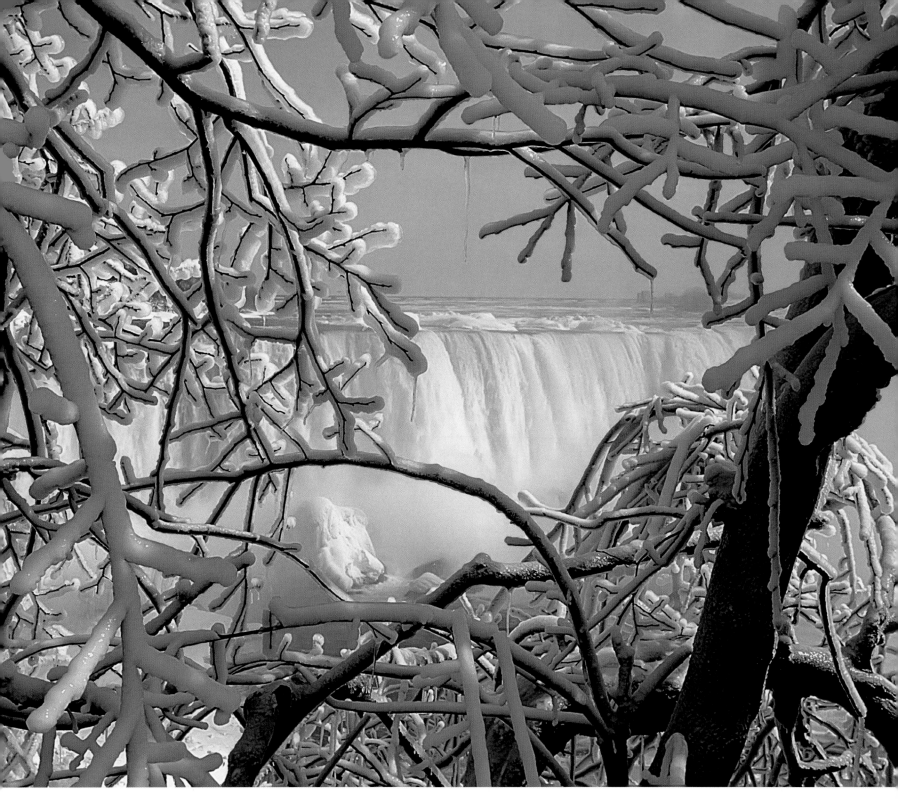

Frozen spray ices the trees around Horseshoe Falls at
Niagara Falls on a cold day in winter.

NEXT SPREAD: Horseshoe
Falls in winter, Niagara Falls.

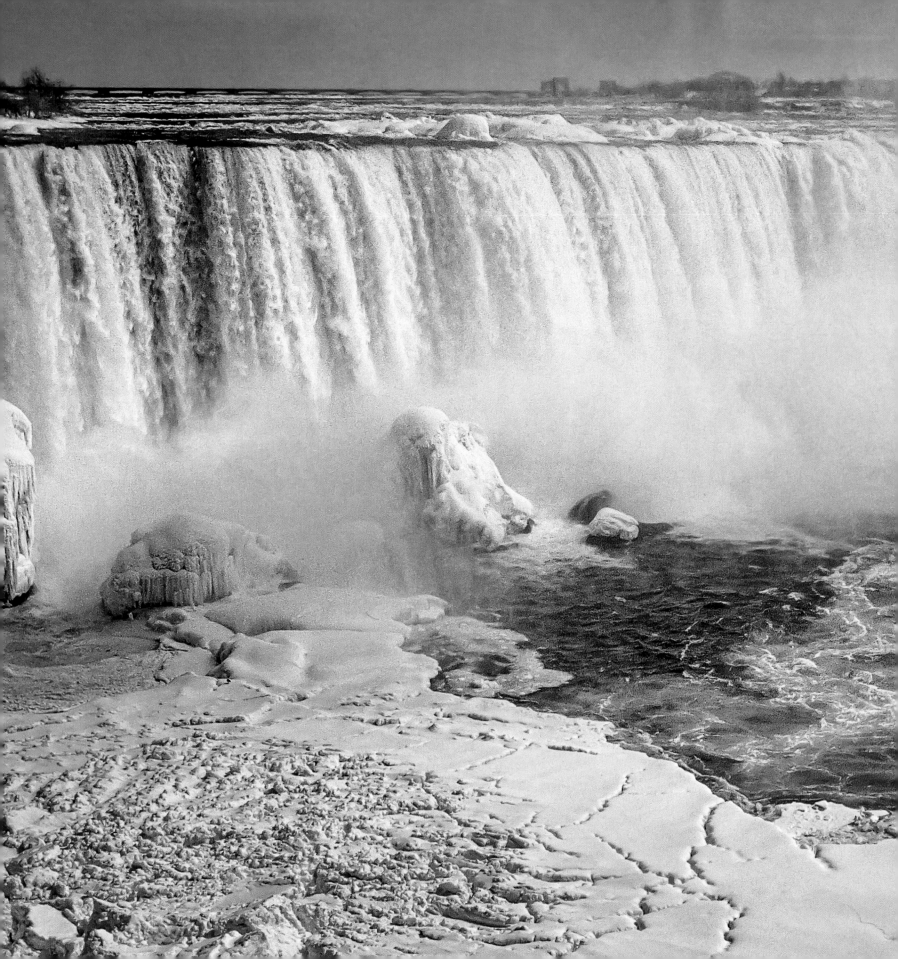

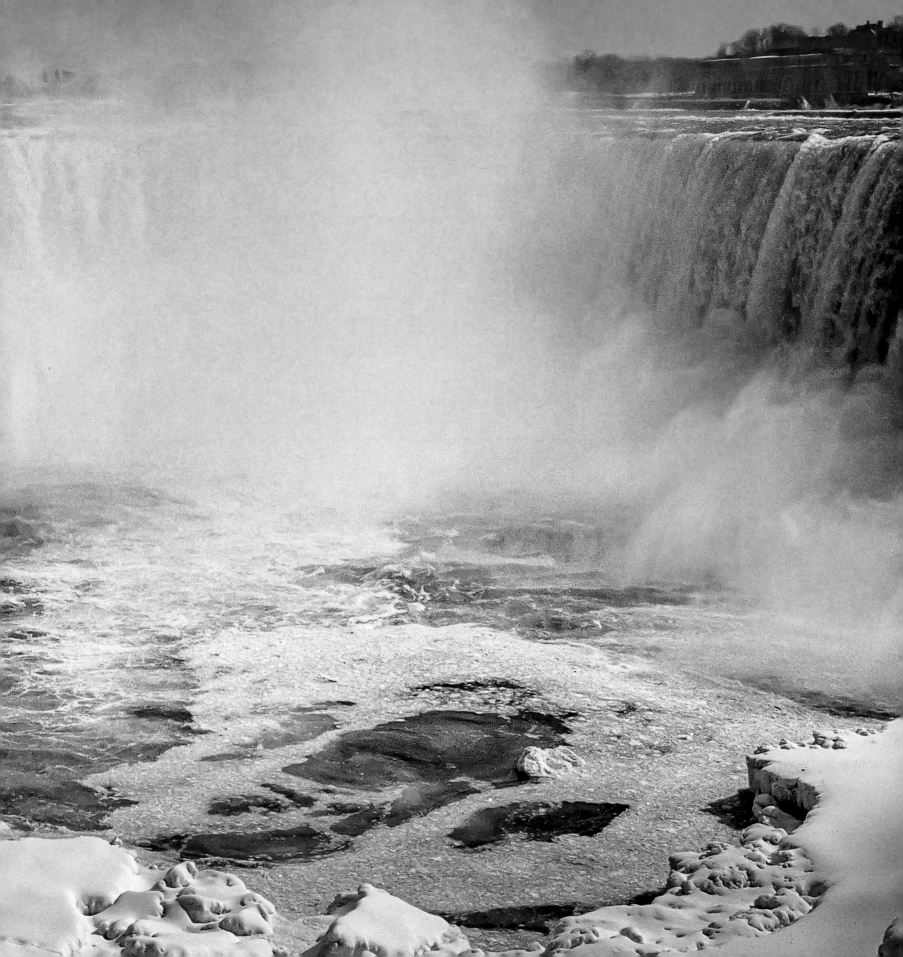

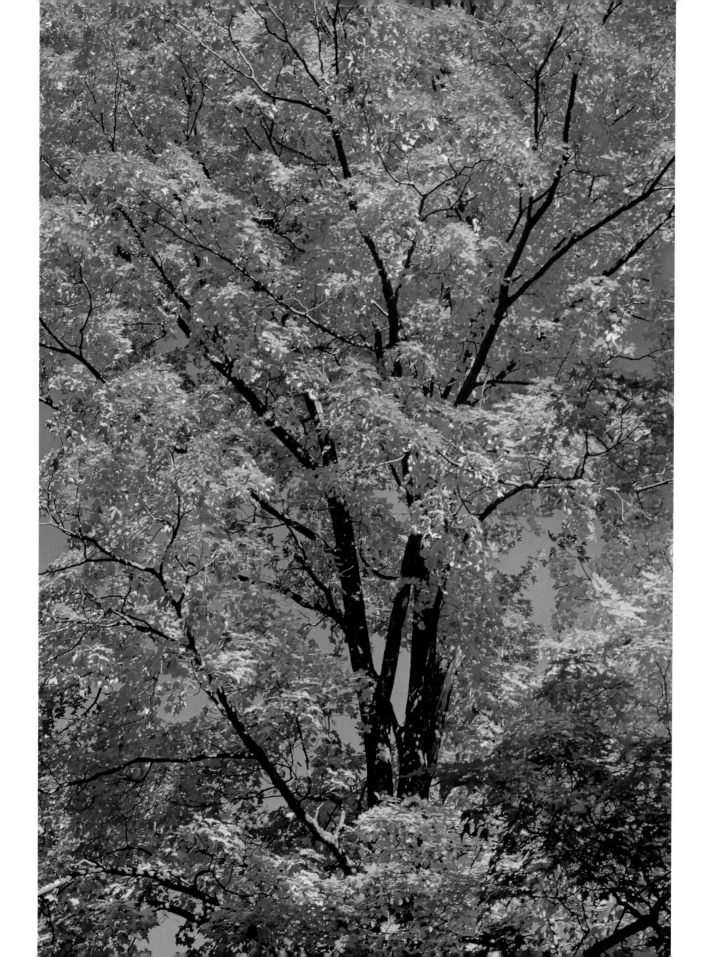

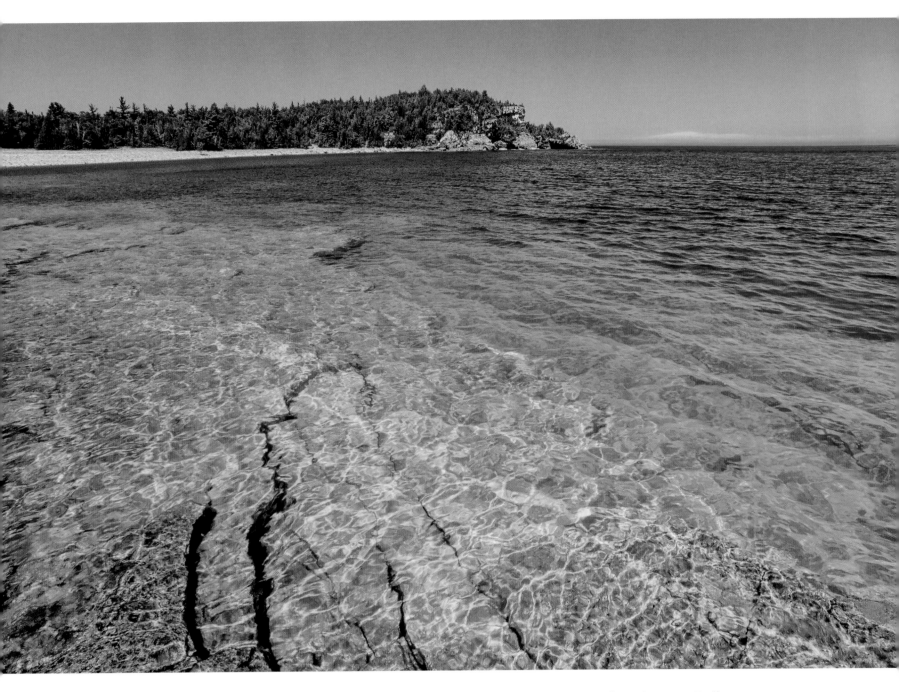

A red maple in autumn in Muskoka.

The emerald waters of Georgian Bay seen from the Bruce Trail at Boulder Beach, Bruce Peninsula National Park.

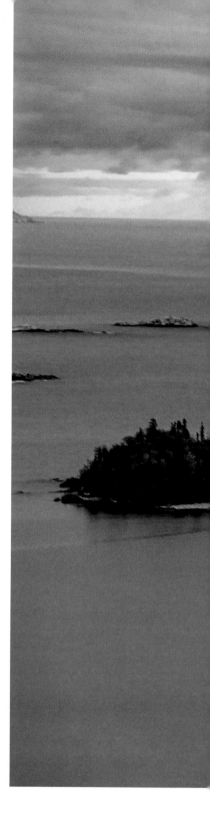

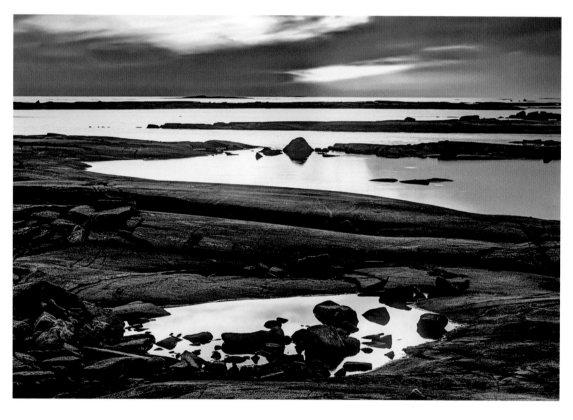

Many of the Thirty Thousand Islands in Georgian Bay are islets of Precambrian rock polished by glaciers during the Ice Age and now swept by frequent storm waves.

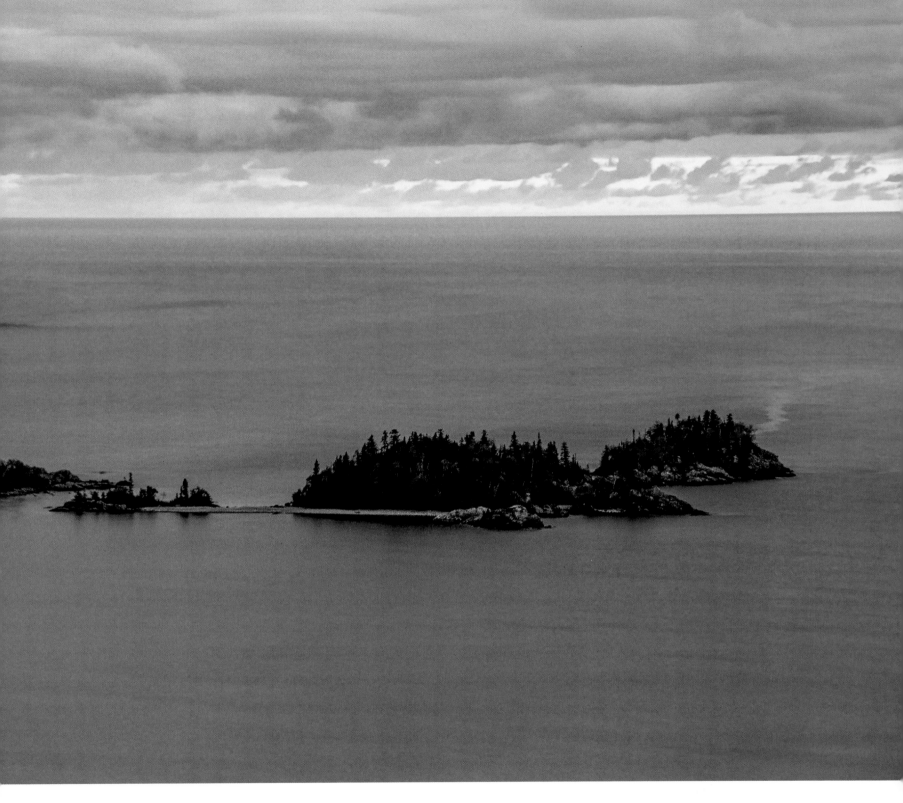

Taylor Island, Old Ned Island and Bell Island in the evening, Terrace Bay, Lake Superior.

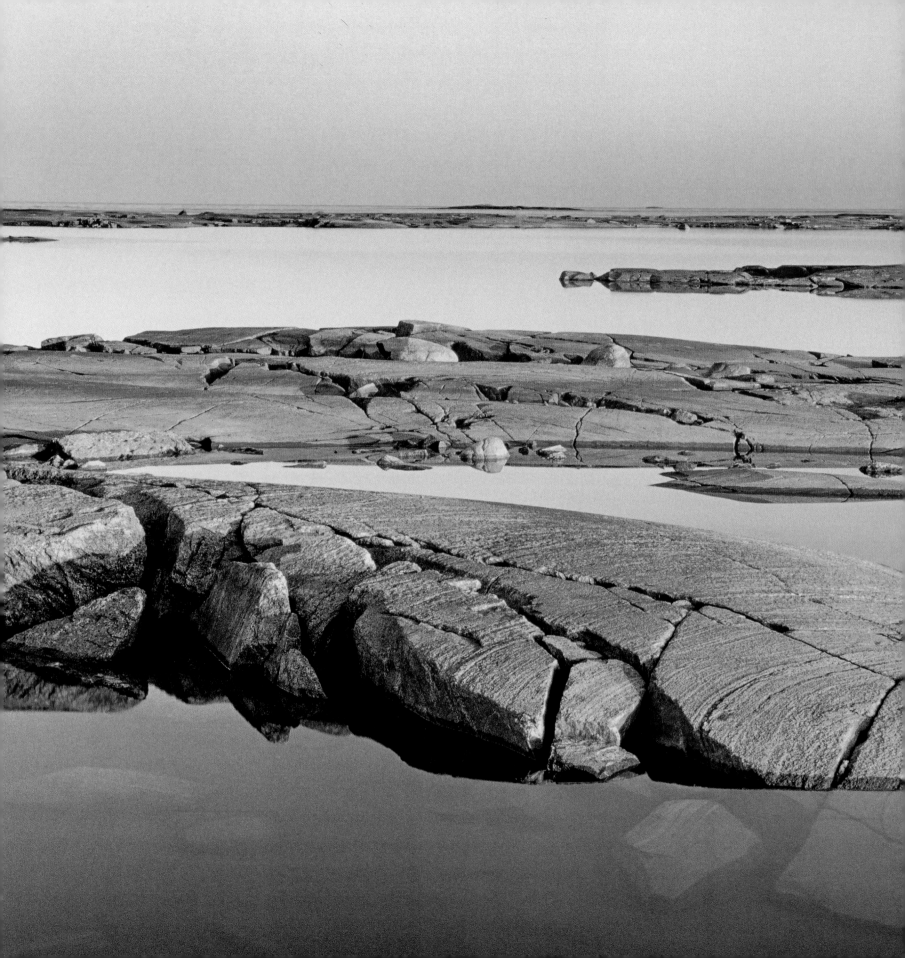

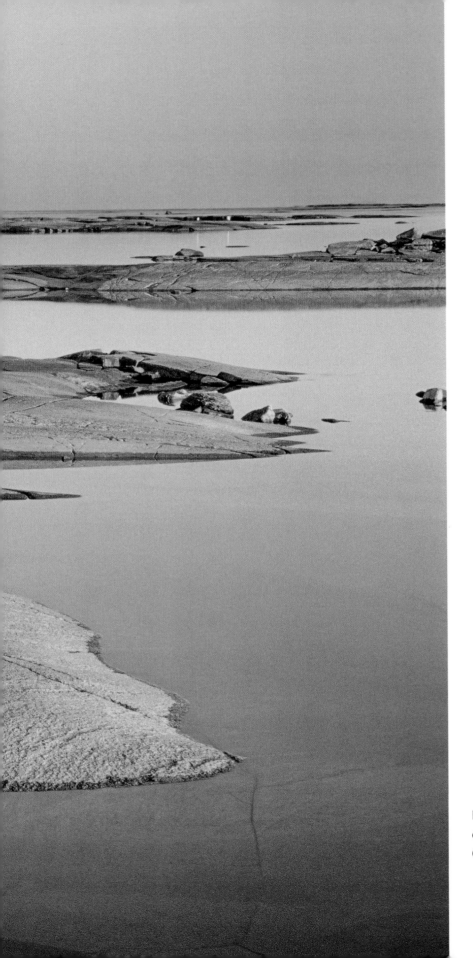

Bare stone is characteristic of the exposed small outer islands in the Thirty Thousands Islands, Georgian Bay.

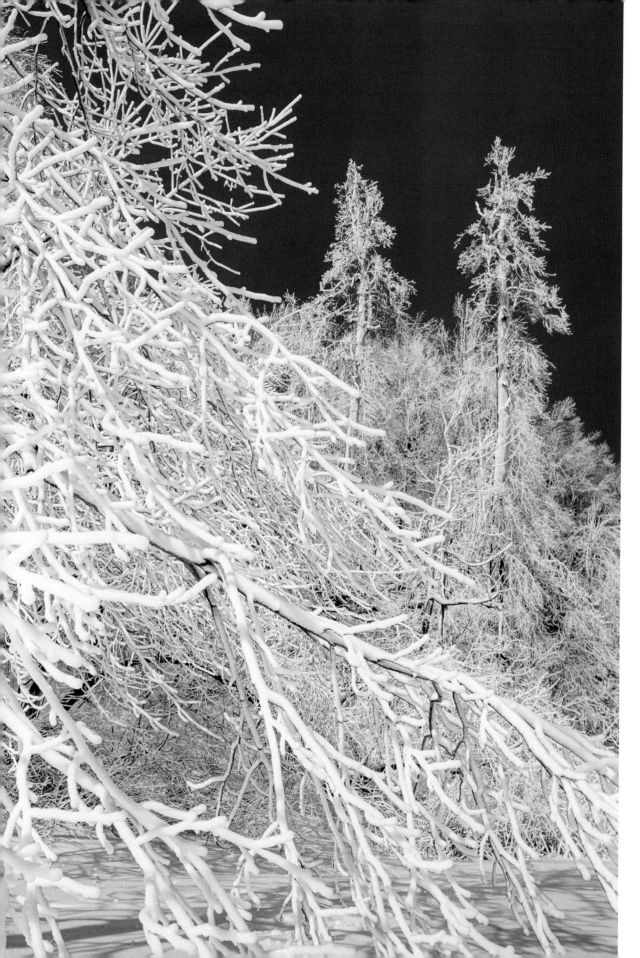

Rime ice from spray and mist coats trees close to the brink of Horseshoe Falls at Niagara Falls.

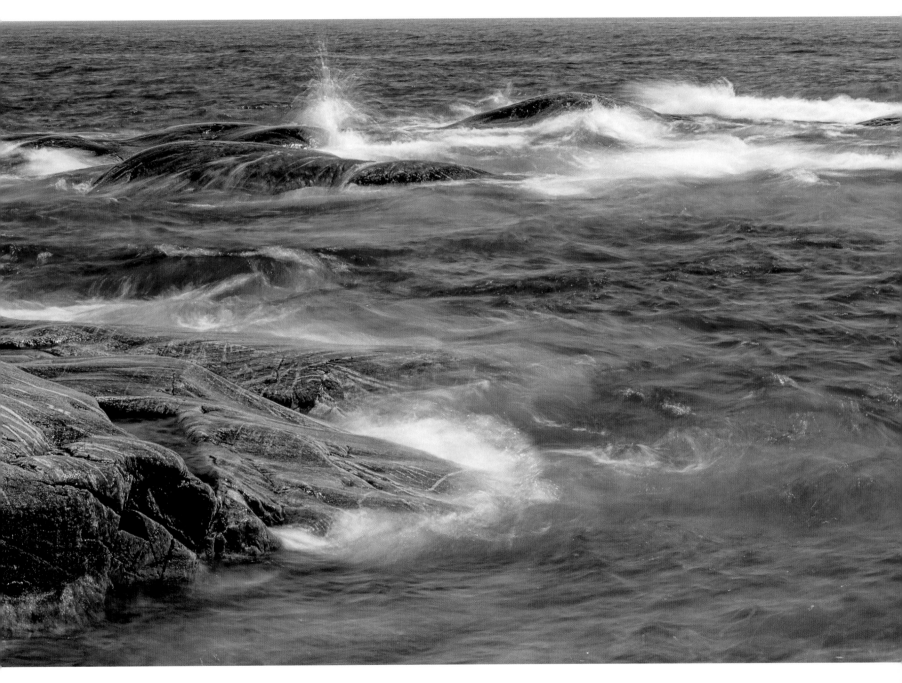

Waves break over the ancient rock coastline in Pukaskwa National
Park, Lake Superior.

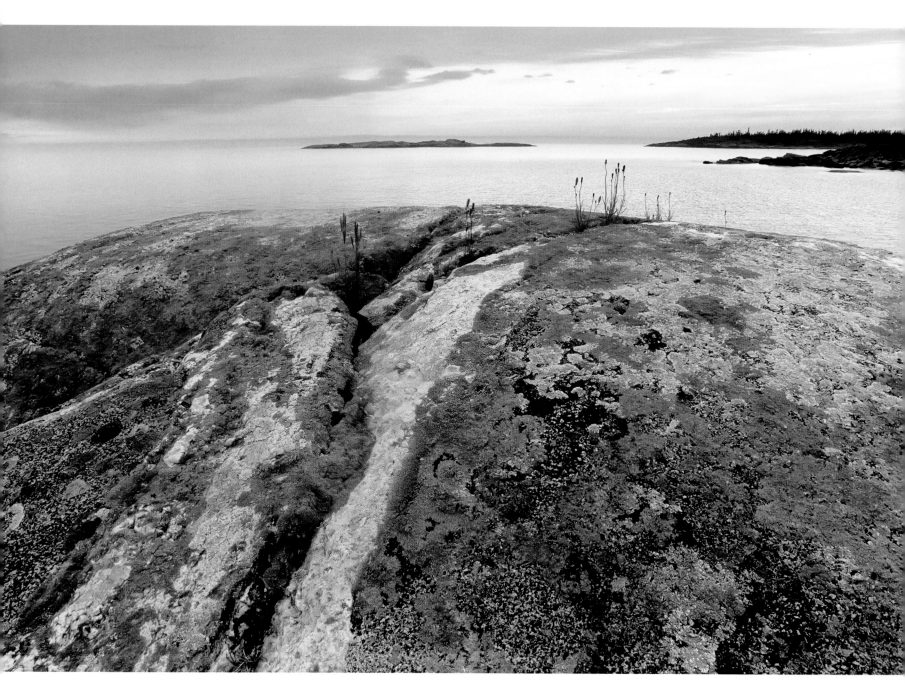

Lichens on billion-year-old Precambrian Shield rock along the
Coastal Hiking Trail near Fish Cove, Pukaskwa National Park.

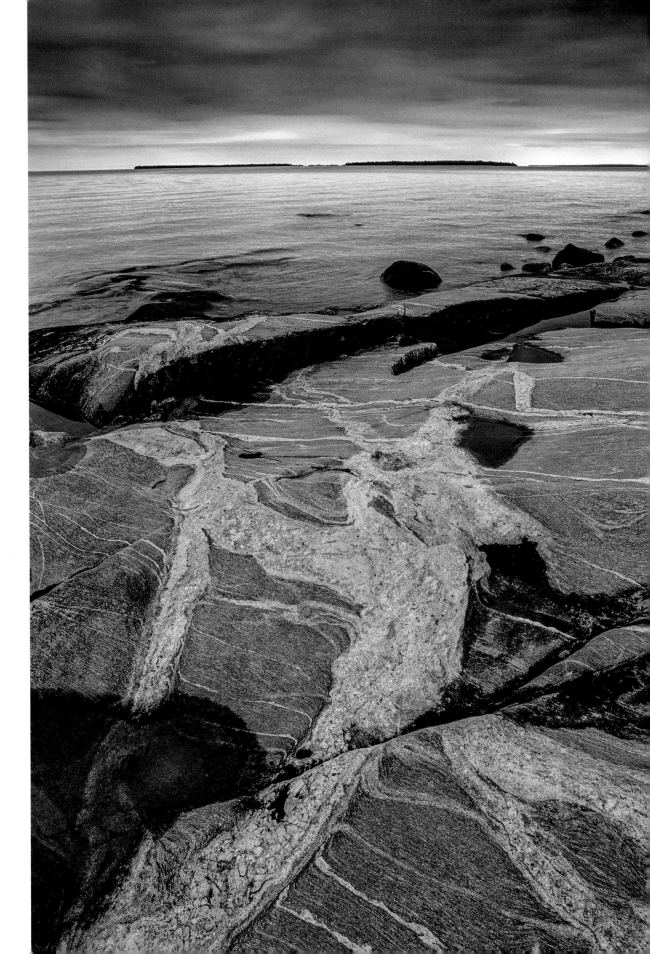

Katherine Cove, Lake Superior Provincial Park. The complex igneous and metamorphic geology along the coast of Lake Superior contains some of the oldest rock on earth.

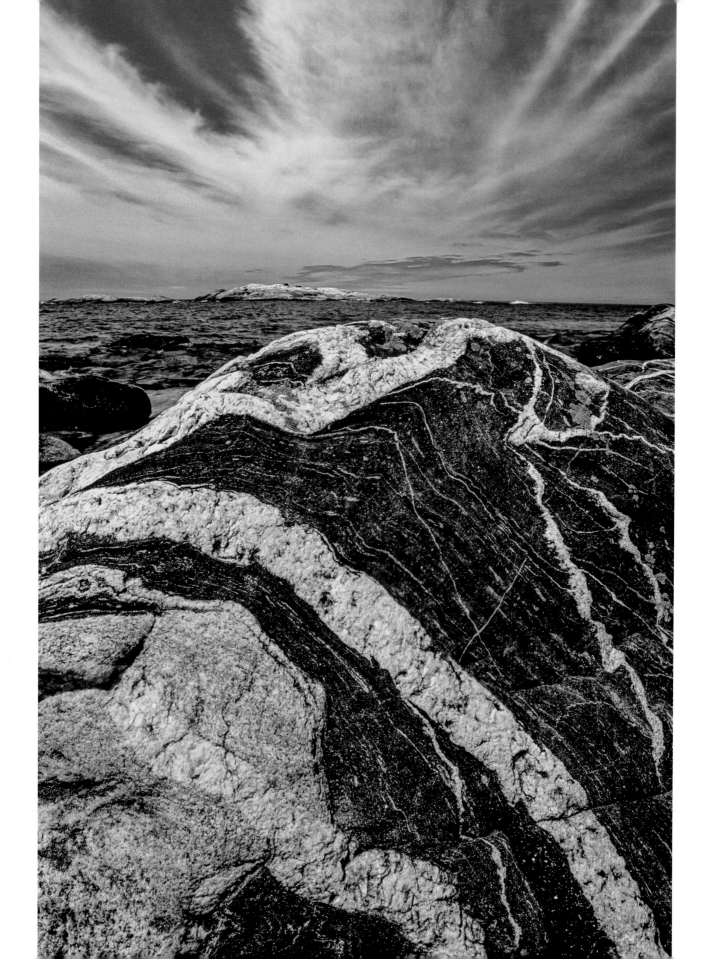

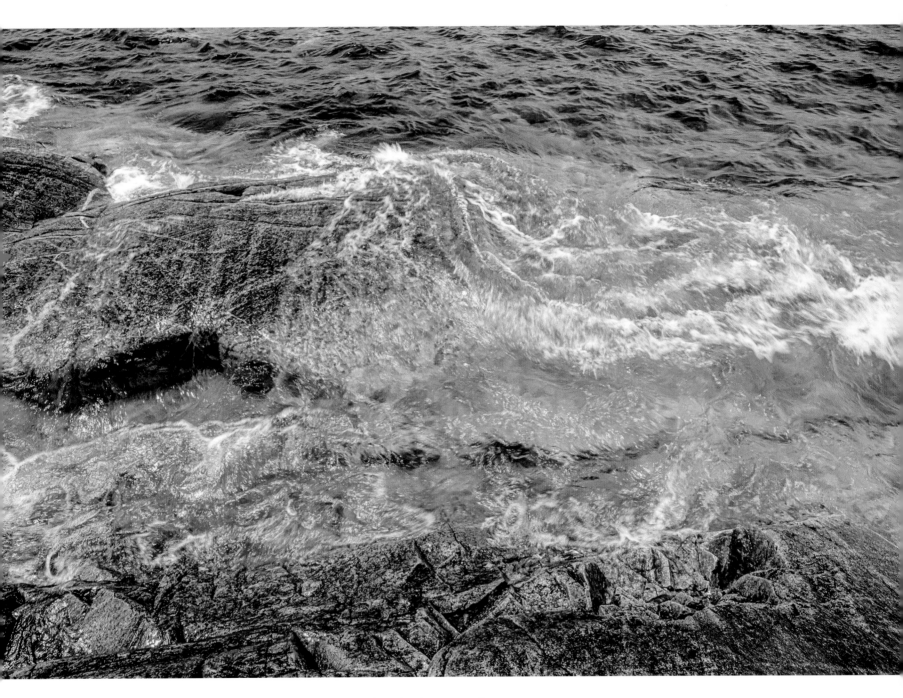

Along the coast of Lake Superior in Pukaskwa National Park. The exposed
bedrock here of two-billon-year old granitic gneiss is more than 100,000
times older than the great lake itself, which is a mere 10,000 years young.

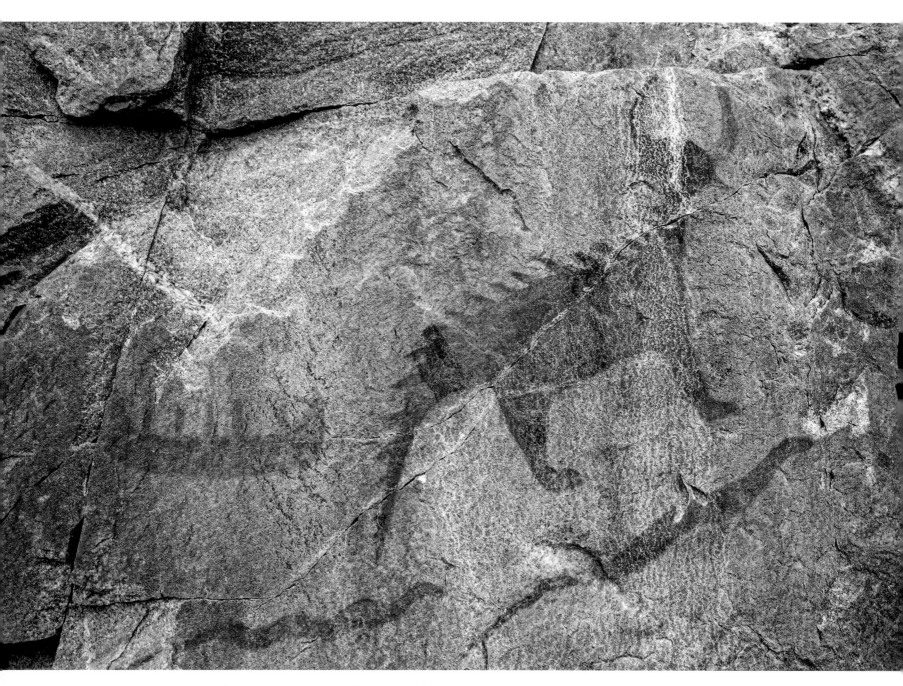

The presence of First Nations is painted and carved into the very bedrock of the land. Pictographs at Agawa Bay on the coast of Lake Superior (above) and petroglyphs at Petroglyphs Provincial Park near Peterborough.

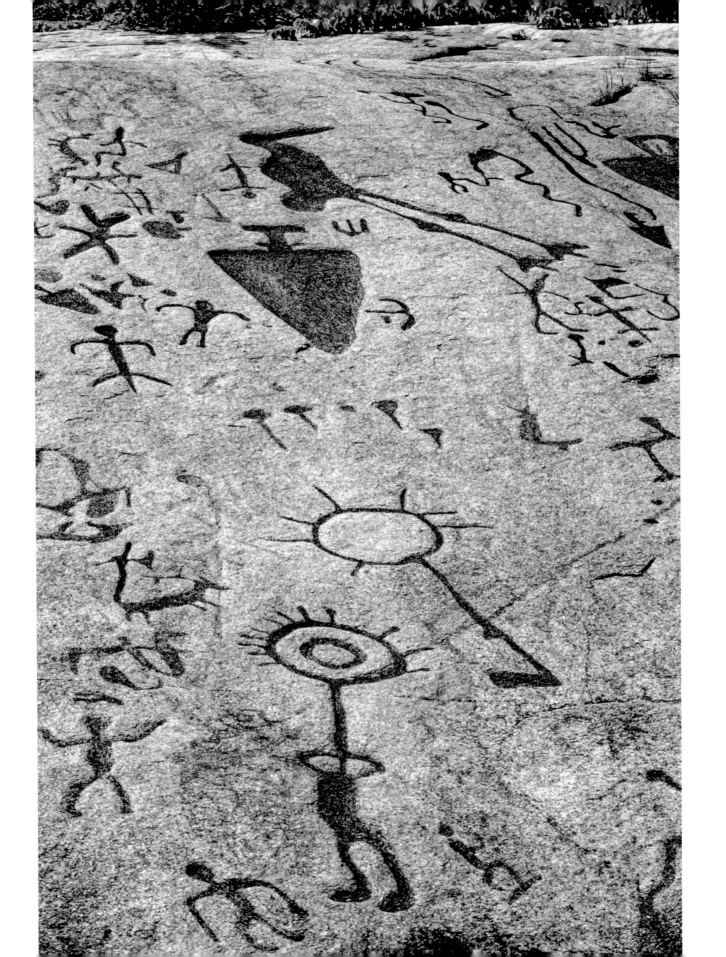

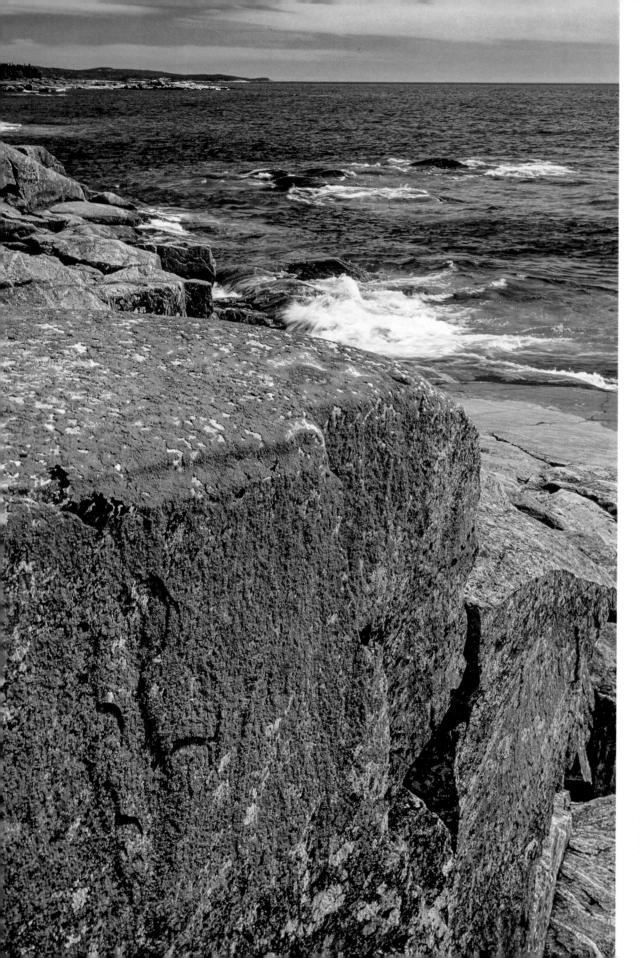

Lichen-covered stone on the shore of Lake Superior along the sixty-kilometre Coastal Hiking Trail in Pukaskwa National Park.

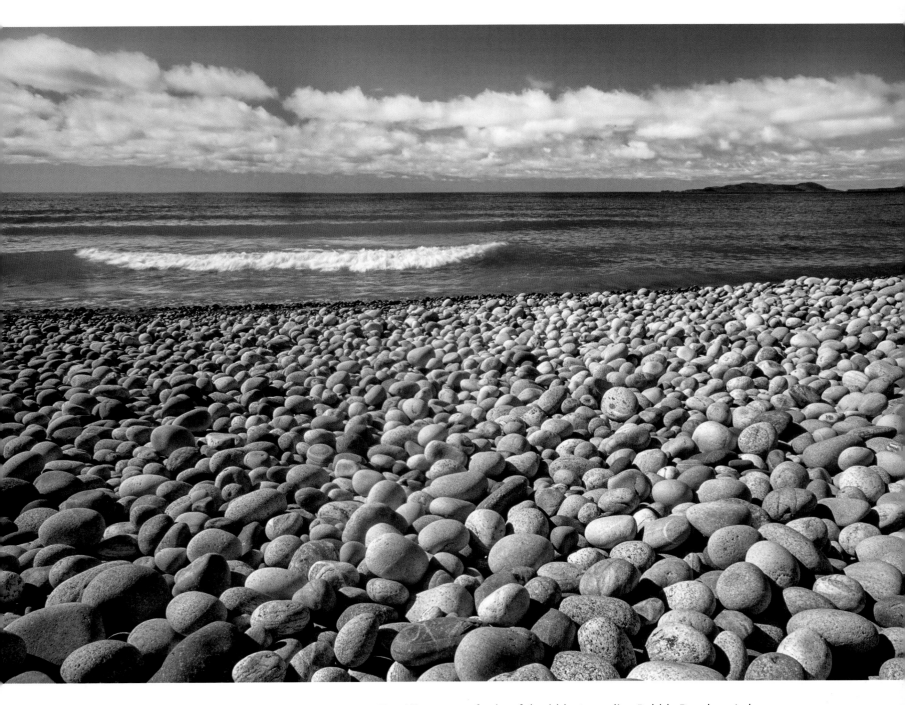

Two kilometres of colourful cobblestones line Pebble Beach on Lake Superior, at Marathon.

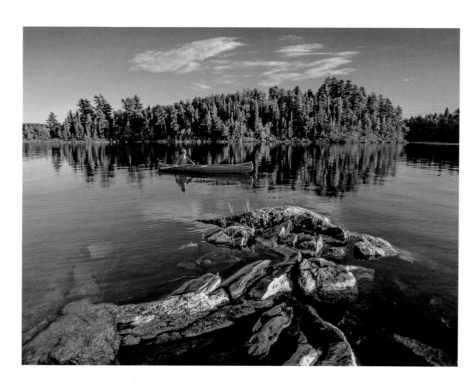

Canoeing in Quetico Provincial Park on Pickerel Lake (above) and kayaking in Lake Superior at Simpson Island near Rossport.

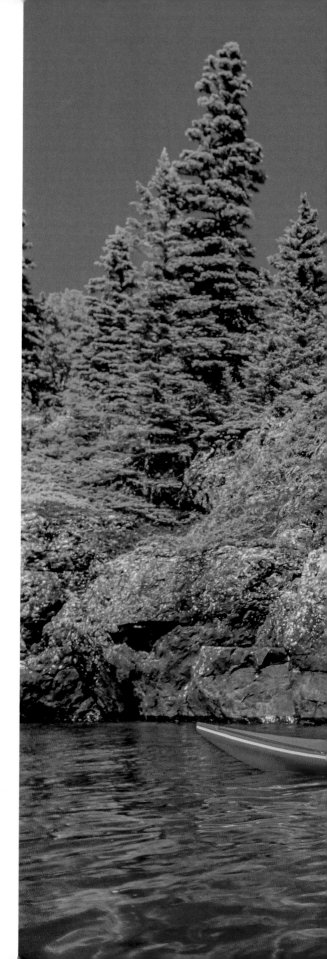

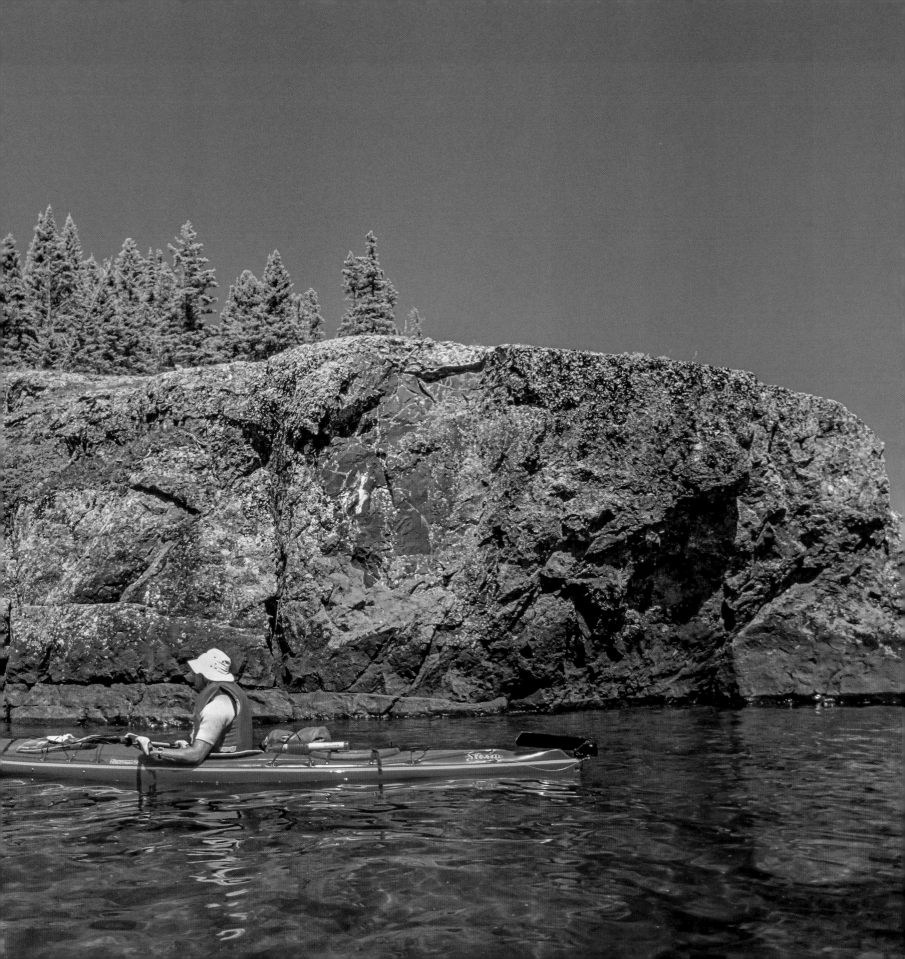

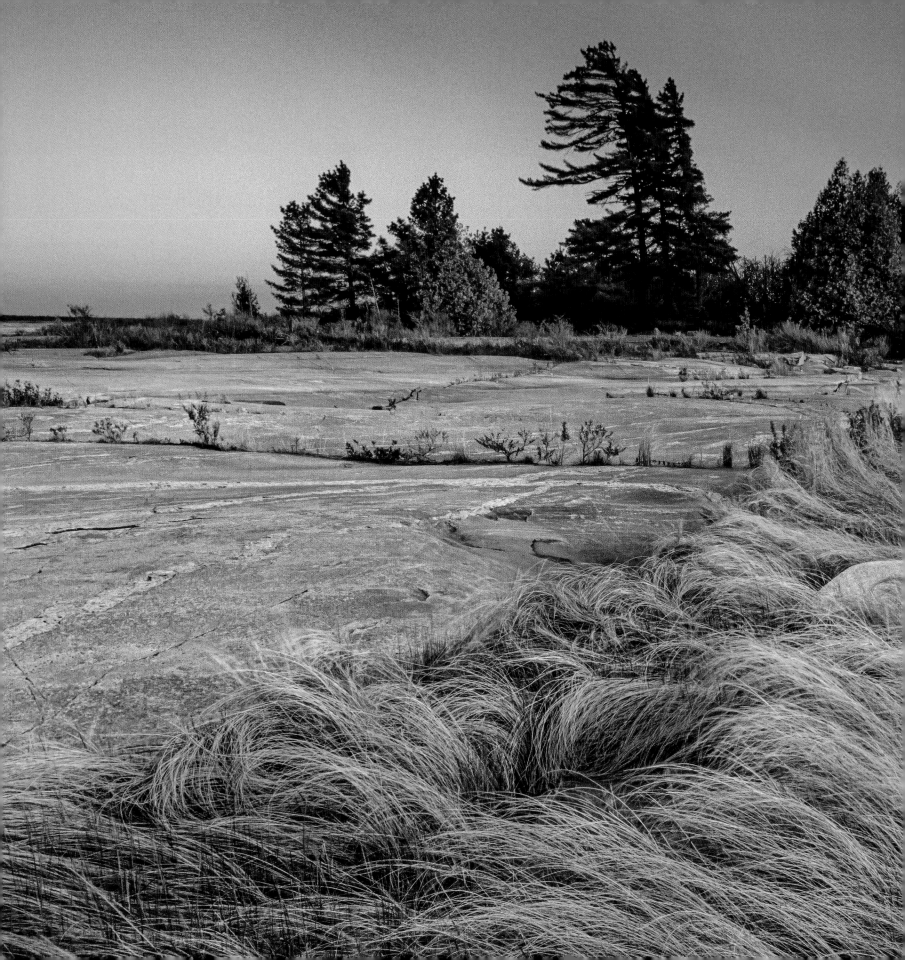

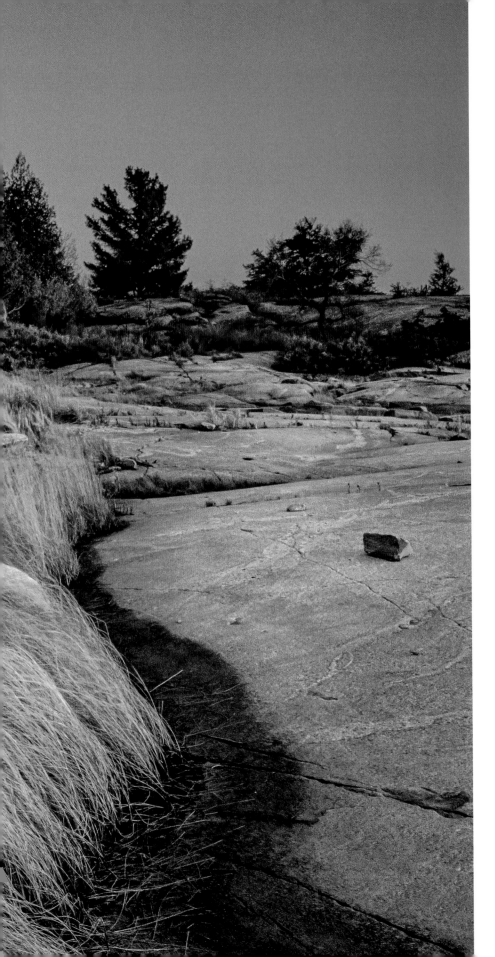

Grasses and pine trees at evening on Head Island in the Thirty Thousand Islands north of Bayfield Inlet, Georgian Bay.

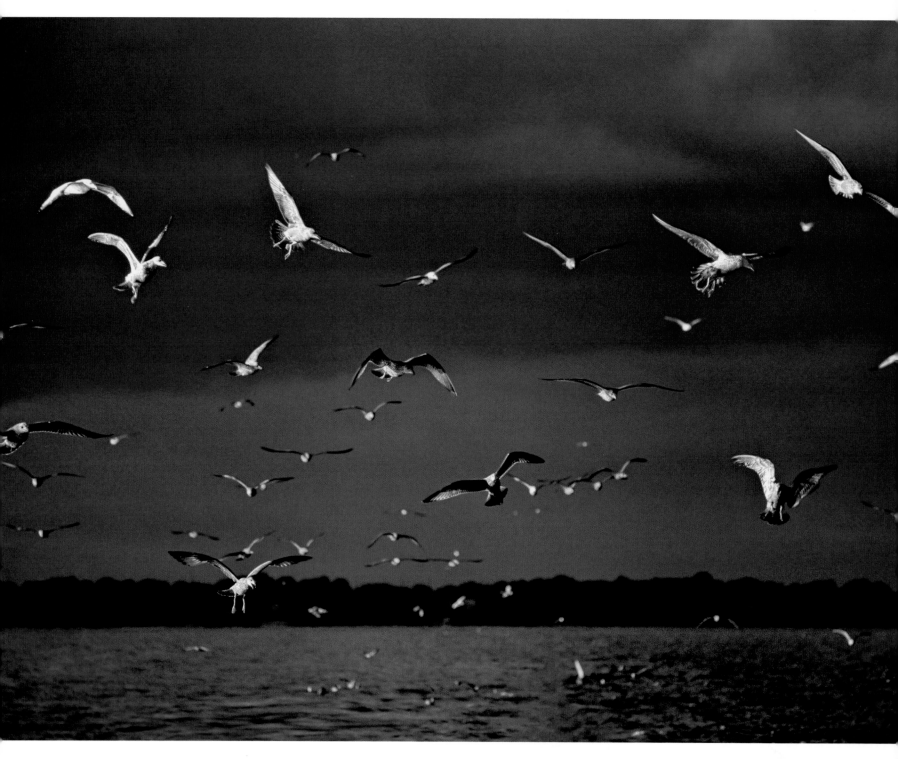

Evening sunlight illuminates gulls following the ferry to Pelee Island, the southernmost inhabited land in Canada.

Sunlit silvery waters before an approaching storm front off the long spit at the end of Point Pelee in Point Pelee National Park.

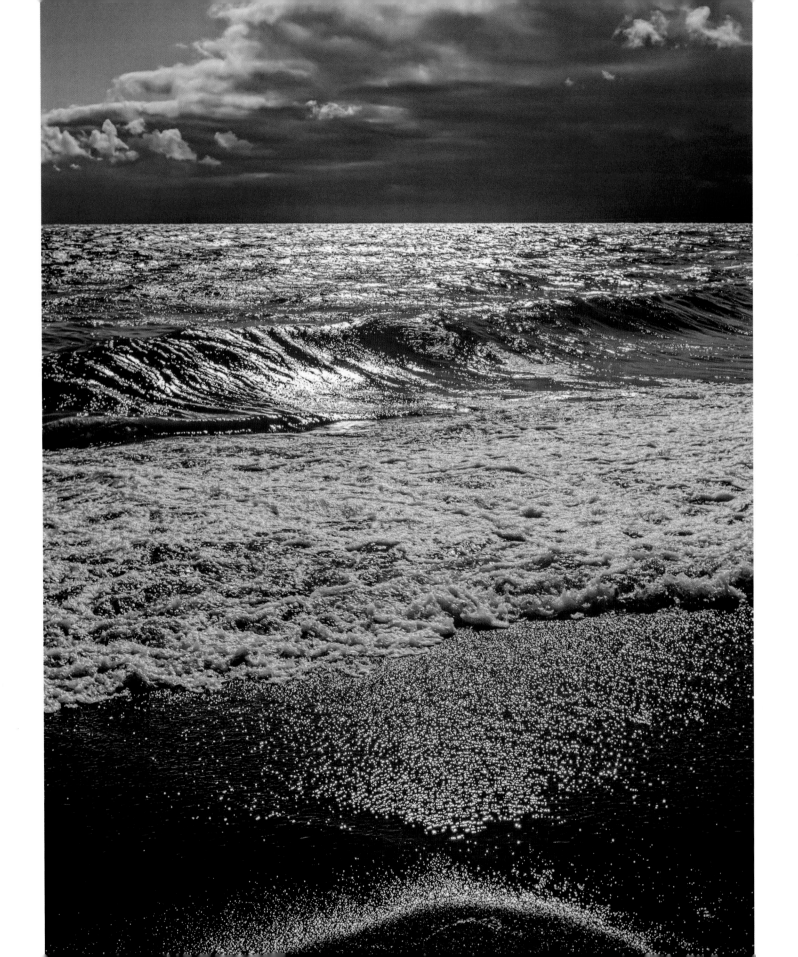

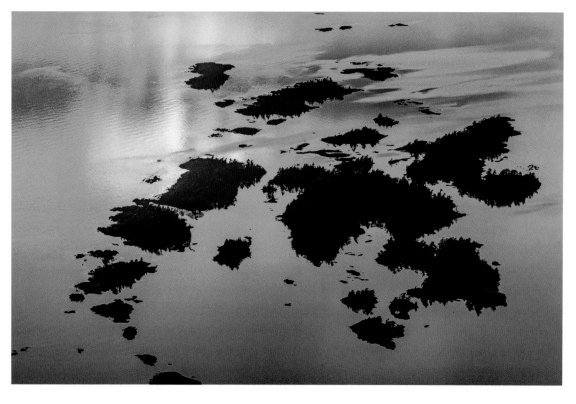

A small group of islands within the vast Thirty Thousand Islands at sunset just west of Starvation Bay include Windy Island, Martin Island, Warburton Island, Jubilee Island and Gages Island.

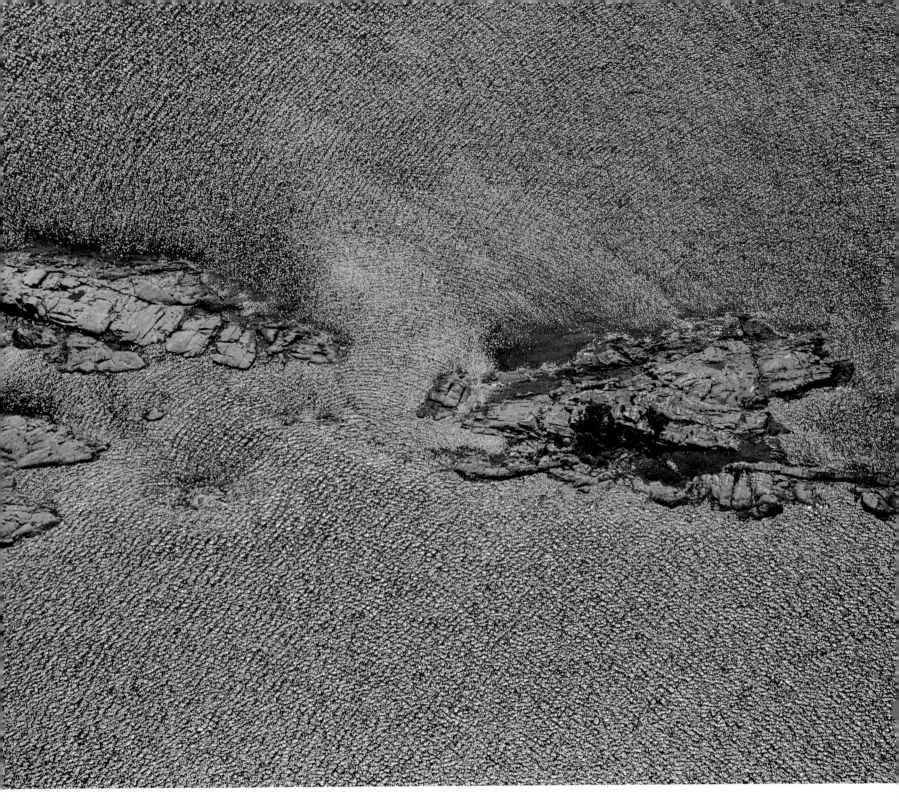

An aerial view of Fitzsimmons Rocks, small islets off the coast of Lake Superior halfway between Terrace Bay and Marathon.

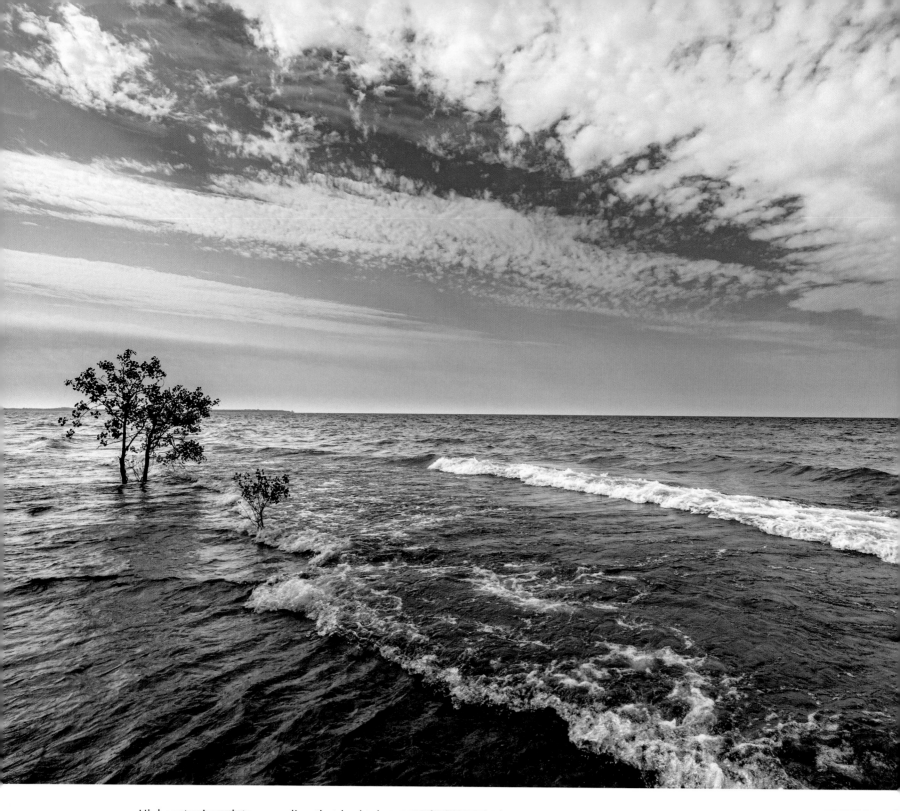

High water inundates a sapling that had taken root during periods of lower water levels in Lake Ontario at West Point in Sandbanks Provincial Park.

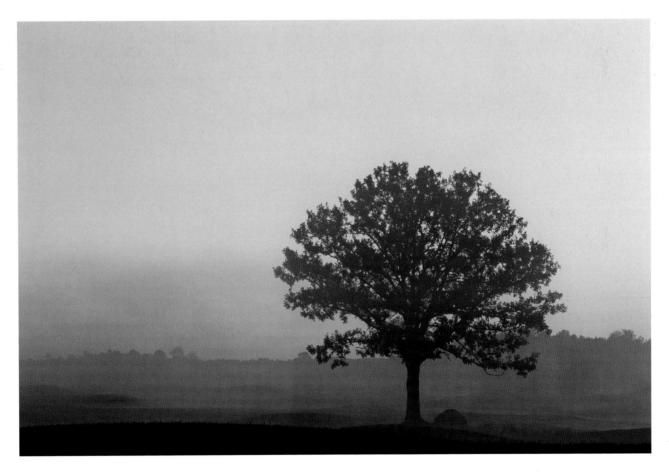

A lone tree in the Innisfill Creek Golf Course south of Barrie at dawn.

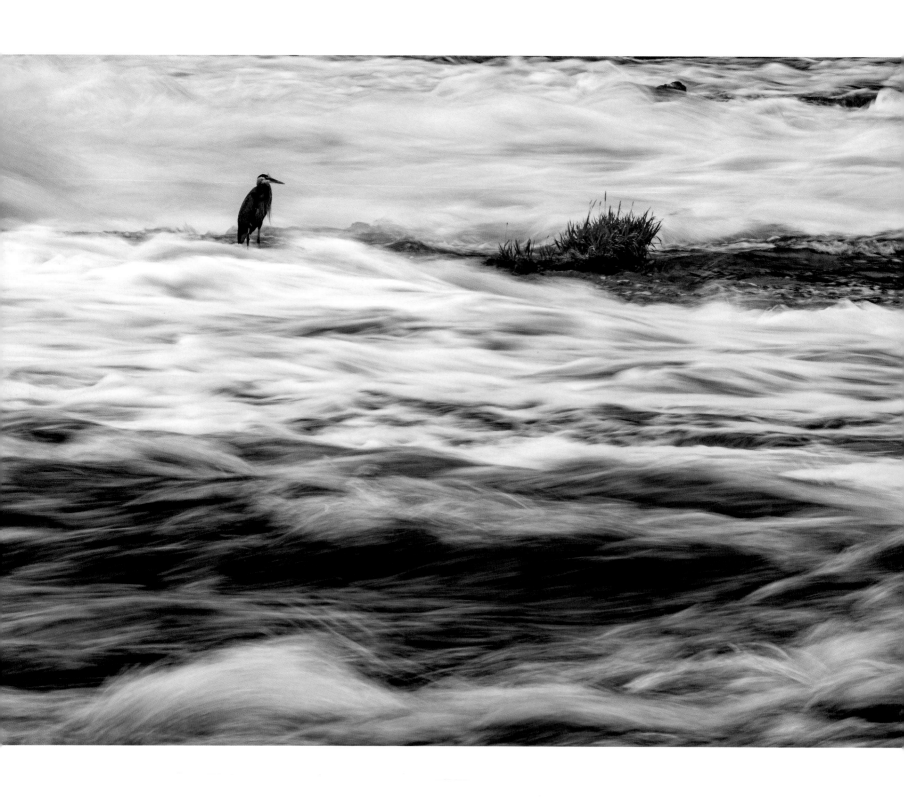

A heron stands amidst the Carleton Place Rapids on the Mississippi River (left) and a gull perches above Recollet Falls on the French River.

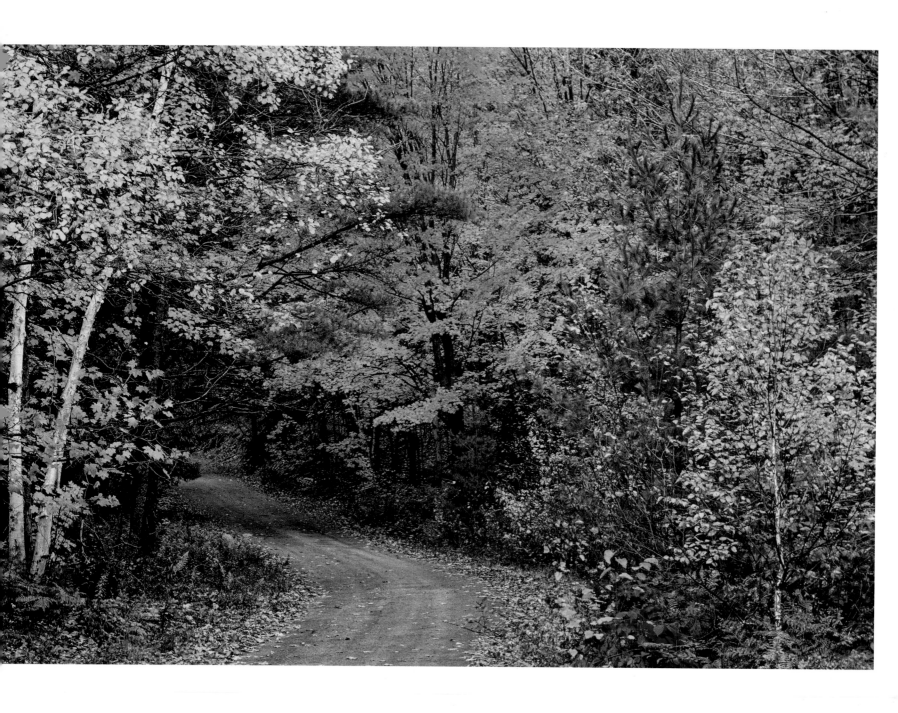

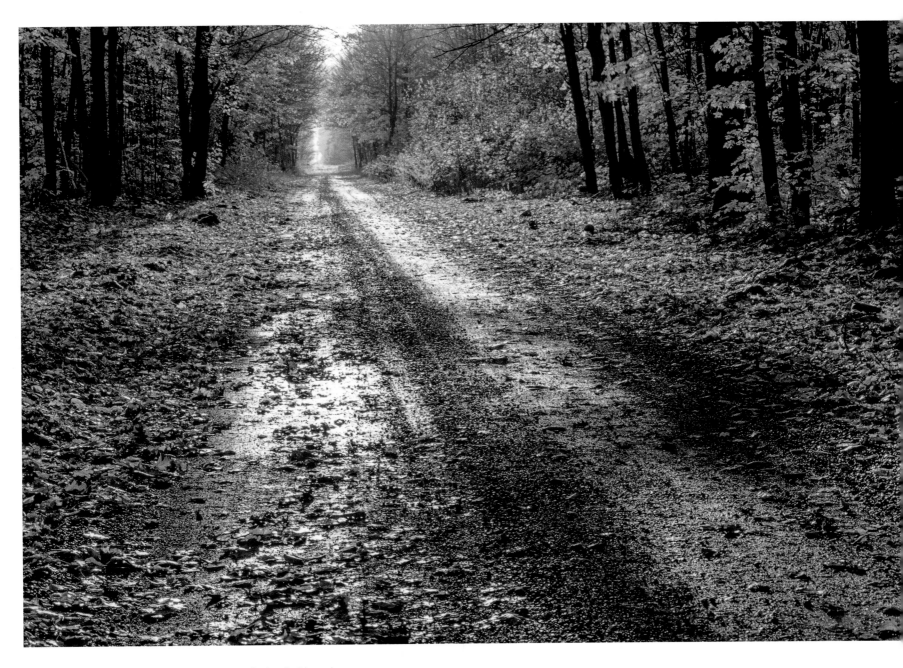

Country roads in autumn in Muskoka (left) and on
St. Joseph Island near Sault Ste. Marie.

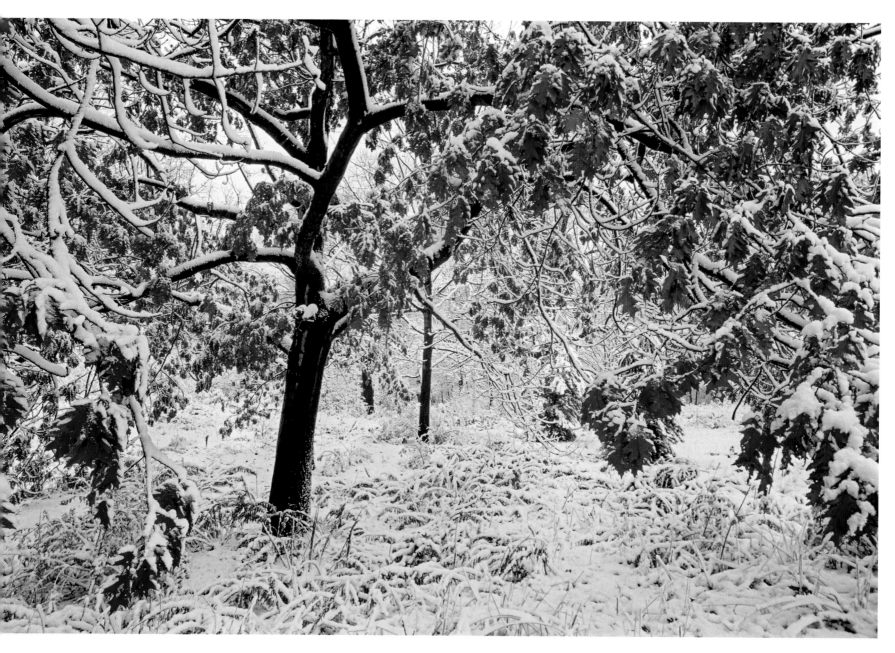

Red oak leaves in winter in High Park, Toronto.

Morning frost on grasses and a small pine tree in Muskoka.

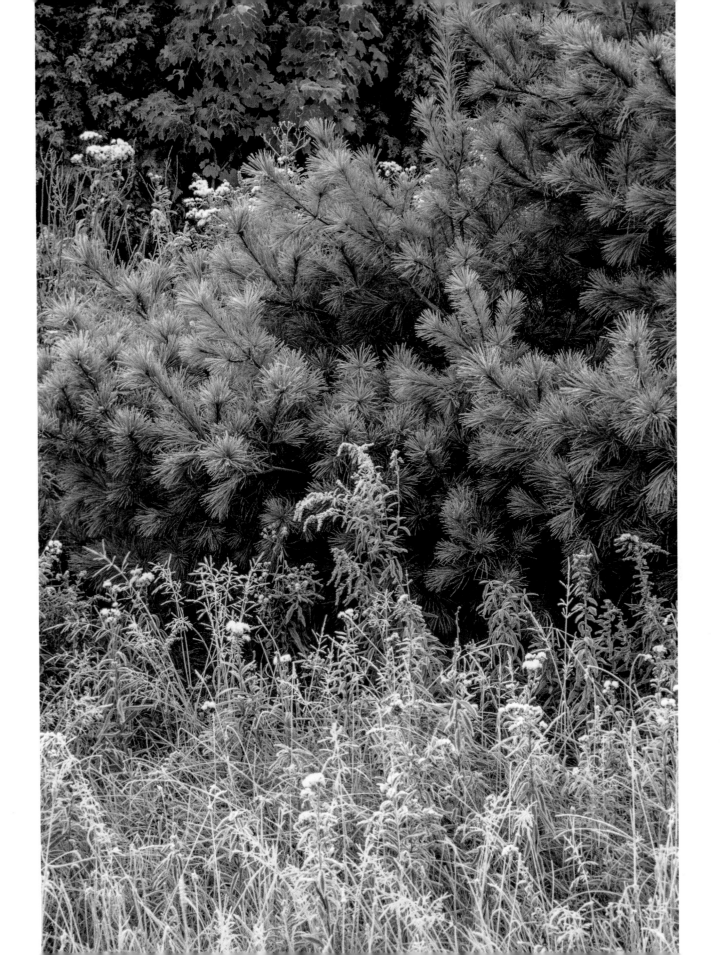

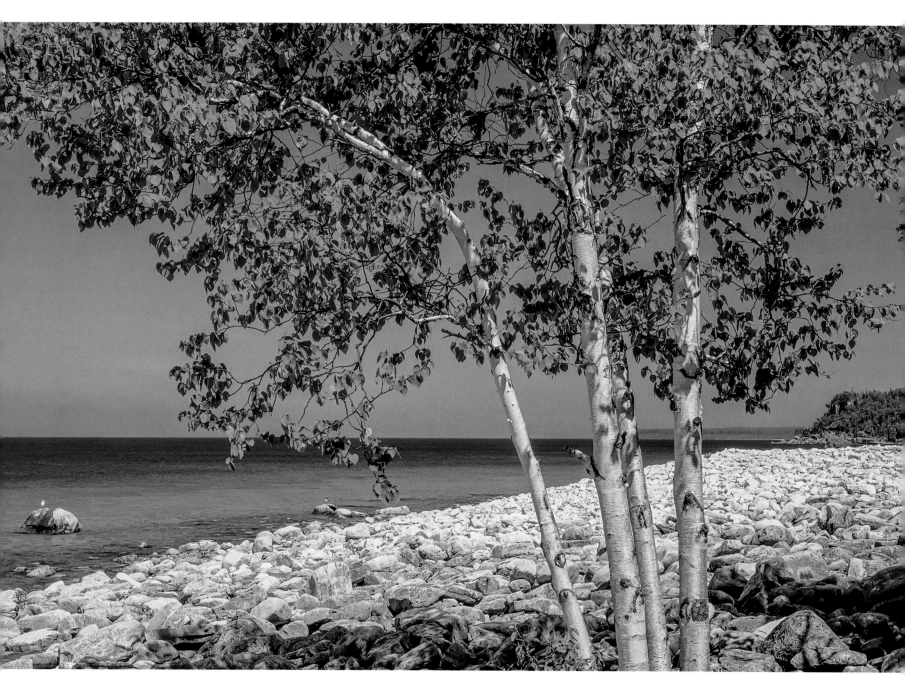

Birch trees overlooking Georgian Bay, Bruce Peninsula National Park.

Pine trees and a half moon at sunset on Beausoleil Island at Honeymoon Bay, Georgian Bay Islands National Park.

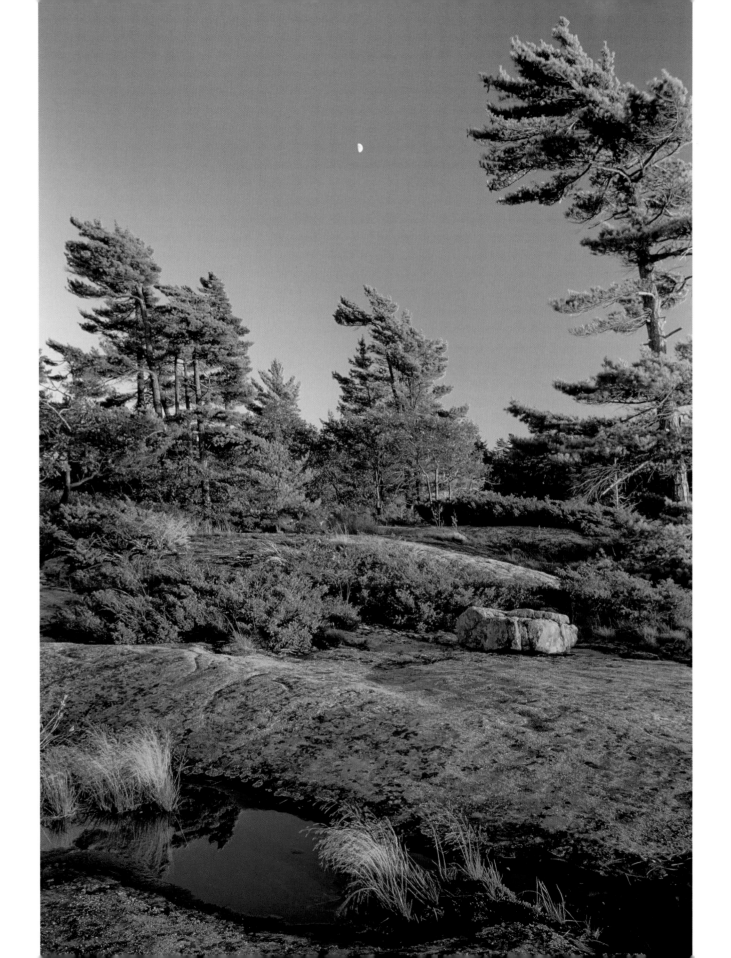

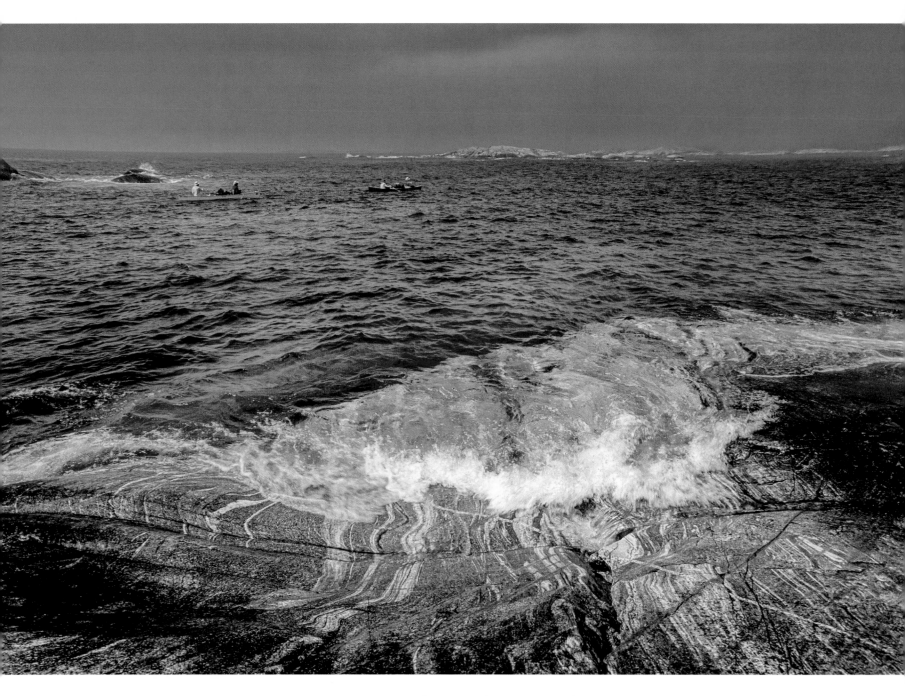

The extraordinary beauty of veined and diked rock that is billions of years old along the remote coast of Pukaskwa National Park attracts canoeists (above) and backpackers to this challenging wilderness.

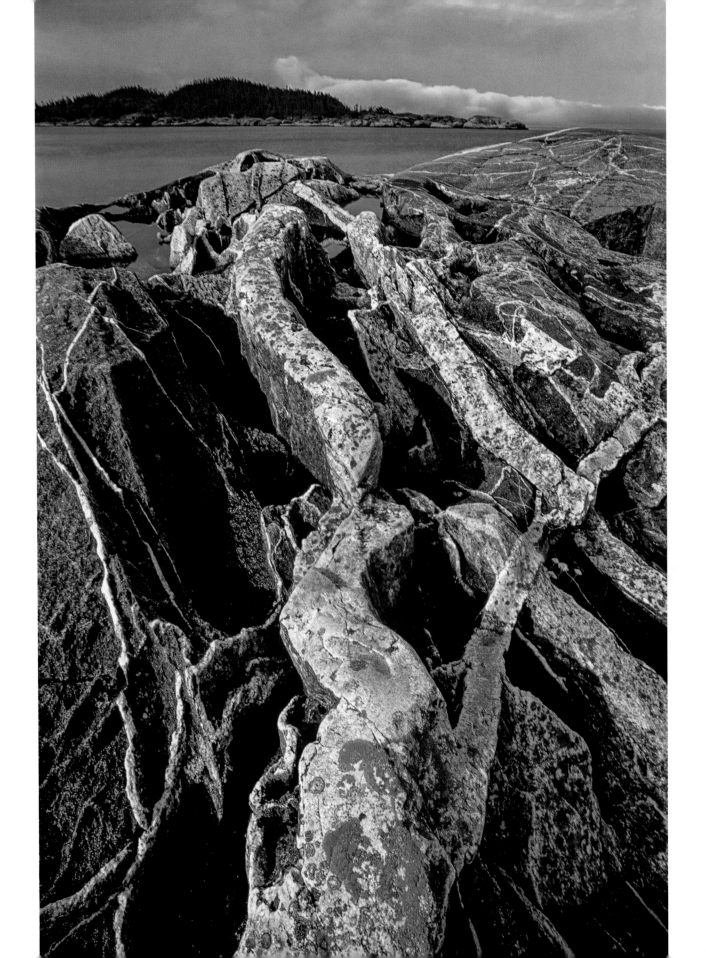

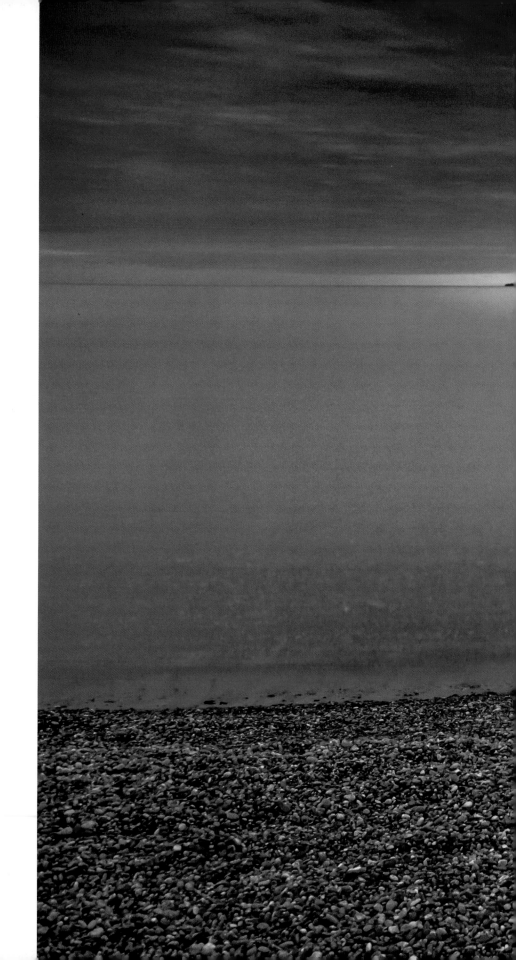

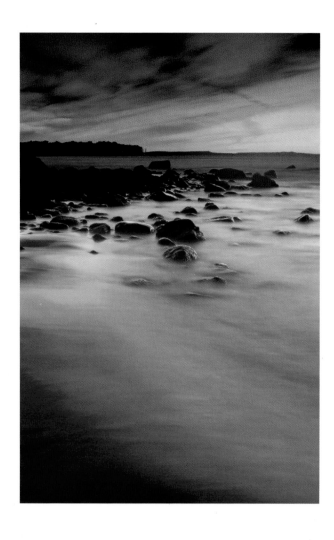

After sunset on the Great Lakes, over southern Georgian Bay, Lake Huron (above) and over Agawa Bay, Lake Superior Provincial Park, Lake Superior.

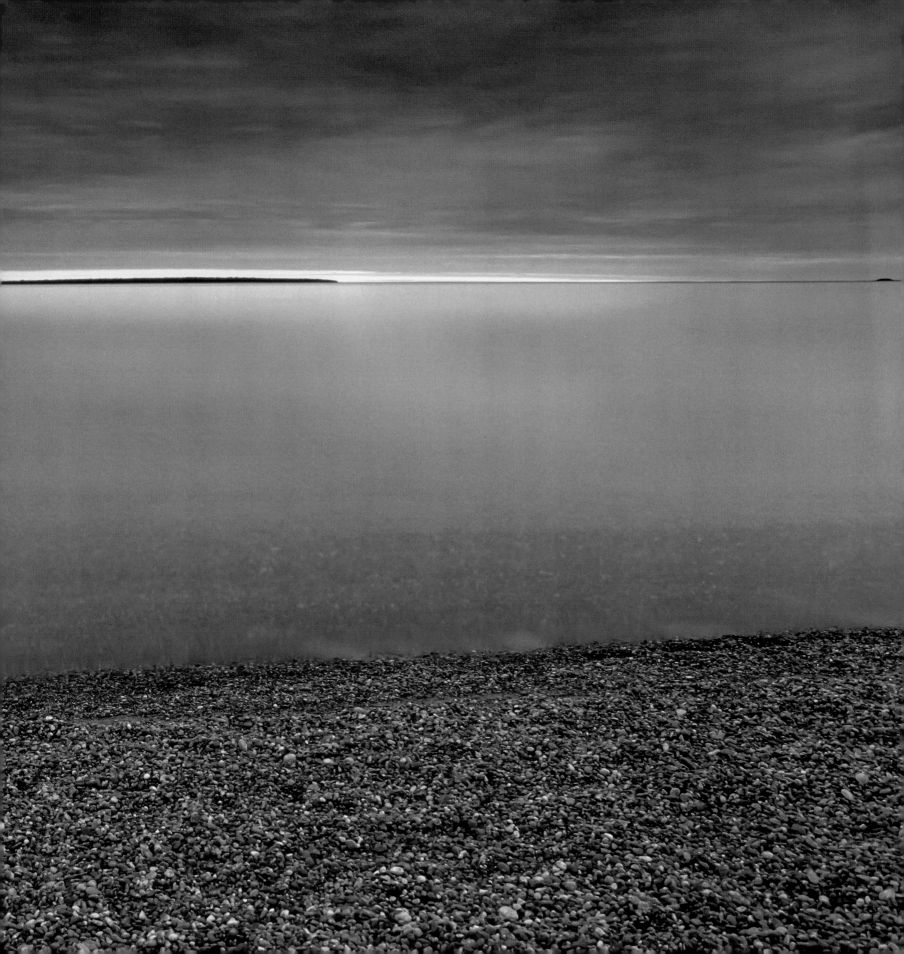

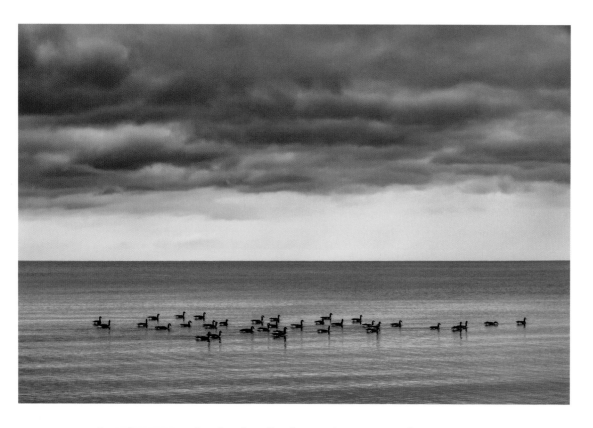

Canada geese cruise the shoreline in Inverhuron Bay, Lake Huron, north of Kincardine.

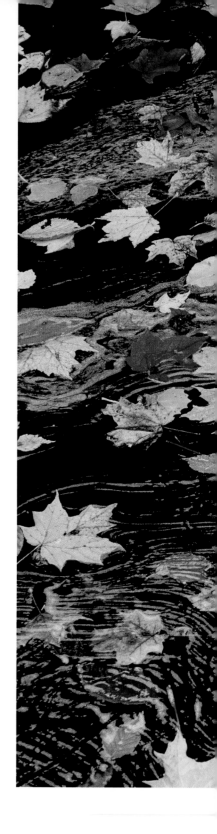

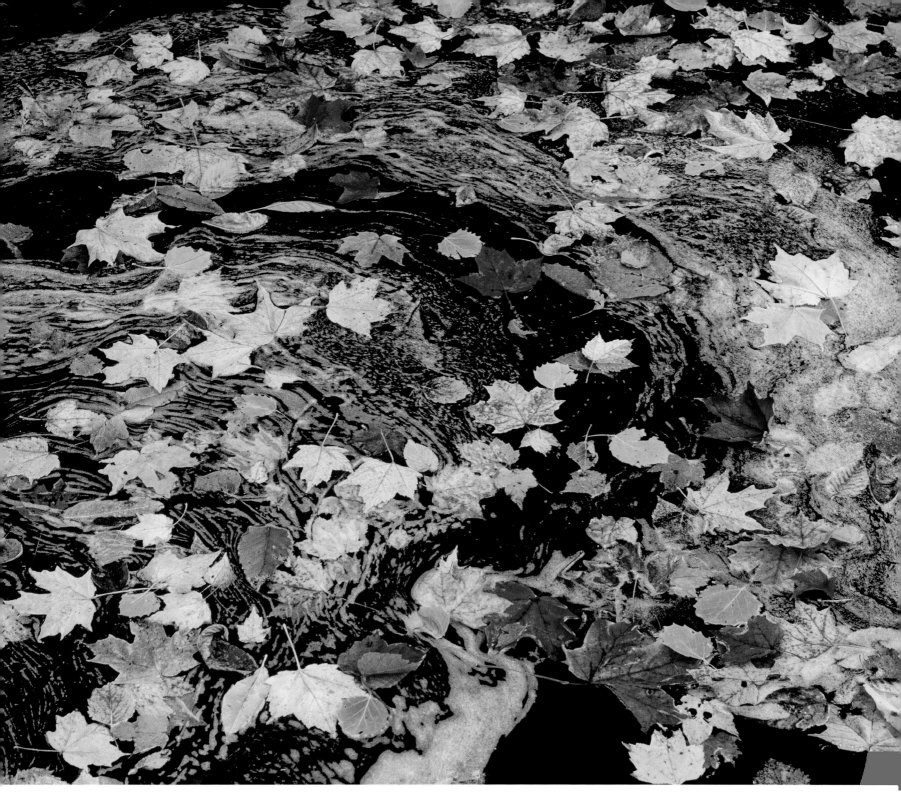

Fallen maple, beech, birch and aspen leaves collect in a pool along a brook in Muskoka.

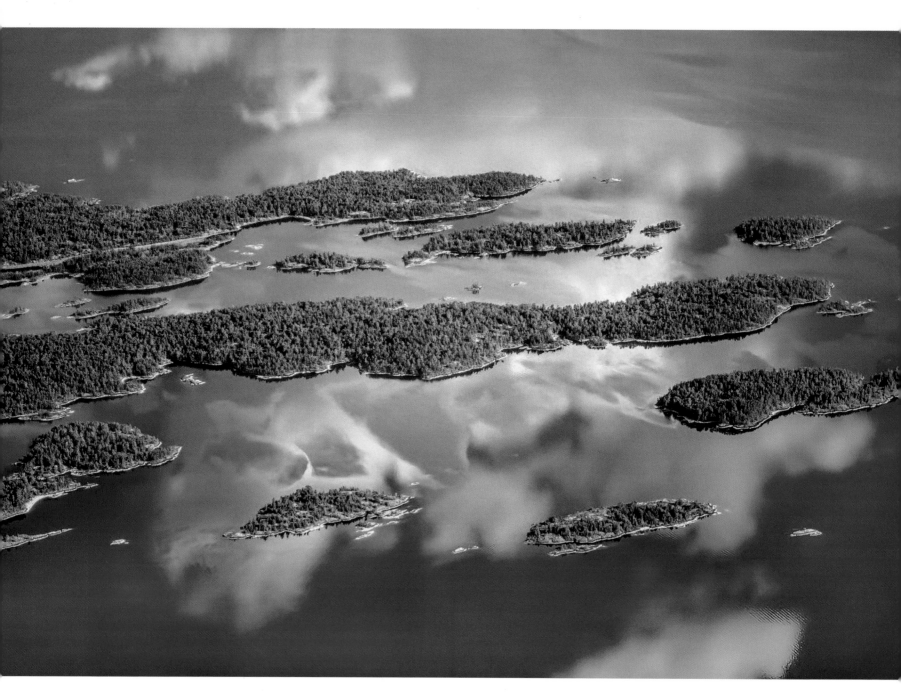

Seen from the air on a calm summer morning east of Fort Frances, the waters of Rainy Lake are still enough to reflect the clouds in the sky.

An aerial view of the delta of the Goulais River where it empties into Lake Superior north of Sault Ste. Marie.

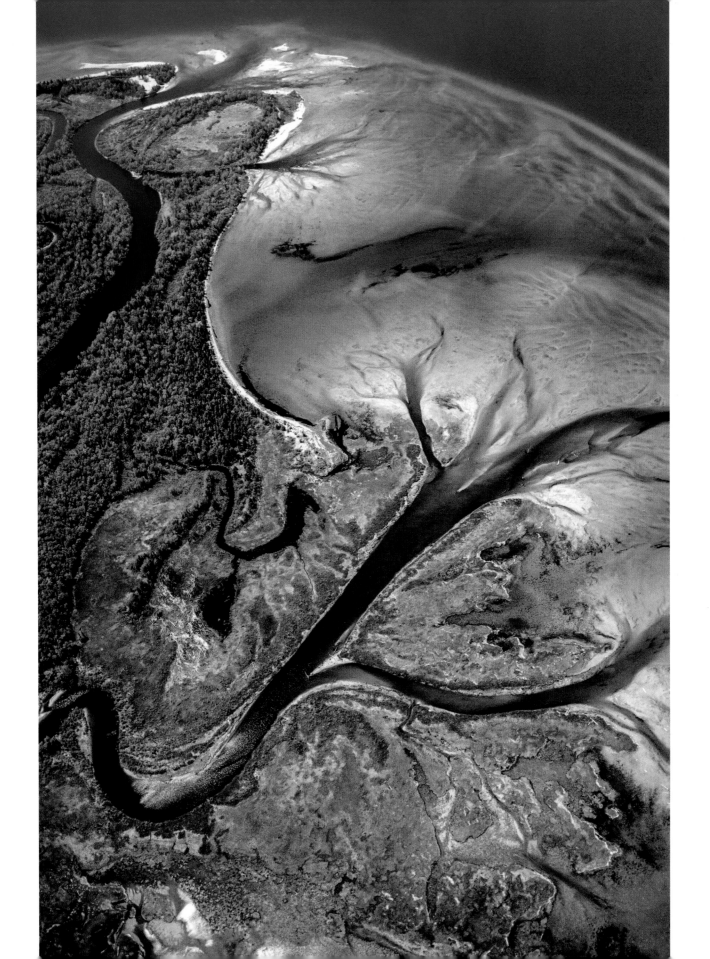

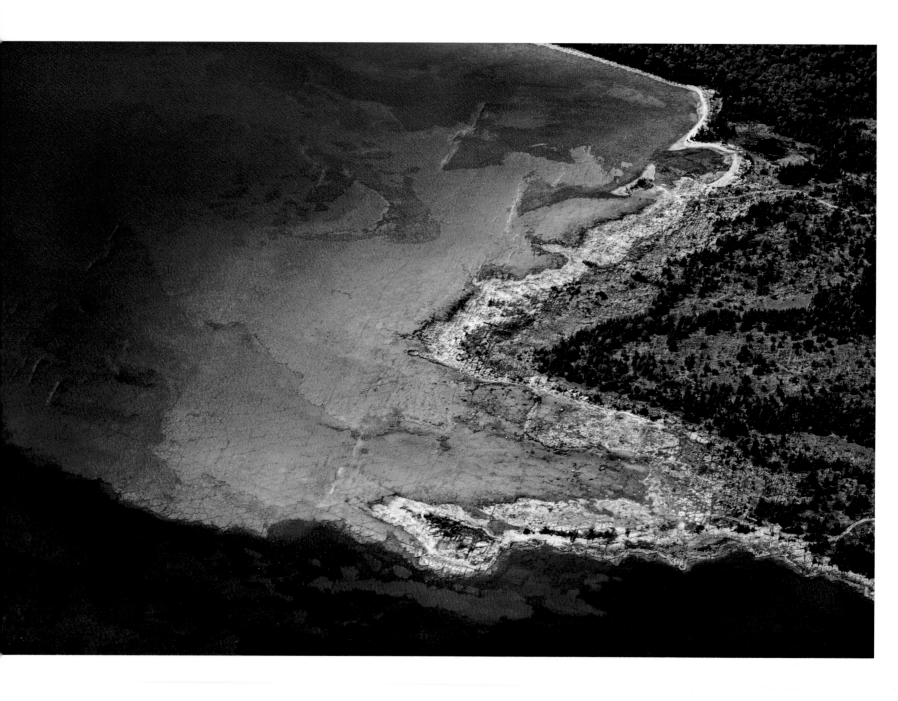

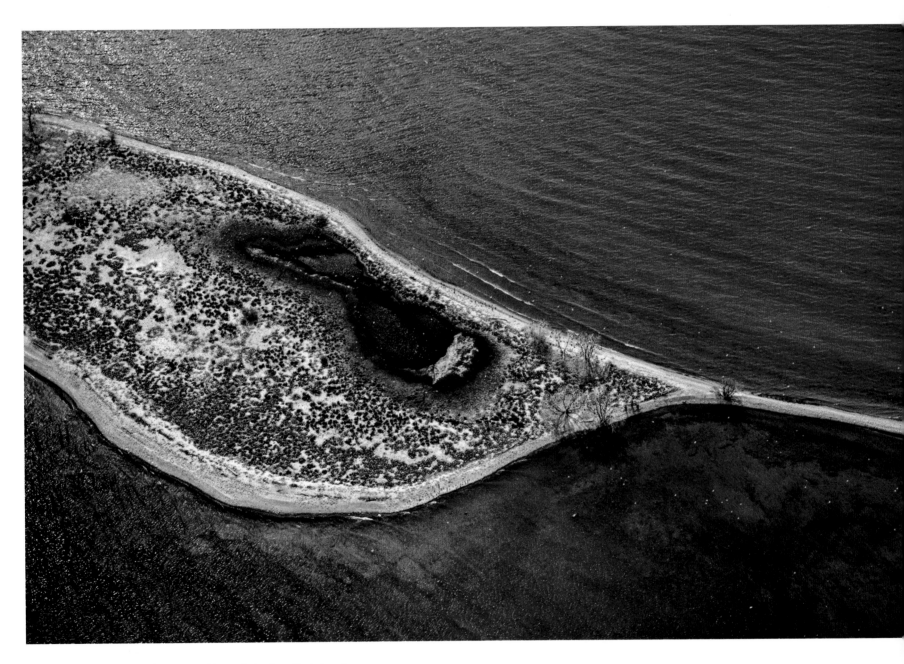

Aerial views of the coastline of Manitoulin Island,
Lake Huron (left) and an island in Presqu'ile Provincial
Park, Lake Ontario.

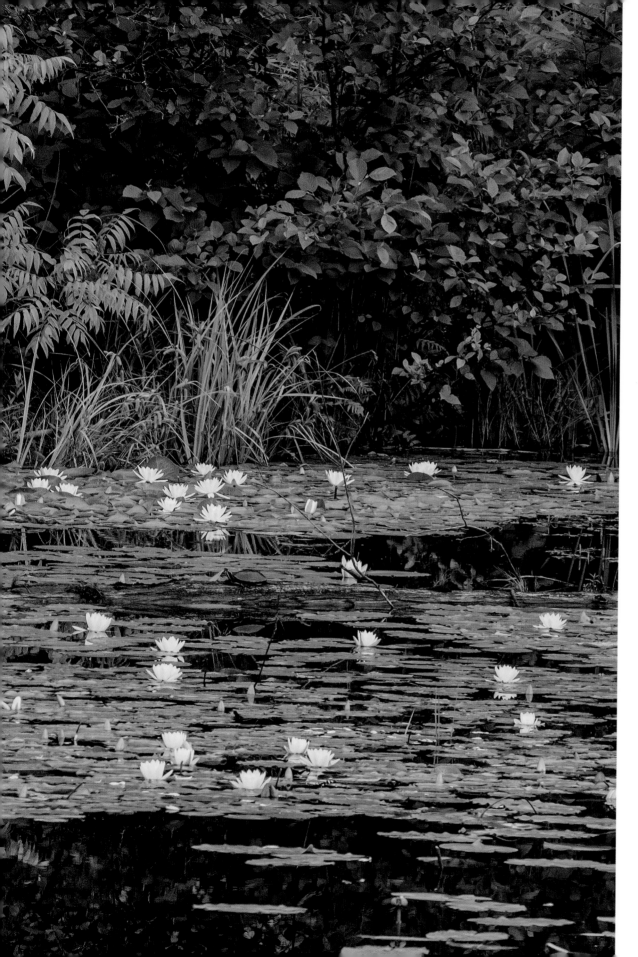

A turtle and water lilies in a pond beside the historic Monck Road, Kawartha Lakes Road 45, west of Uphill.

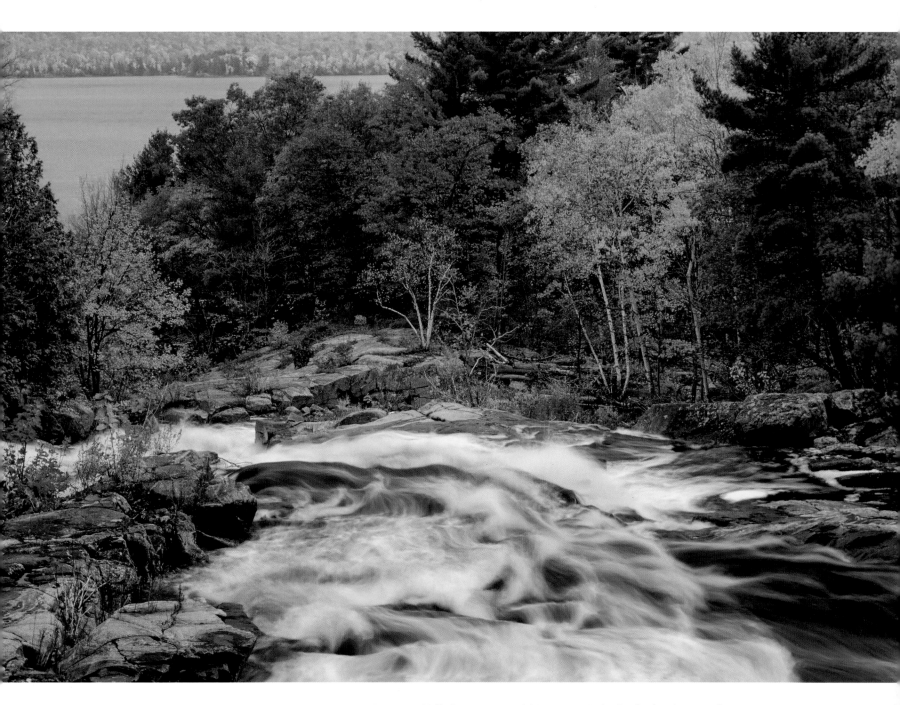

Rosseau Falls in autumn with Rosseau Lake in the background, Muskoka.

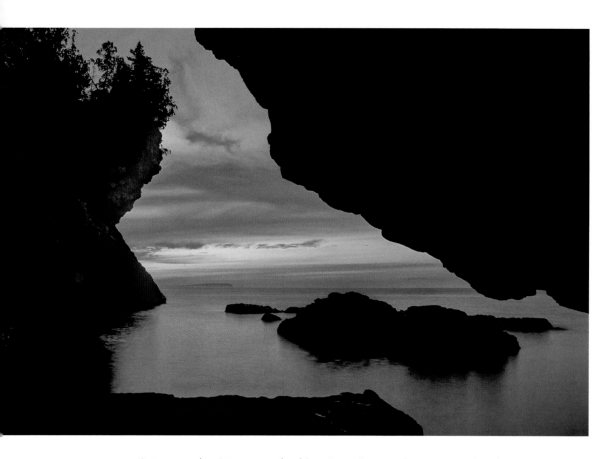

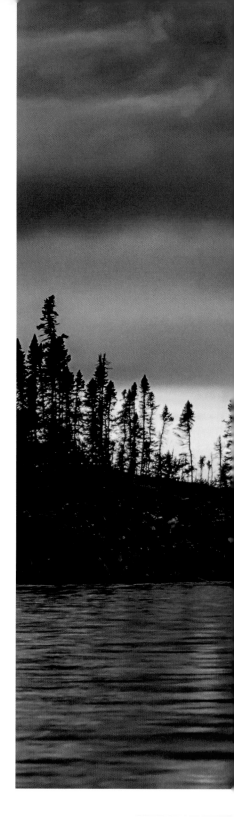

Sunset at the Grotto overlooking Georgian Bay in Bruce Peninsula National Park.

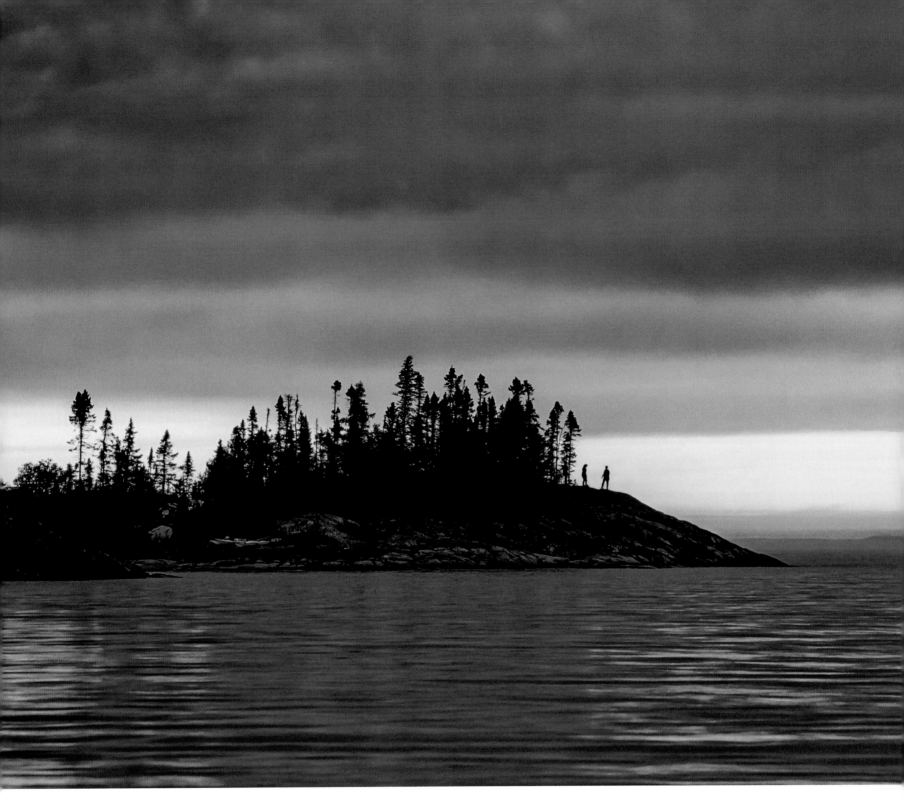

Kayakers admire the sunset from an island campsite off the Coastal Hiking Trail in Pukaskwa National Park.

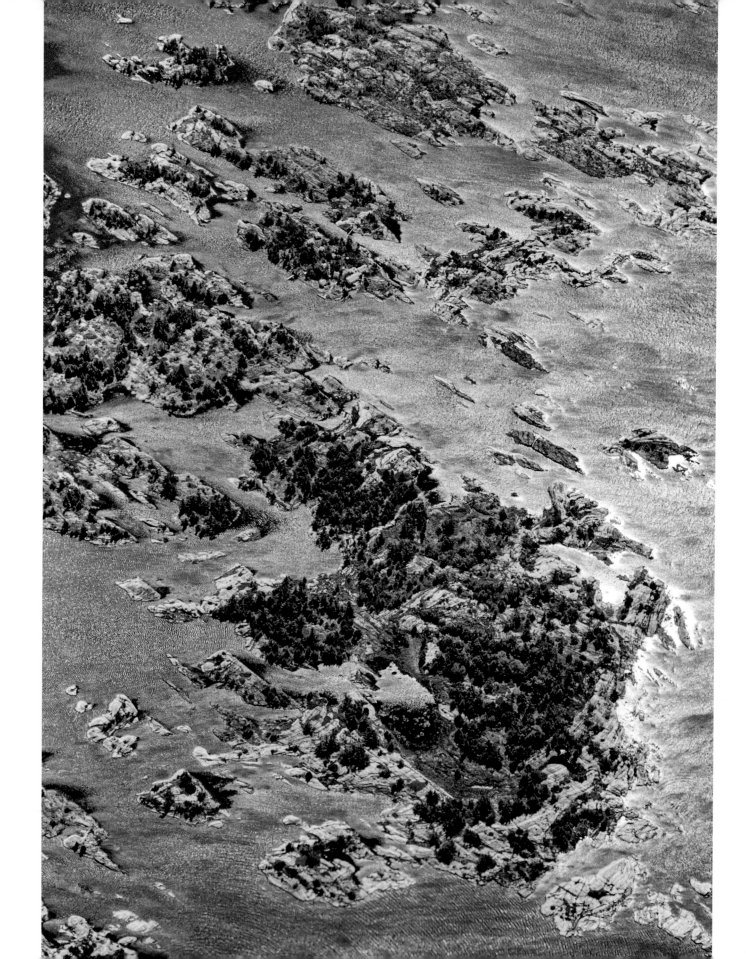

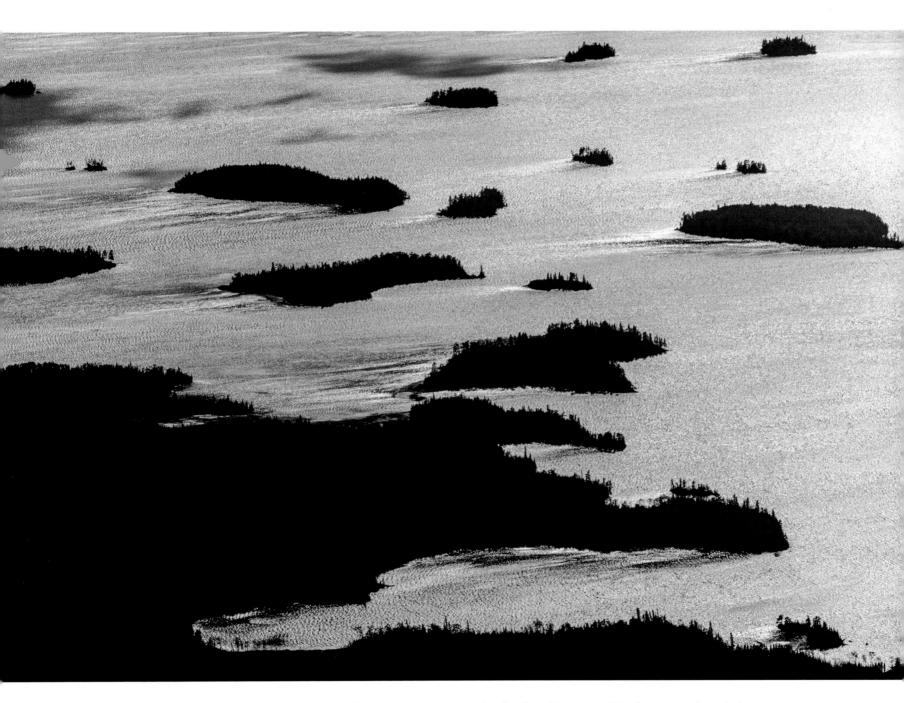

A small part of the Thirty Thousand Islands along the east coast of Georgian Bay from the air. From the water, the maze of rock and water can confound the navigator.

The district of Kenora in Northwestern Ontario is a network of lakes, islands, forest and water easy to get lost in and bewildering even from the air.

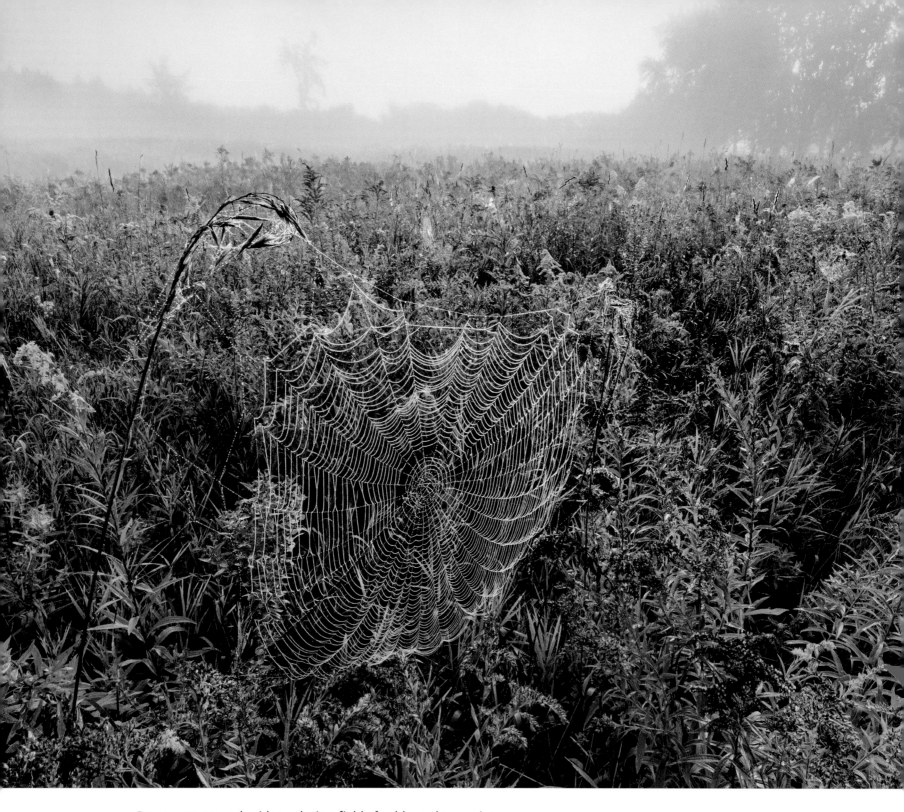

Dew traces around spider webs in a field of goldenrod on a misty
September morning in Uxbridge, north of Toronto.

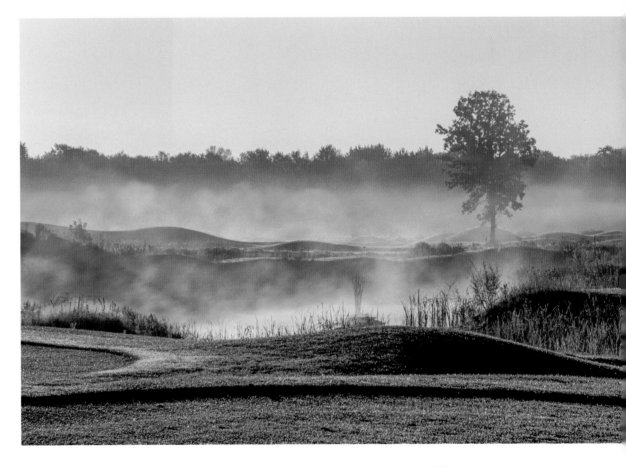

Dawn mist settles into the manicured landscape of the Innisfill Creek Golf Course off Highway 400 south of Barrie.

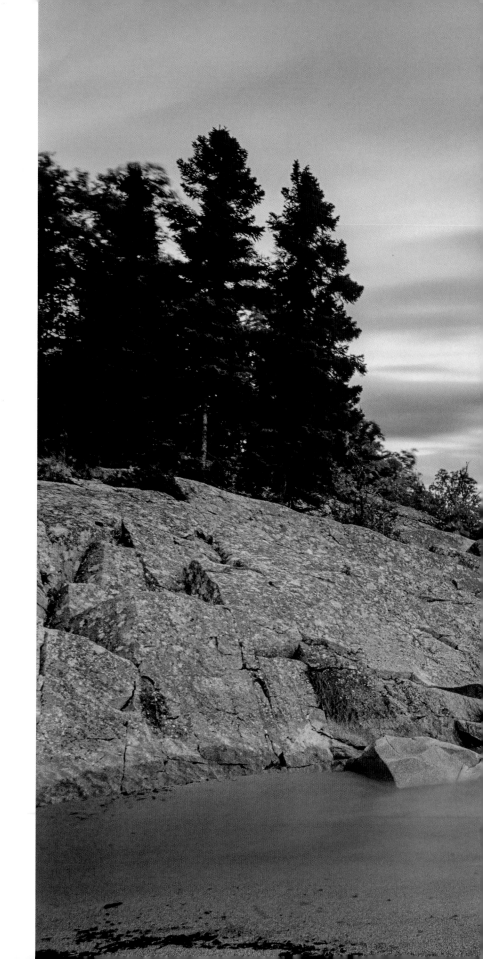

The Lake Superior coast at sunrise, Terrace Bay
Beach, Terrace Bay.

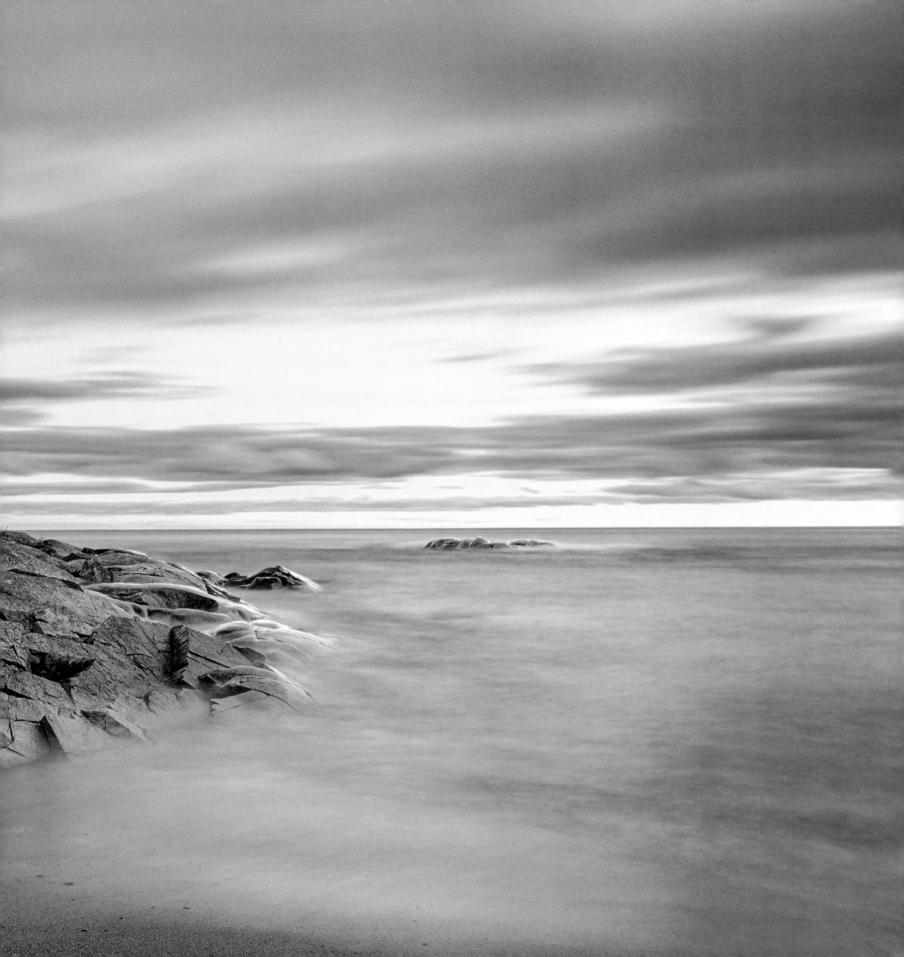

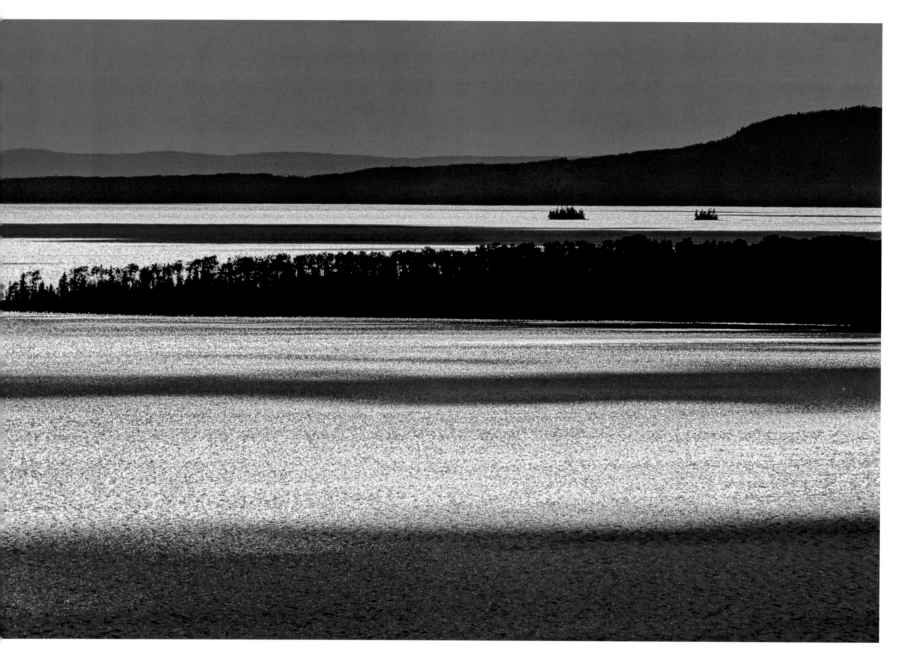

Clouds cast alternating bands of shadow and light across the silvery
backlit waters of Nipigon Bay, Lake Superior.

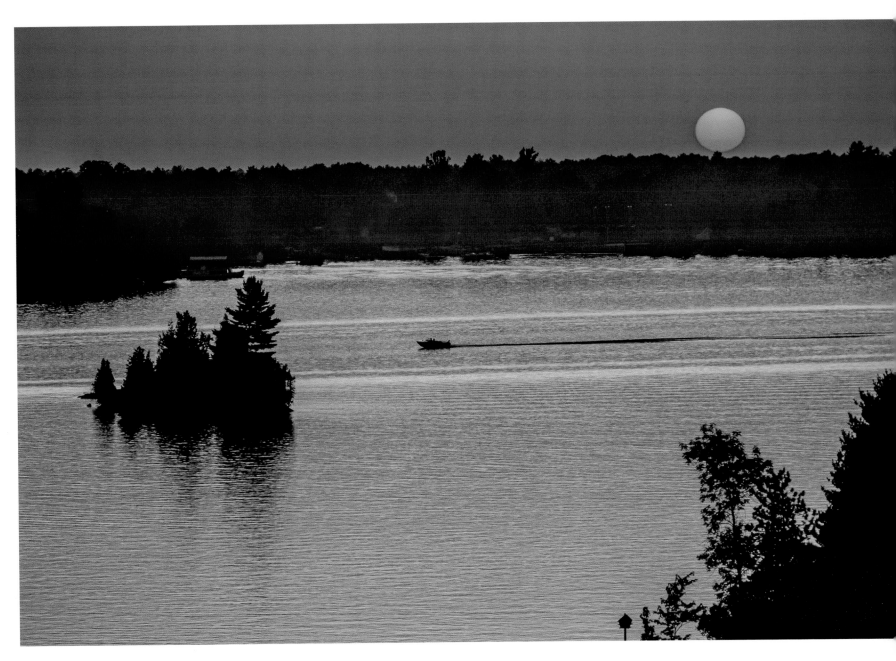

Sundown at Greavette Island on the south end of Lake Muskoka at Gravenhurst.

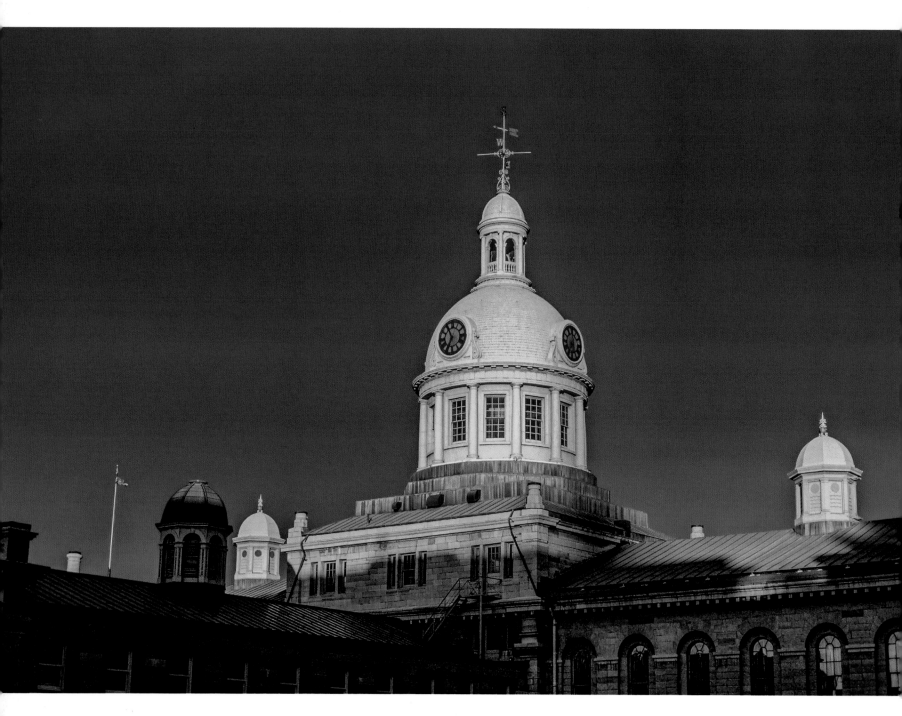

The neoclassical dome on Kingston City Hall, which was rebuilt after it was destroyed by fire in 1908. Kingston was the first capital of the Province of Canada before the British colony became a country upon Confederation in 1867.

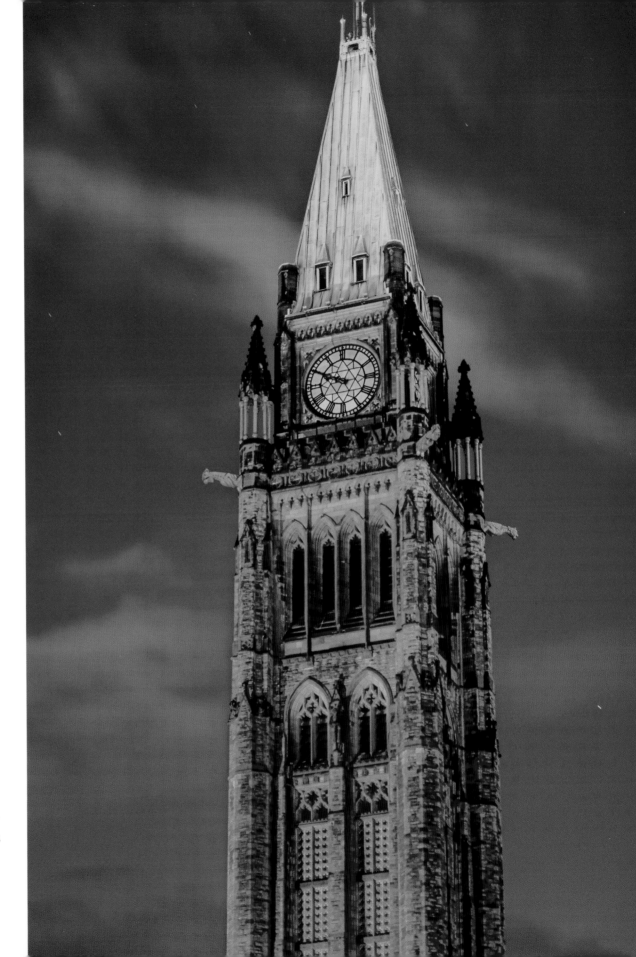

The Peace Tower of the Centre
Block of the Parliament Buildings
in Ottawa illuminated at night.

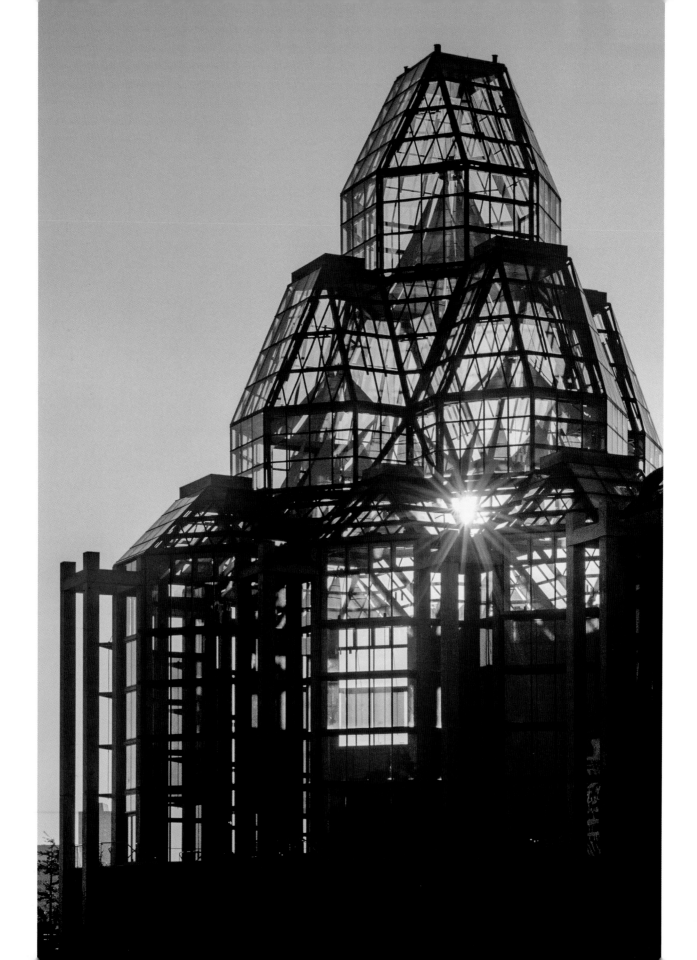

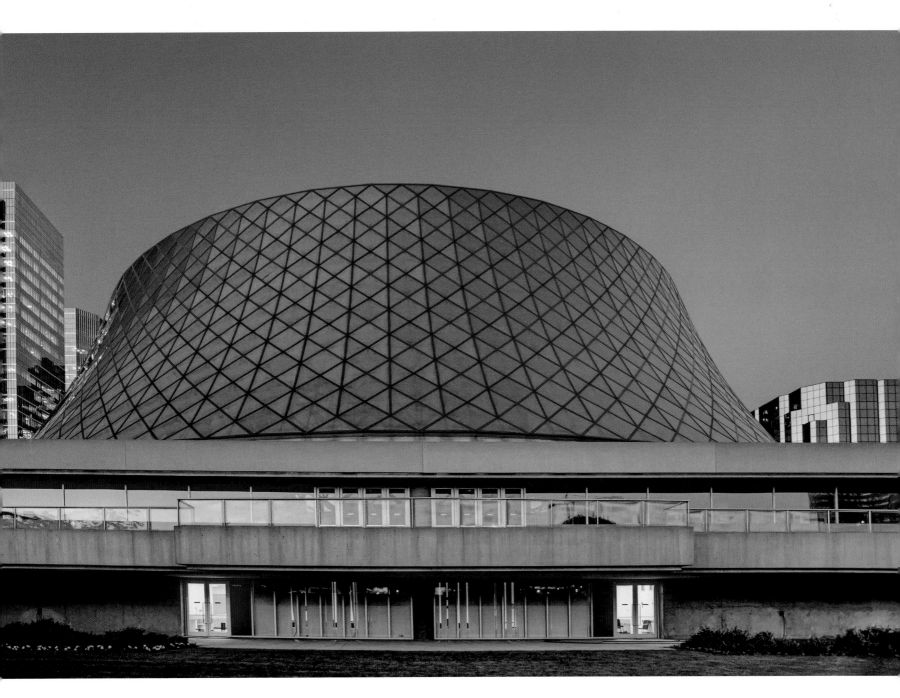

Cathedrals of culture by two of Canada's most renowned architects:
the National Gallery of Canada in Ottawa designed by Moshe Safdie
(left) and Roy Thomson Hall in Toronto designed by Arthur Erickson.

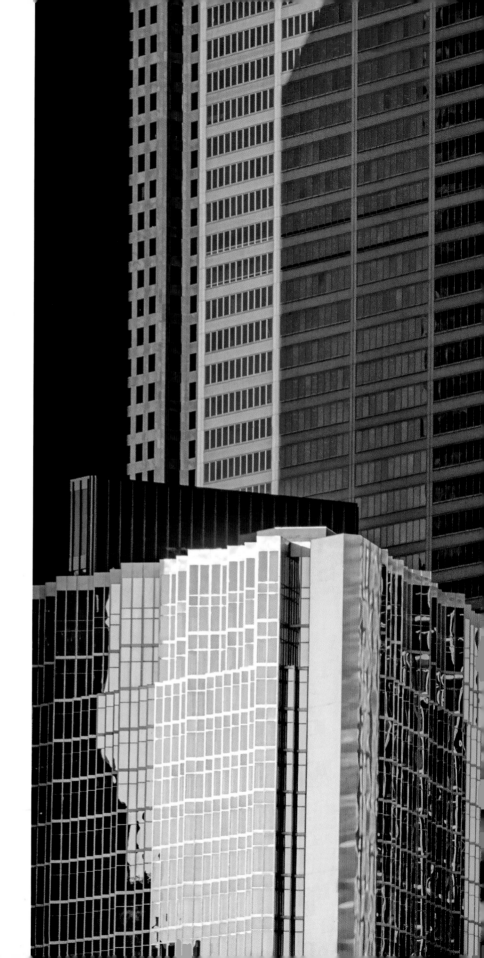

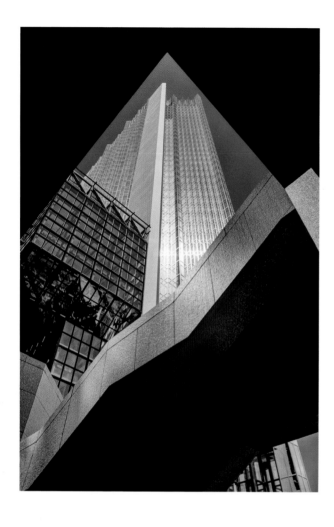

The Royal Bank Plaza in Toronto, looking upwards at the South Tower (above) and against a backdrop of other downtown skyscrapers. The 14,000 windows are coloured with 71 kilograms of real gold.

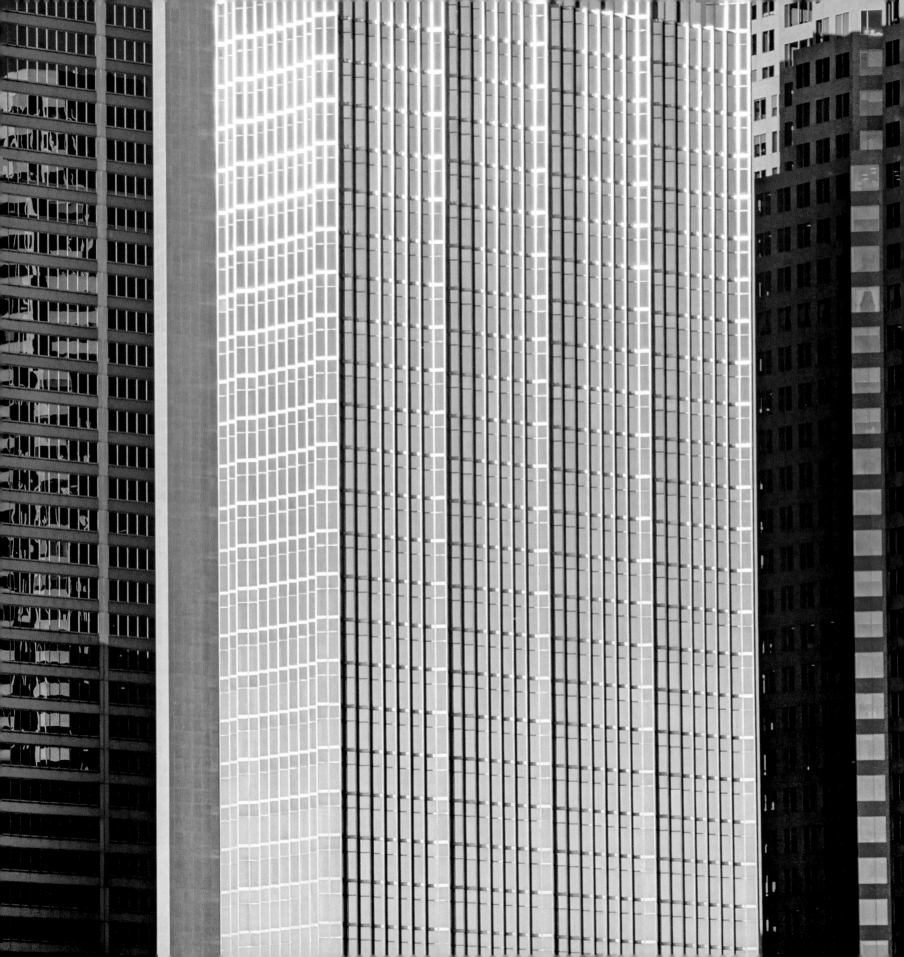

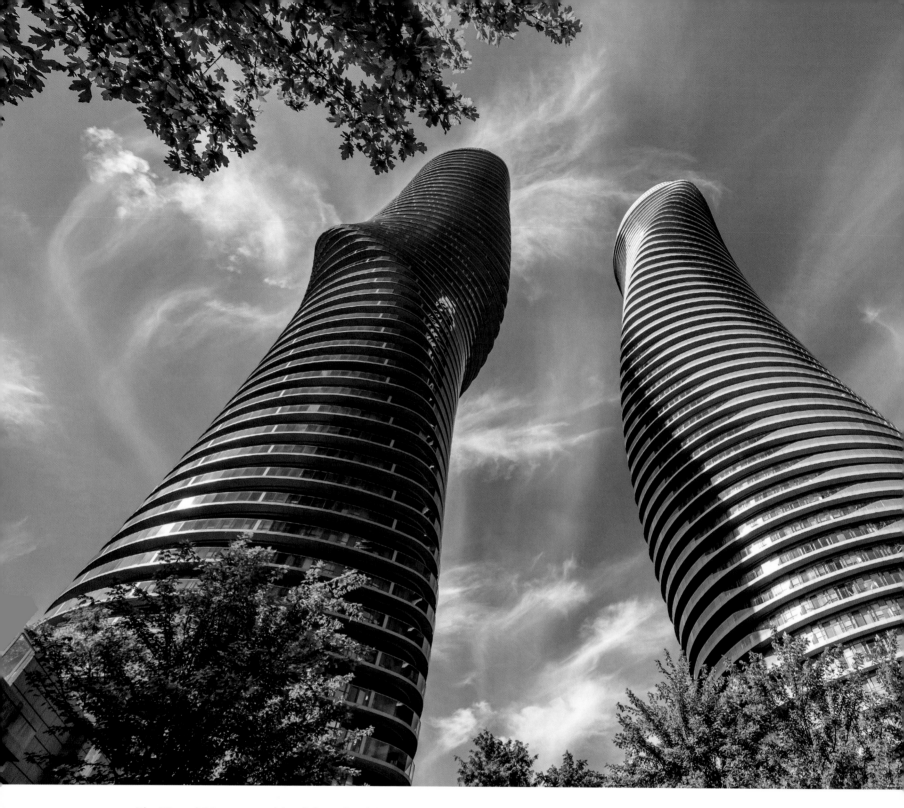

The 50 and 56-storey residential condominium towers of Absolute World in Mississauga have been judged as among the world's best new skyscrapers. The curvaceous taller of the two is popularly known as the Marilyn Monroe building.

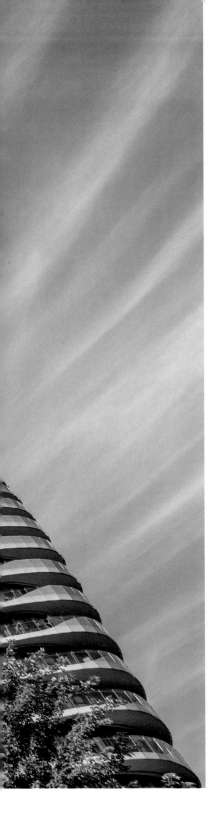

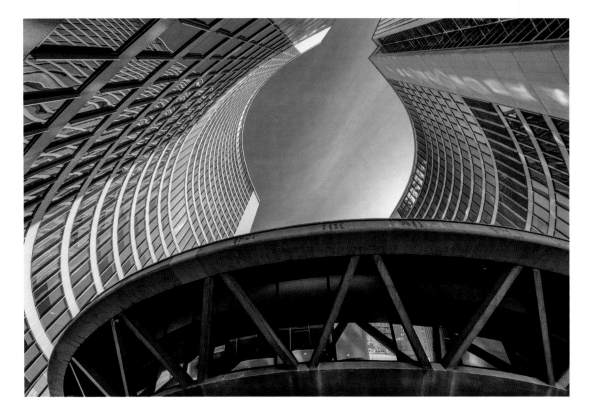

Opened in 1965, Toronto City Hall is still one of the most recognizable and distinct architectural landmarks in the world.

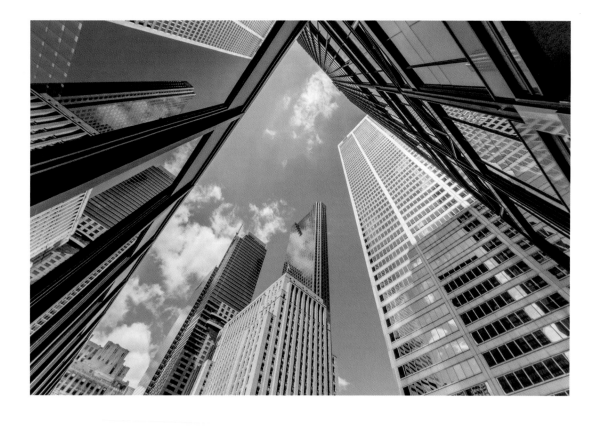

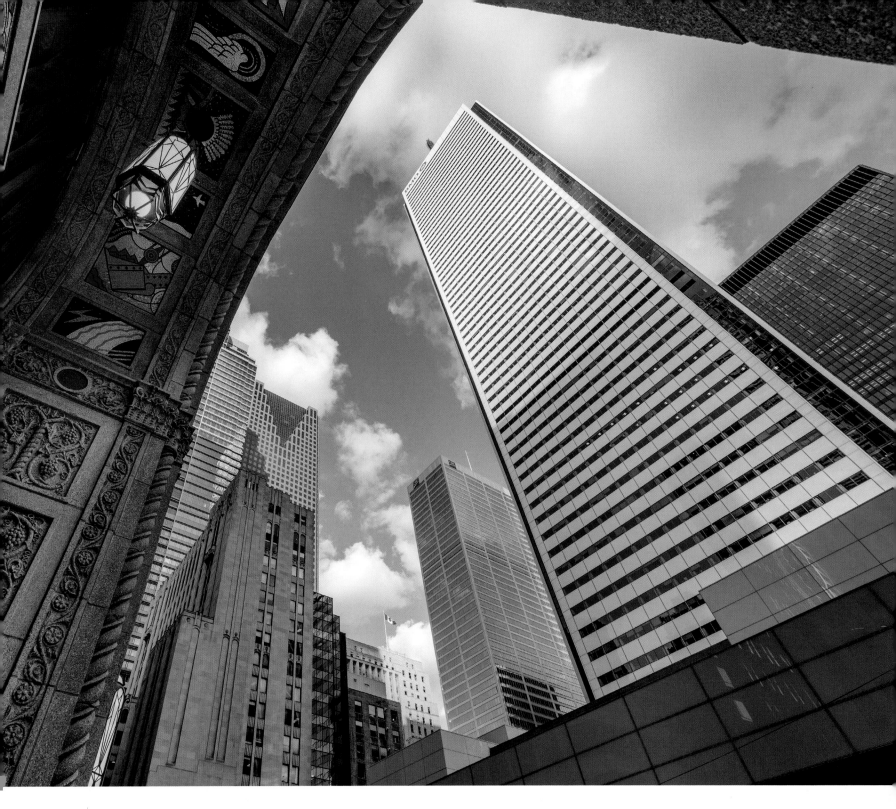

Skyscrapers in the financial district of downtown Toronto. The city contains the eight tallest buildings in Canada and two-thirds of all the buildings in the country taller than 150 metres.

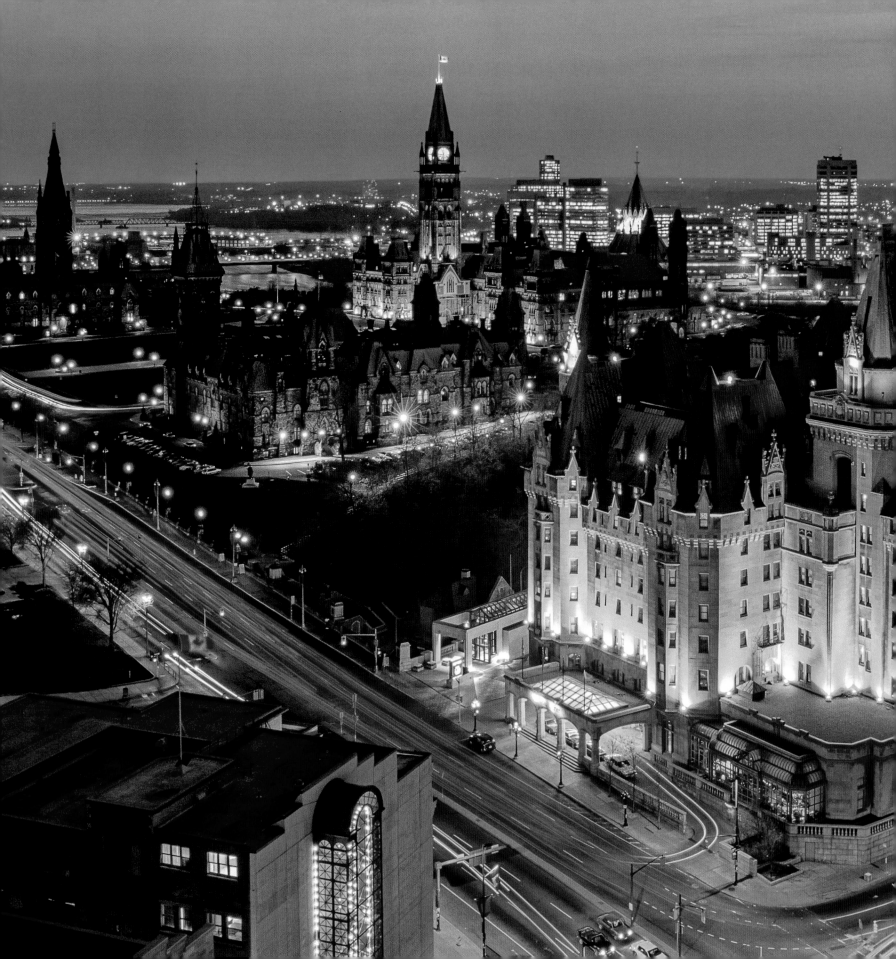

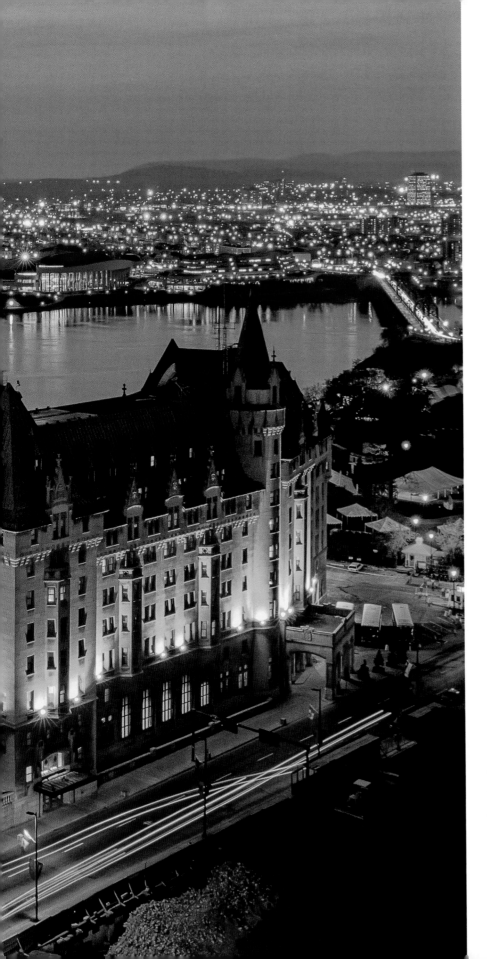

The Gothic skyline of Ottawa in early evening, with the West Block, East Block and Centre Block of the Parliament Buildings and the Chateau Laurier. The lights of Hull, Quebec are visible beyond.

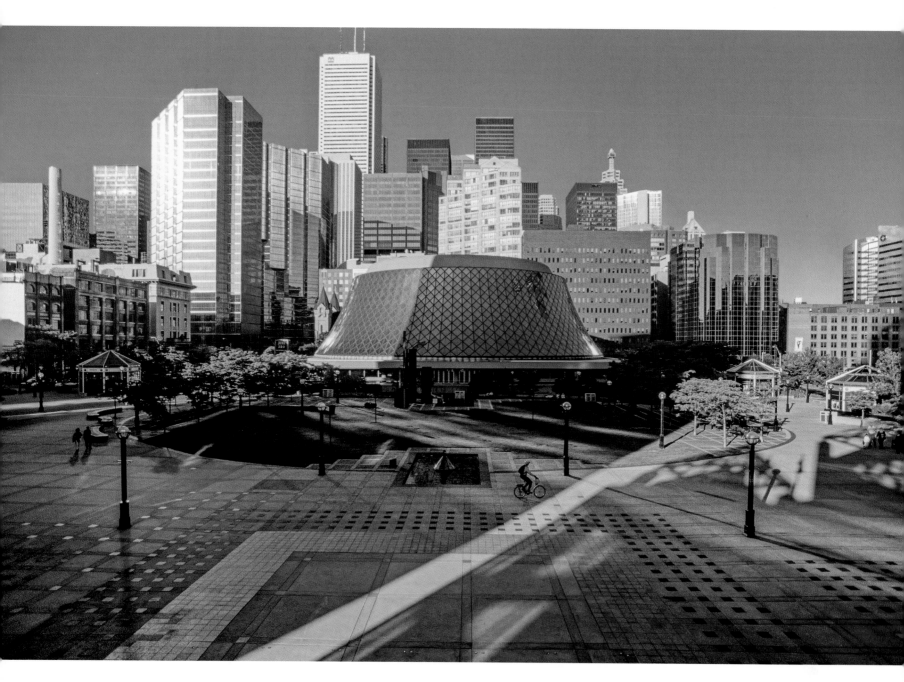

Pecaut Square, Roy Thompson Hall and downtown Toronto from
Metro Hall.

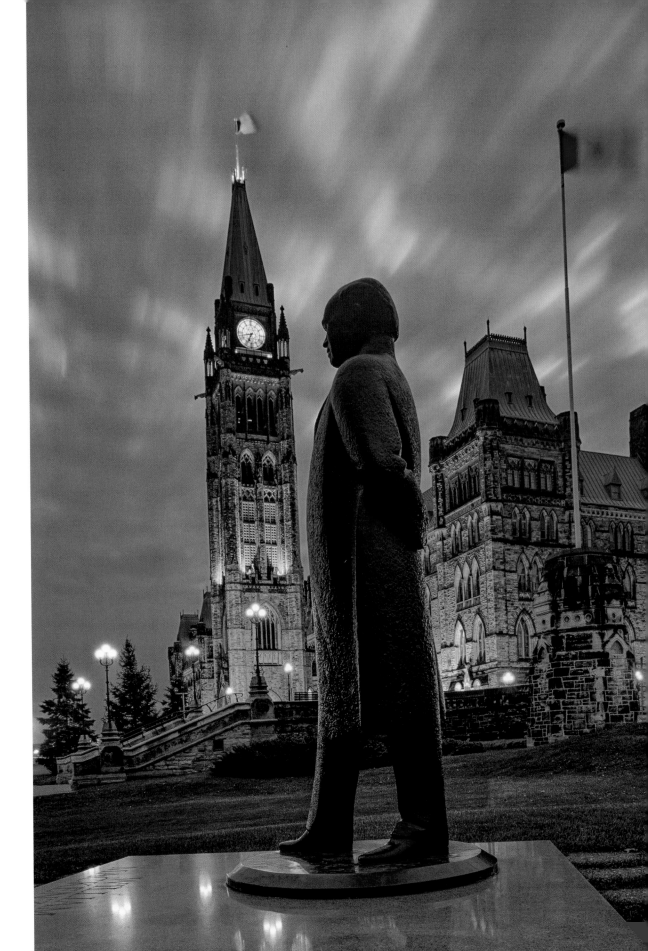

The statue of William Lyon Mackenzie King on Parliament Hill in Ottawa. King was the longest-serving prime minister in Canadian History and led the country throughout the Second World War.

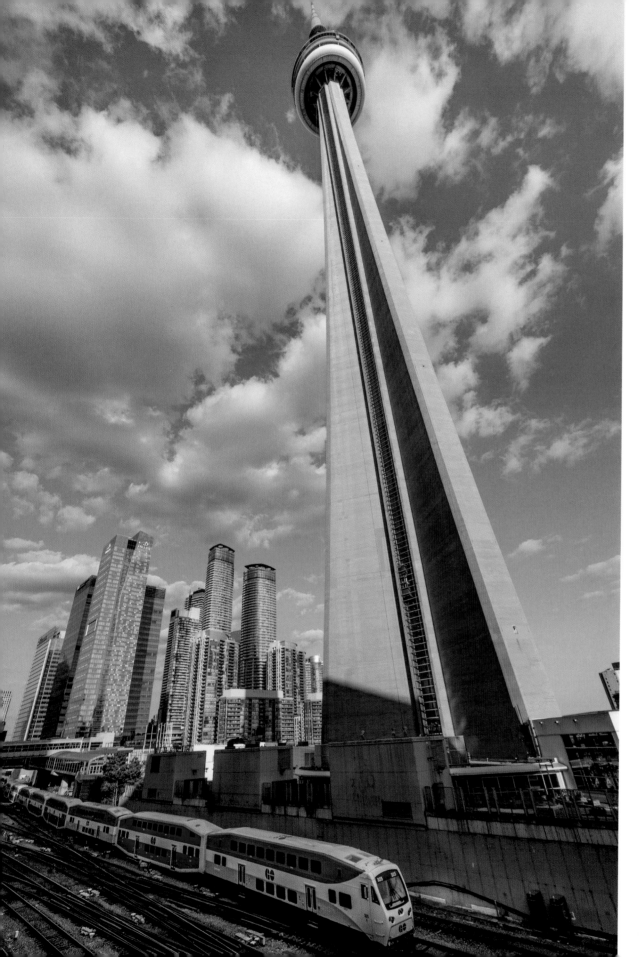

A GO train leaves Union Station running past the CN Tower and the ever-changing waterfront condominium skyline.

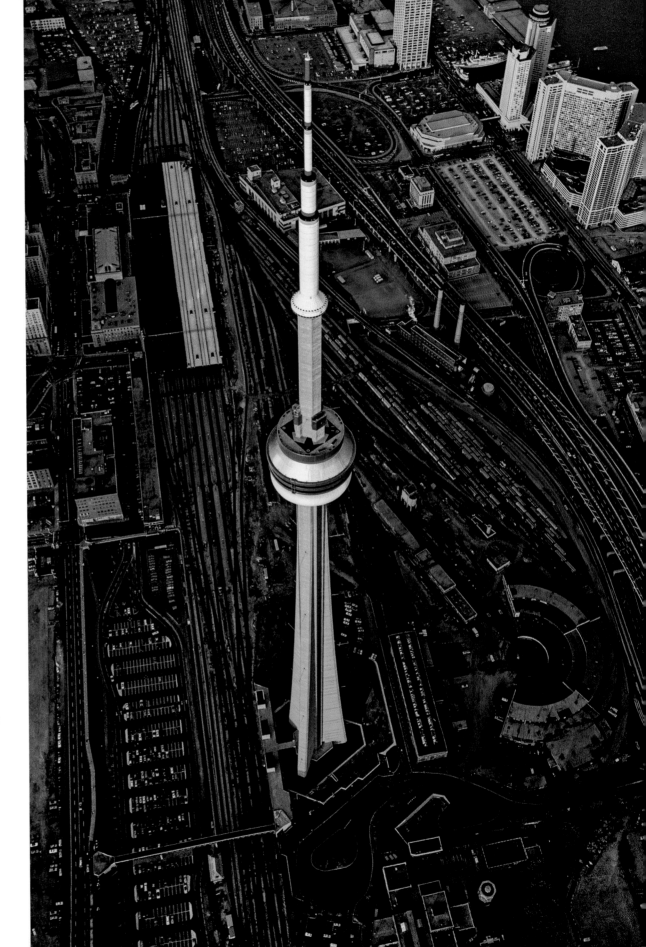

An aerial view of the CN Tower taken in 1980, a few years after it was completed in 1976. Almost everything around the base has since changed completely, with the building of the SkyDome (now Rogers Centre), the Metro Toronto Convention Centre and other structures.

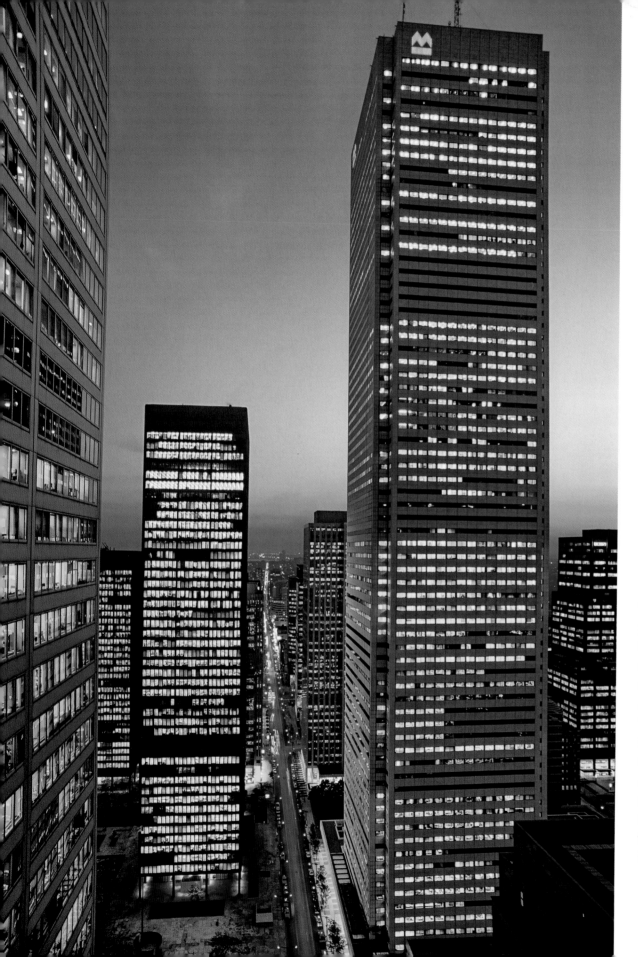

The view from the rooftop gallery of Commerce Court, looking west along King Street at (left to right) Commerce Court, TD Centre and First Canadian Place in downtown Toronto. First Canadian Place, the tallest building in the British Commonwealth, has had its entire exterior cladding replaced since this photo was taken after a large slab of marble from the facade crashed into the street below.

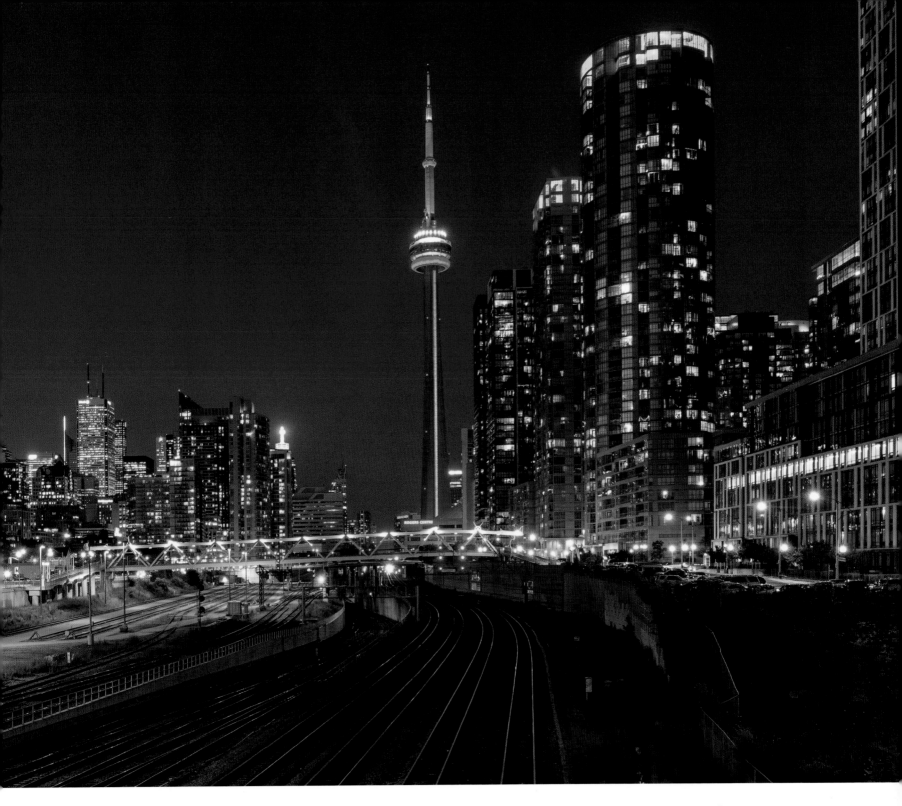

The CN Tower and a forest of
condominiums soar above the
railway tracks in downtown Toronto.

LEFT: Fort George National Historic Site at Niagara-on-the-Lake.

A private heritage house built in 1905 in Stratford. The city was judged the "prettiest in the world" on the basis of environmental, heritage and community management in an international competition in 1997.

The campus of Queen's University, Kingston. The view from Dunning Hall looks across University Avenue to the century-old Douglas Library.

Fronting University Avenue, Douglas Library (nearest), Ontario Hall and Grant Hall are among the most historic buildings at Queen's.

Architectural details at Queen's University: the windows of the
John Deutsch University Centre's Memorial Room (above) and
ivy-wrapped columns at an entranceway to Kingston Hall.

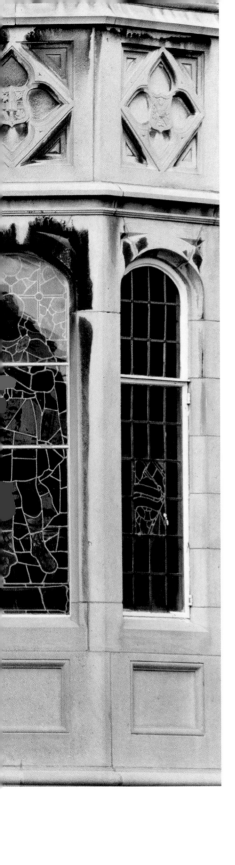
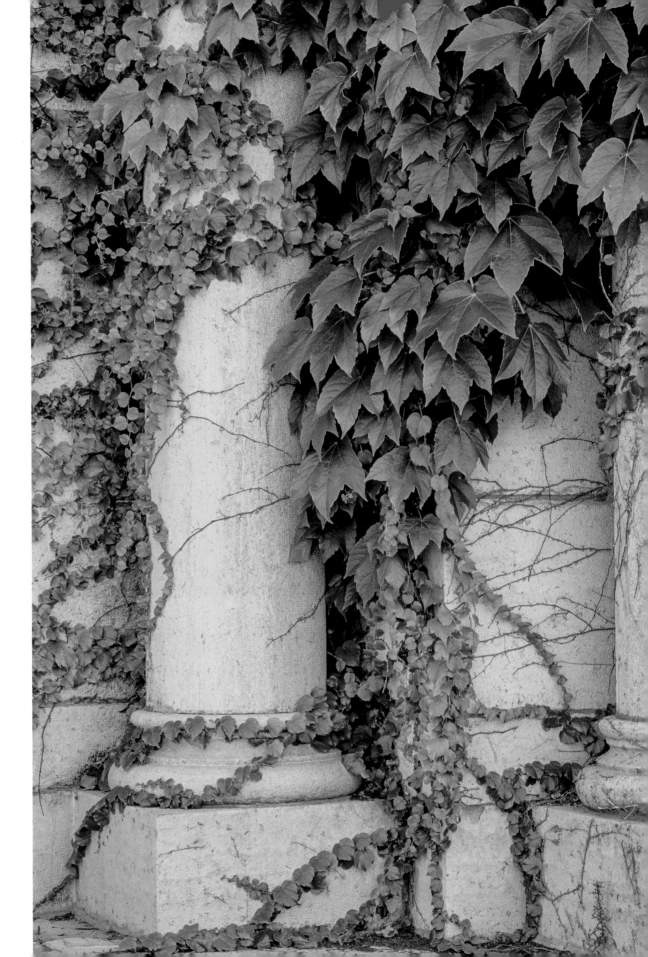

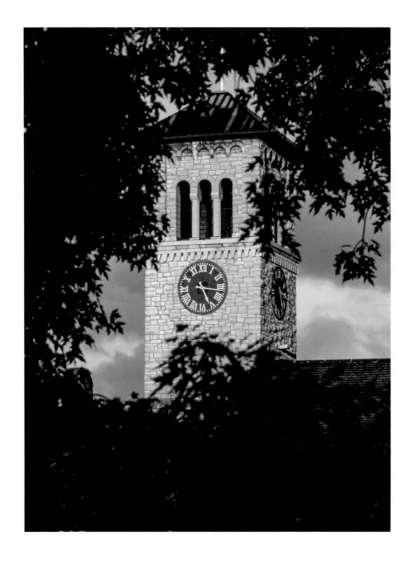

The clock tower on Grant Hall, Queen's
University, Kingston.

Dundurn Castle is a 1,700 square-metre neoclassical mansion
completed in 1835 and now owned and operated as a civic museum
by the City of Hamilton.

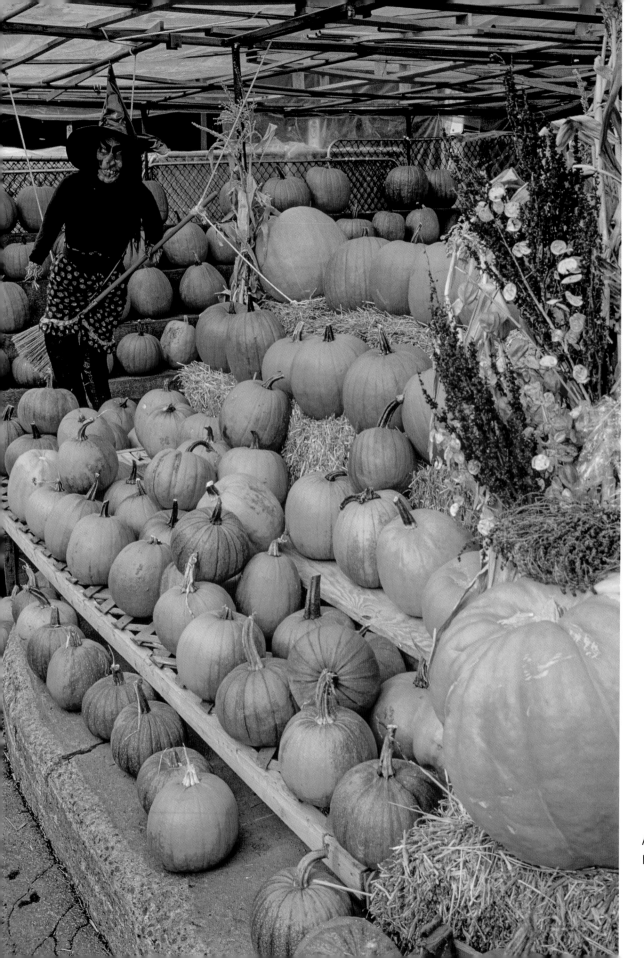

A pumpkin stall in October in the ByWard Market, Ottawa.

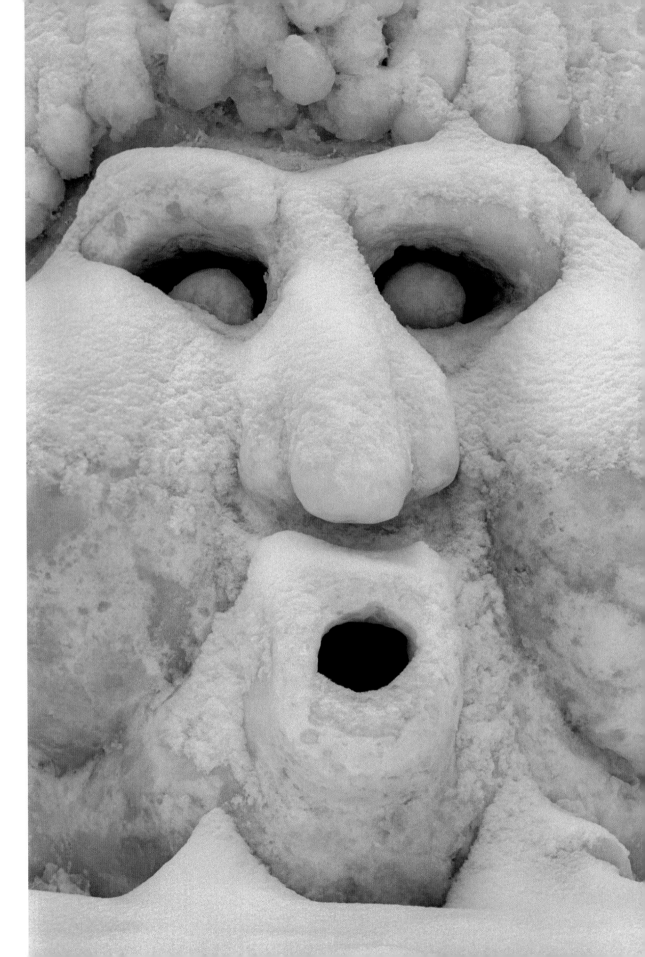

Fresh snow on part of an ice sculpture on Dows Lake, Ottawa, during Winterlude.

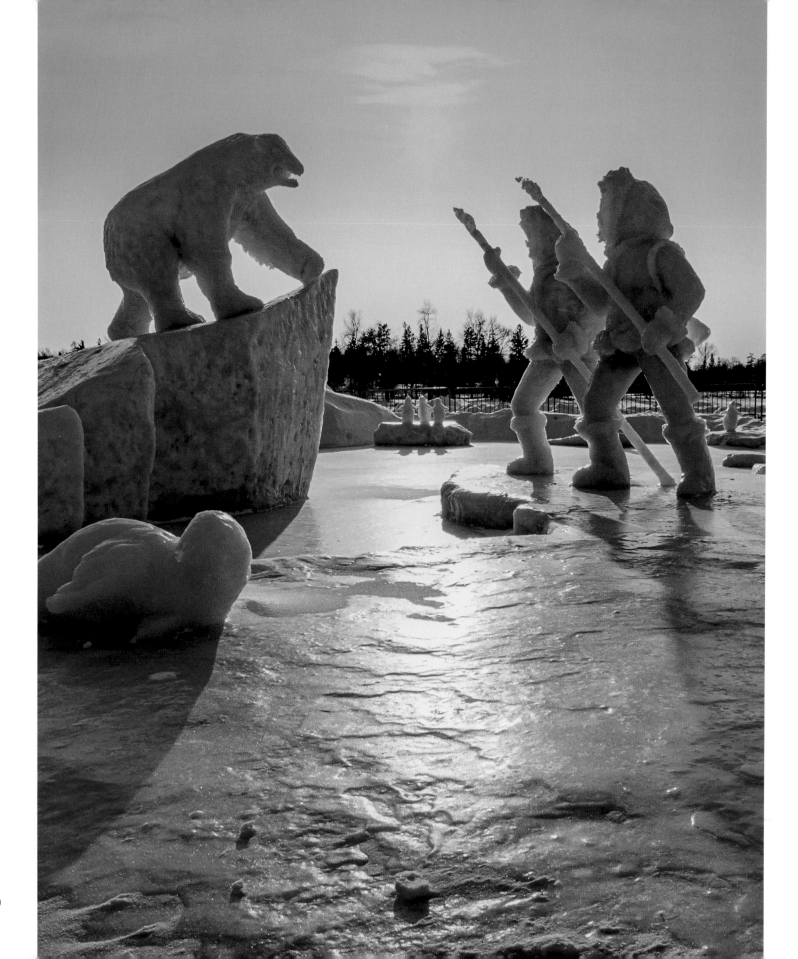

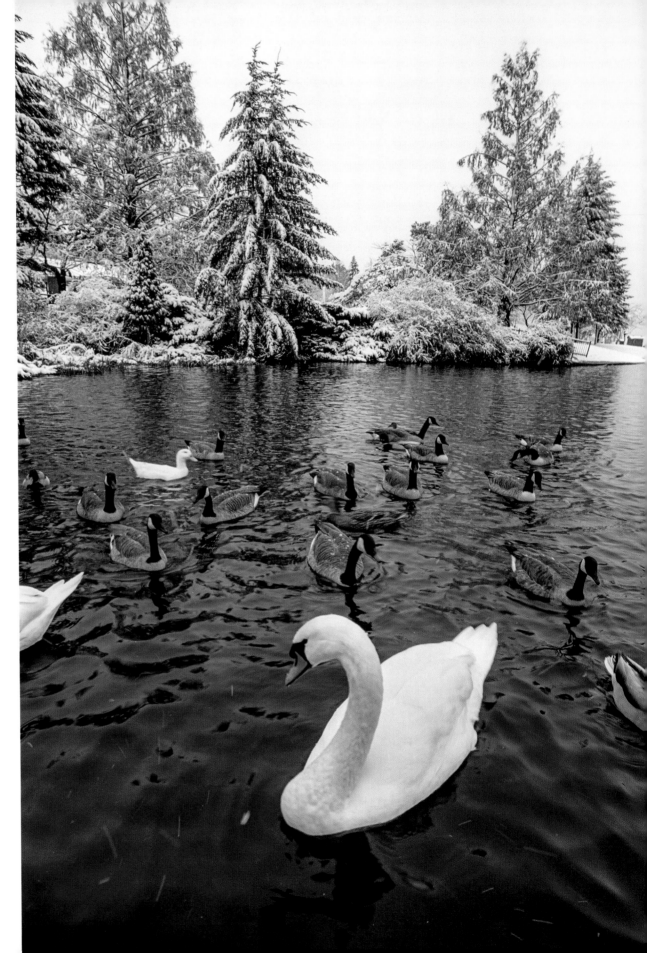

LEFT: An ice sculpture of a polar bear confronting Inuit hunters at Dows Lake. The Winterlude festival held in the National Capital Region attracts upwards of a million tourists each winter.

A swan, Canada geese and ducks on a pond after a fresh snowfall, High Park, Toronto.

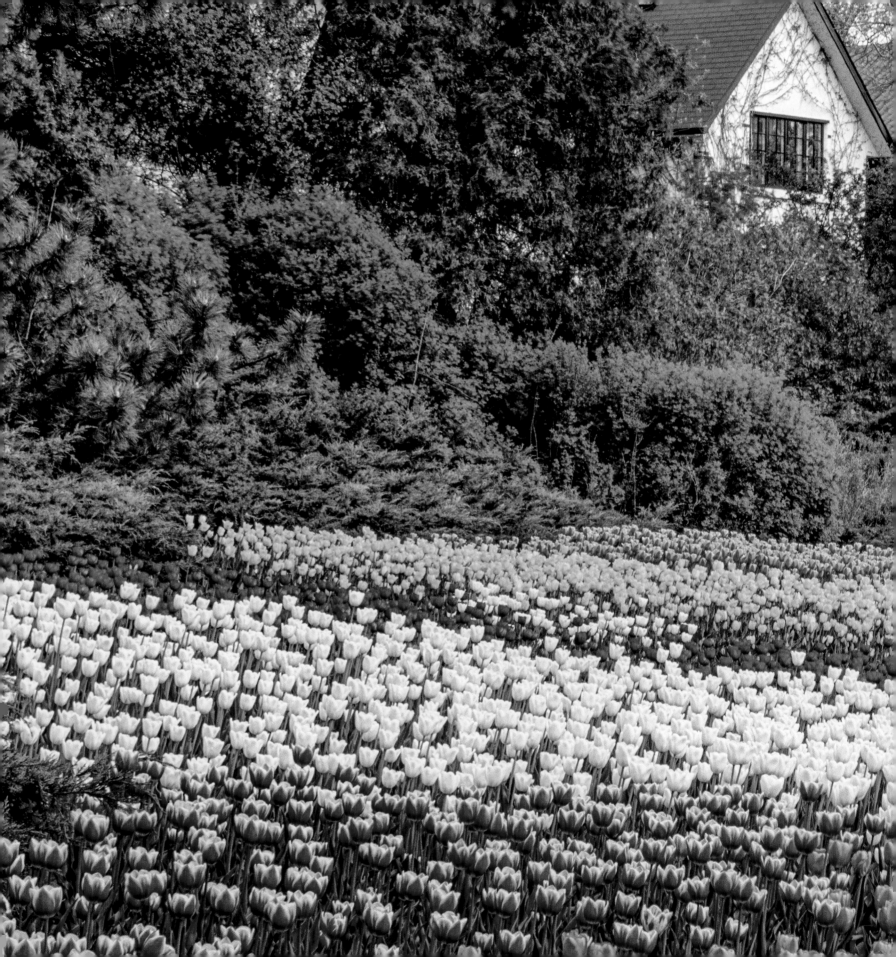

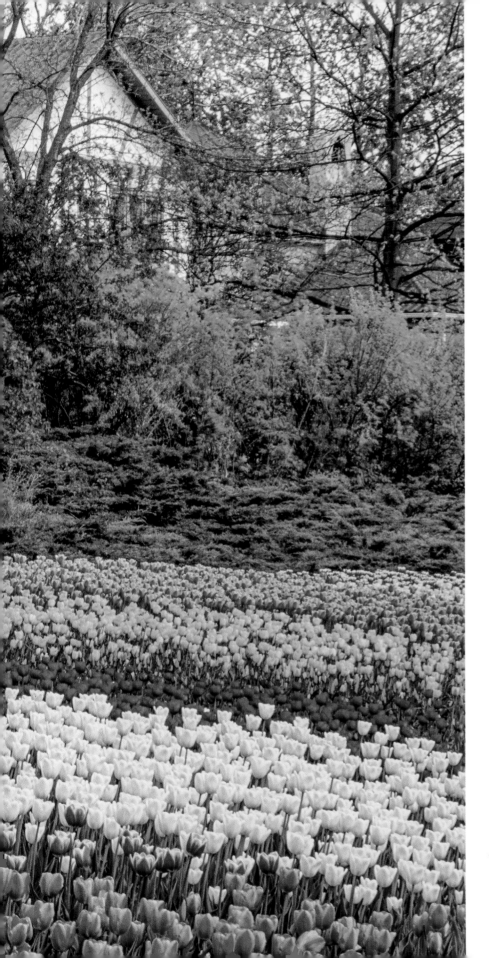

Enormous numbers of tulips bloom every May in Commissioners Park along Dows Lake, part of the Canadian Tulip Festival in Ottawa.

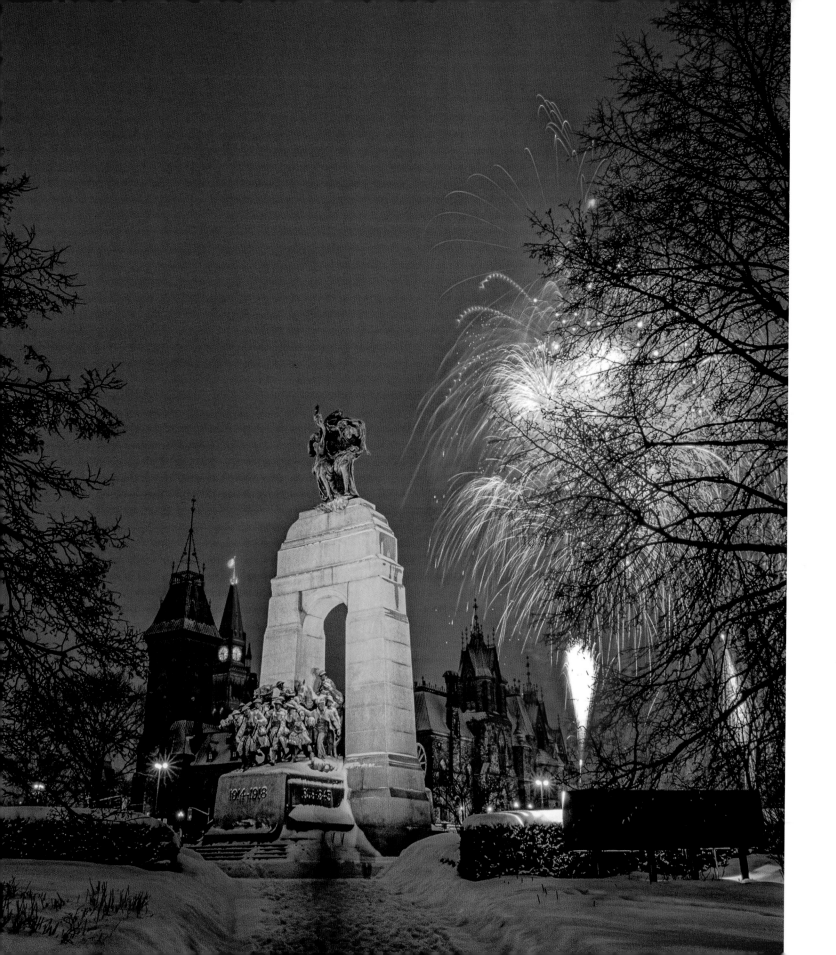

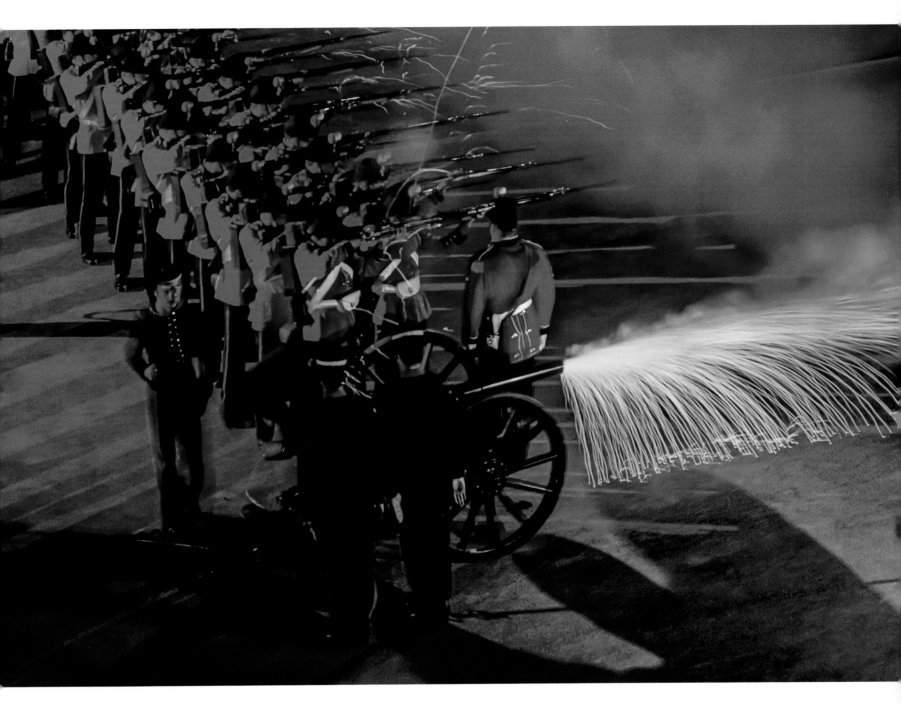

Fireworks behind the National War Memorial in Confederation Square, Ottawa.

A reenactment of rifle and cannon firing during the Sunset Ceremony at Fort Henry National Historic Site, Kingston. The fort is included in the designation of the Rideau Canal as a UNESCO World Heritage Site.

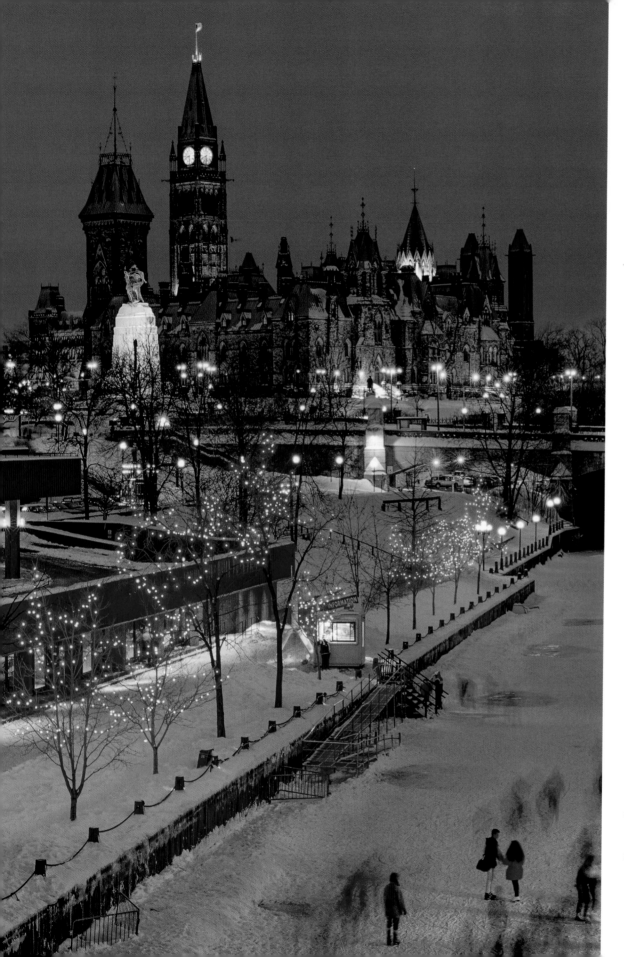

The Parliament Buildings and the illuminated National War Memorial rise beyond the Rideau Canal. In winter an eight-kilometre section of the canal running through the city is cleared of snow and becomes the world's largest skating rink.

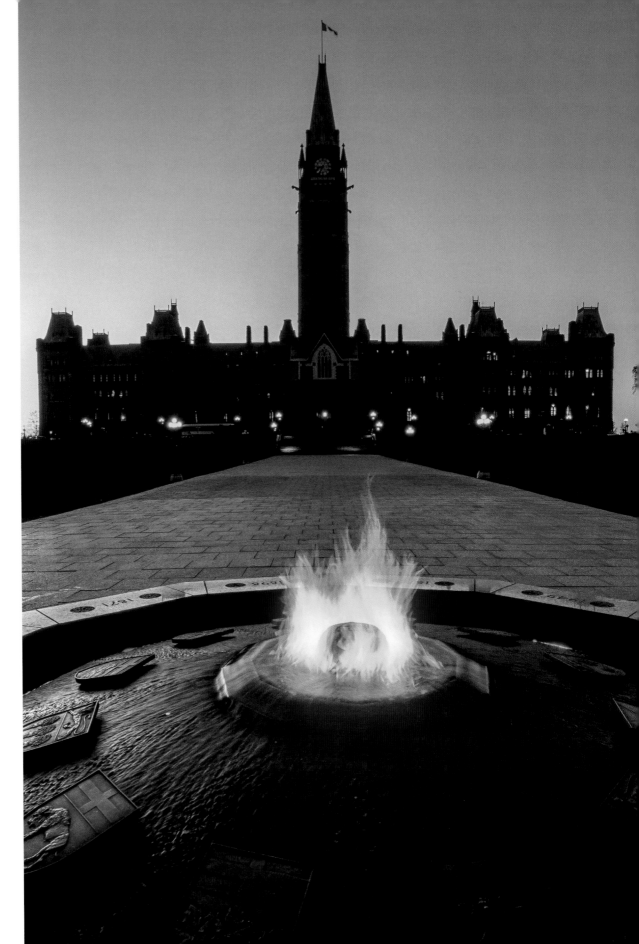

The Centennial Flame, lit in 1967 to commemorate Canada's 100th anniversary of Confederation, burns in front of the Centre Block of the Parliament Buildings.

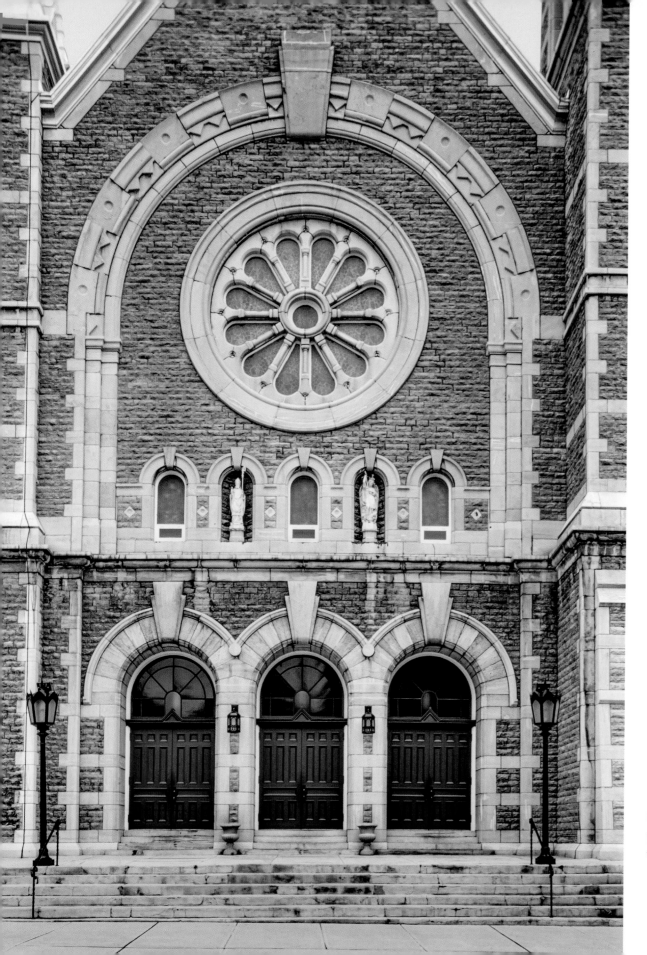

Saint John Chrysostom Catholic Church in Arnprior (left) and the steeples of the First Presbyterian Church in Brockville. The latter is today more restrained in colour and pattern after replacement of the roofing.

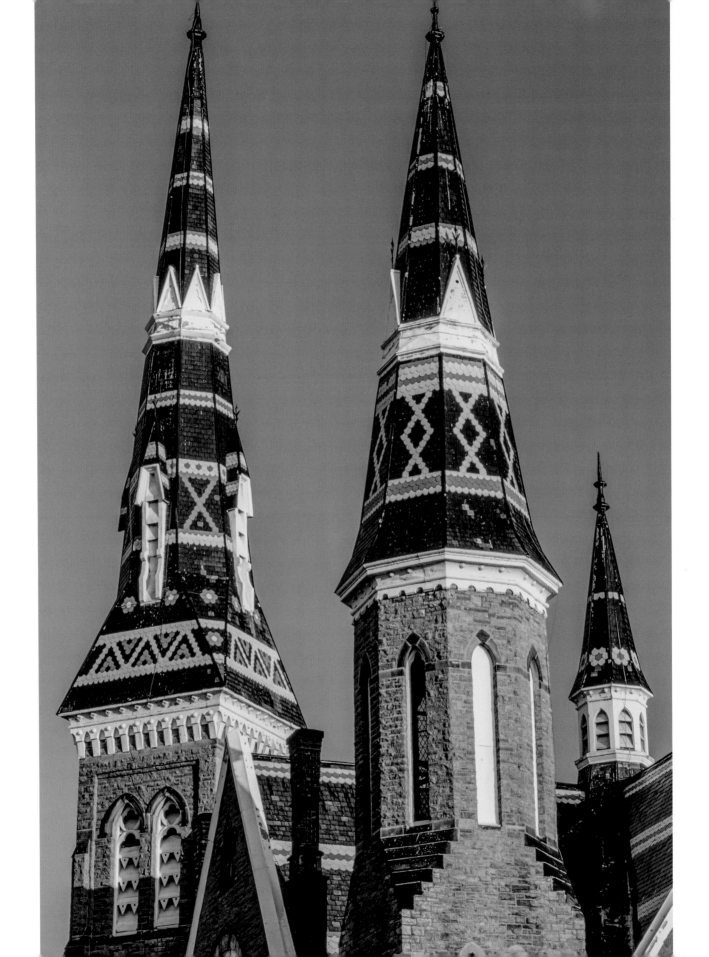

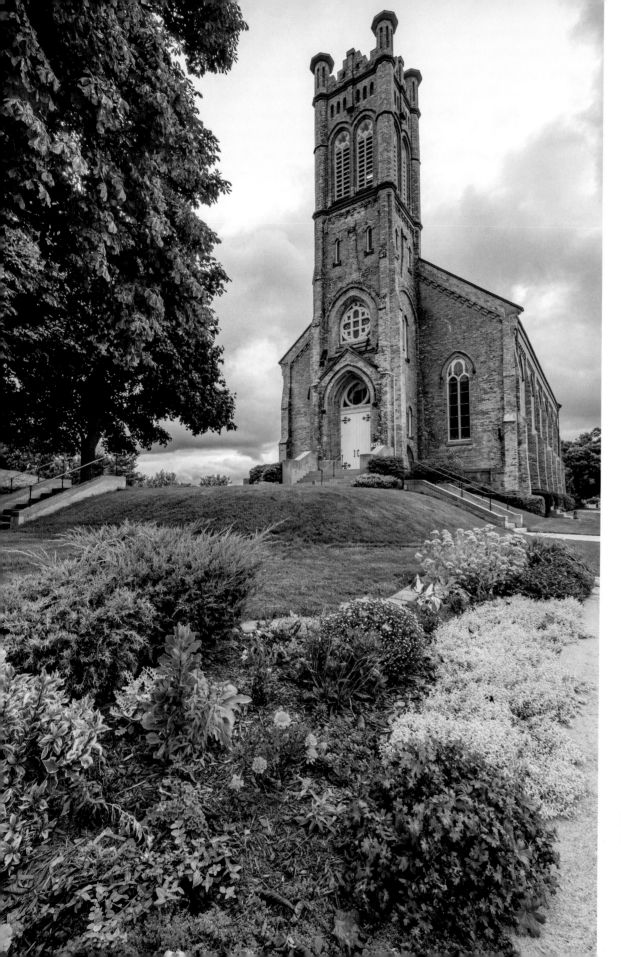

Knox Presbyterian Church in
Kincardine on Lake Huron.

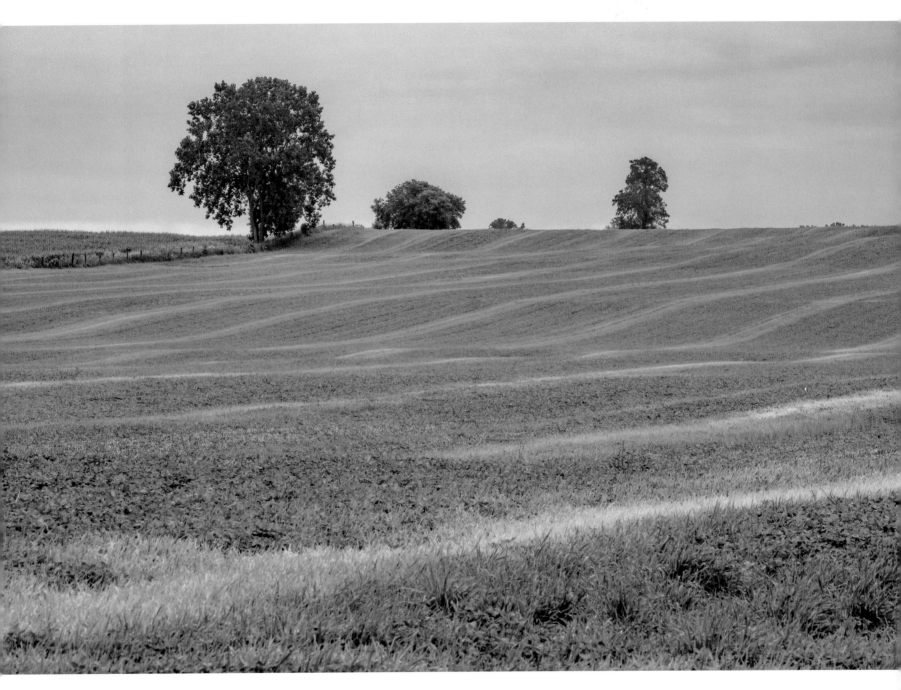

Farm fields along John Wise Line (County Rd 45) south of St. Thomas.

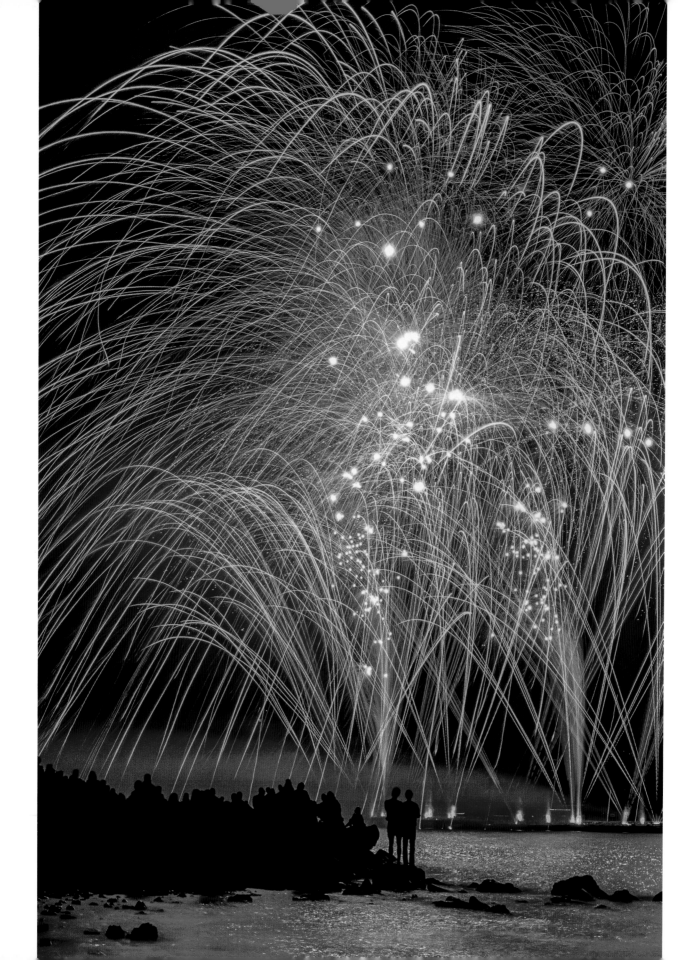

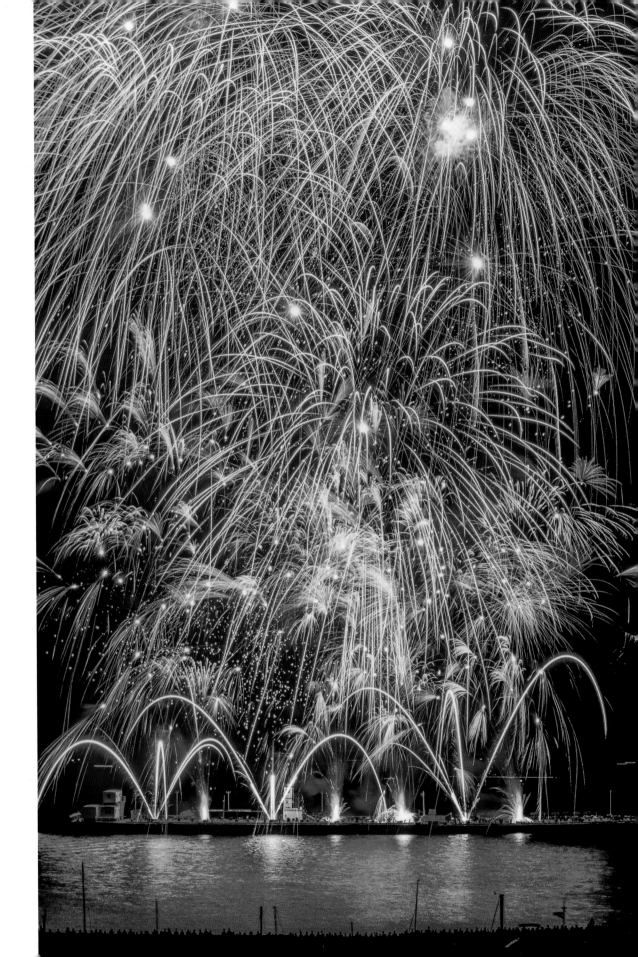

Fireworks in Toronto are usually launched from a barge a safe distance offshore from Ontario Place in Lake Ontario.

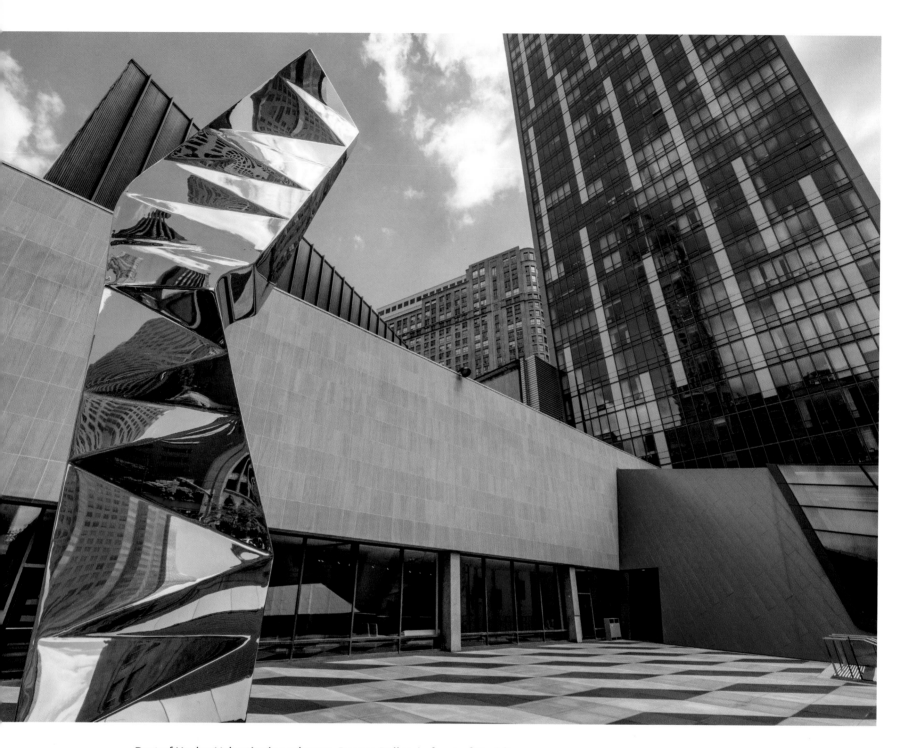

Part of Harley Valentine's sculpture, Dream Ballet, in front of Meridian
Hall (originally O'Keefe Centre), Canada's largest soft-seat theatre
and the residential 58-floor L Tower designed by Daniel Libeskind.

Colourful downtown skyscrapers in Toronto, including the three
tallest in Canada, in order of height: First Canadian Place (white), the
St. Regis (green) and Scotia Plaza (orange).

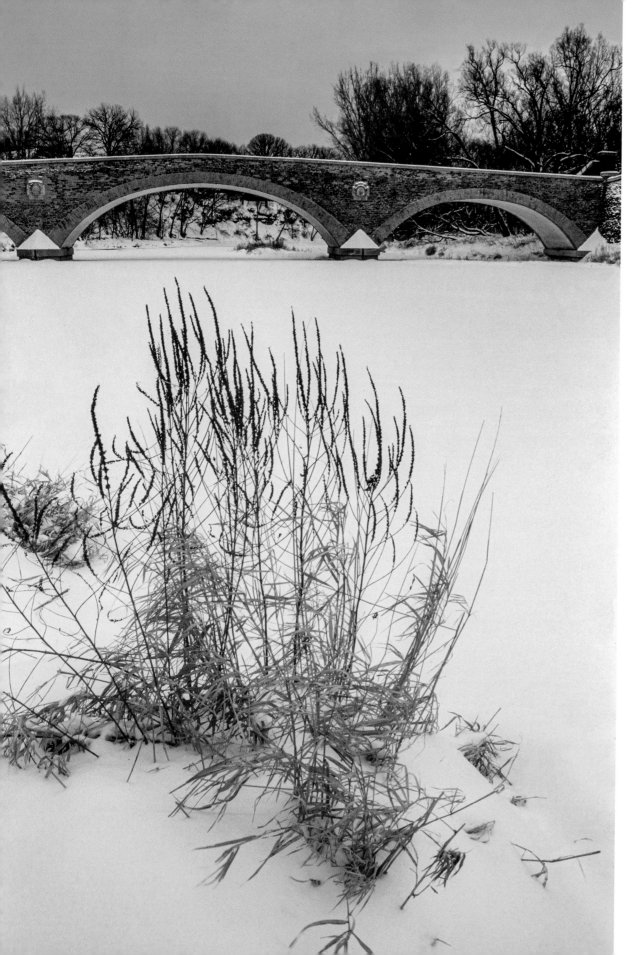

The stone arches of the Old Mill Bridge, built in 1916, span the Humber River in Etienne Brule Park, Toronto.

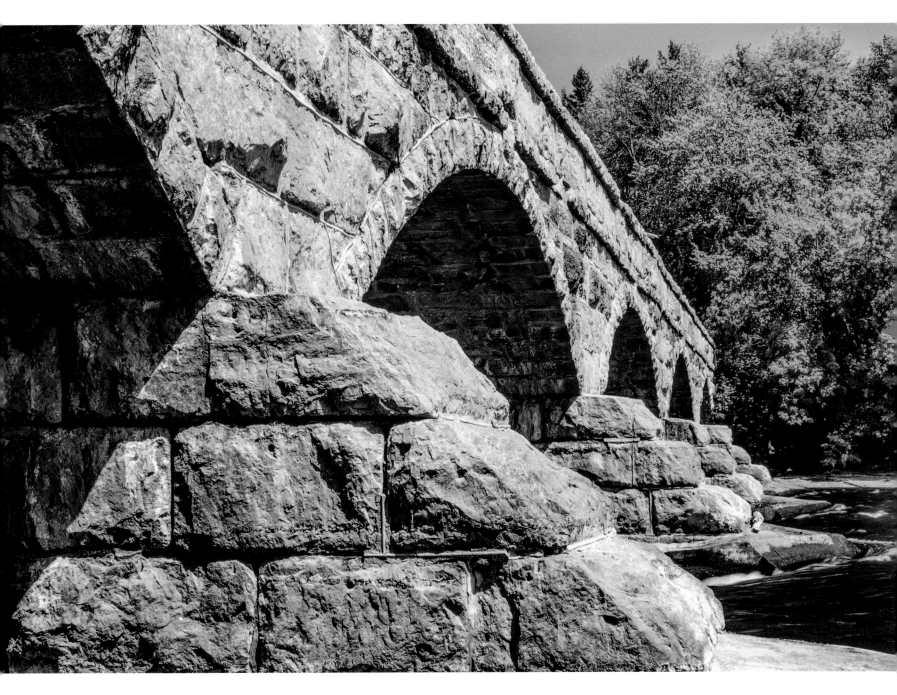

With its five robust stone arches the Pakenham Bridge in Mississippi Mills is unique in North America.

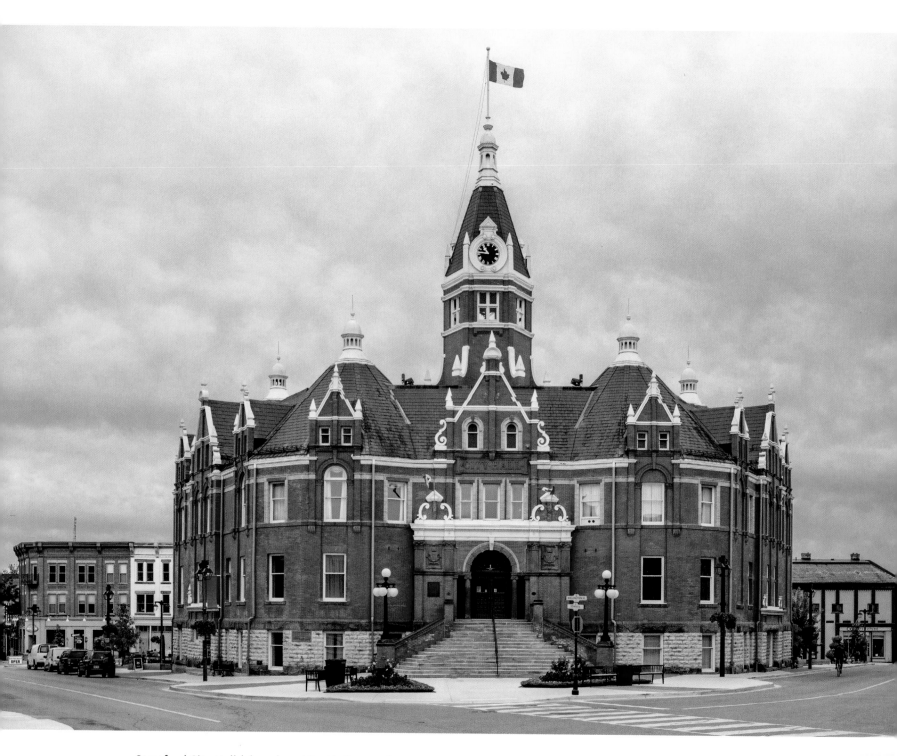

Stratford City Hall (above) and Perth County Court House are two magnificent and eclectically designed 19th century buildings in Stratford.

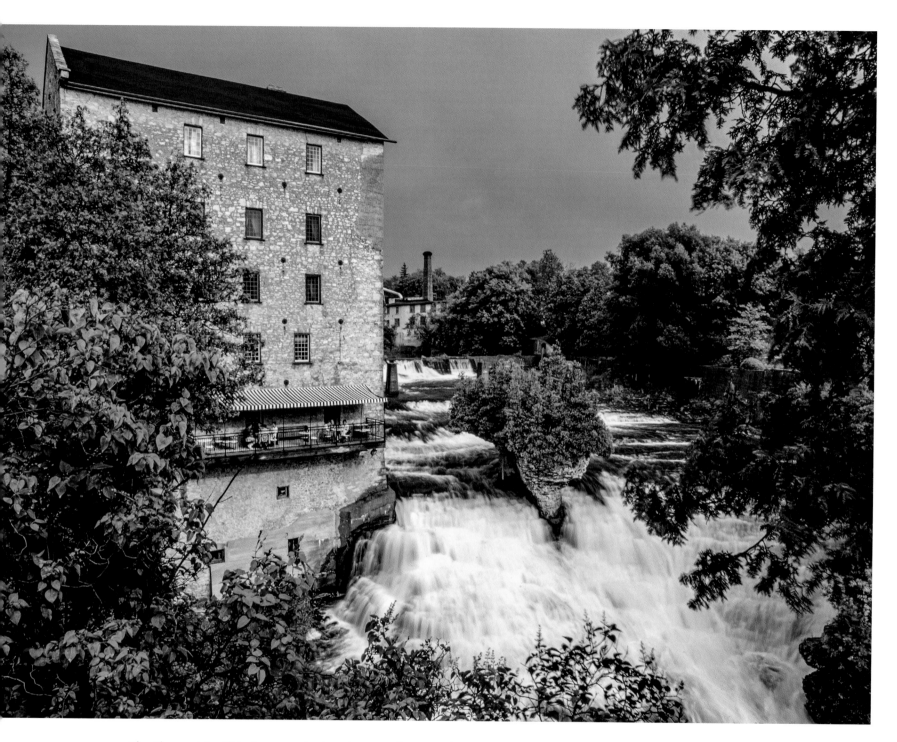

The Elora grist mill before a major hotel renovation completed in 2018 enclosed most of the west elevation in glass-walled balconies. The building overlooks Elora Gorge Falls and the Tooth of Time islet where the Grand River starts its passage through Elora Gorge.

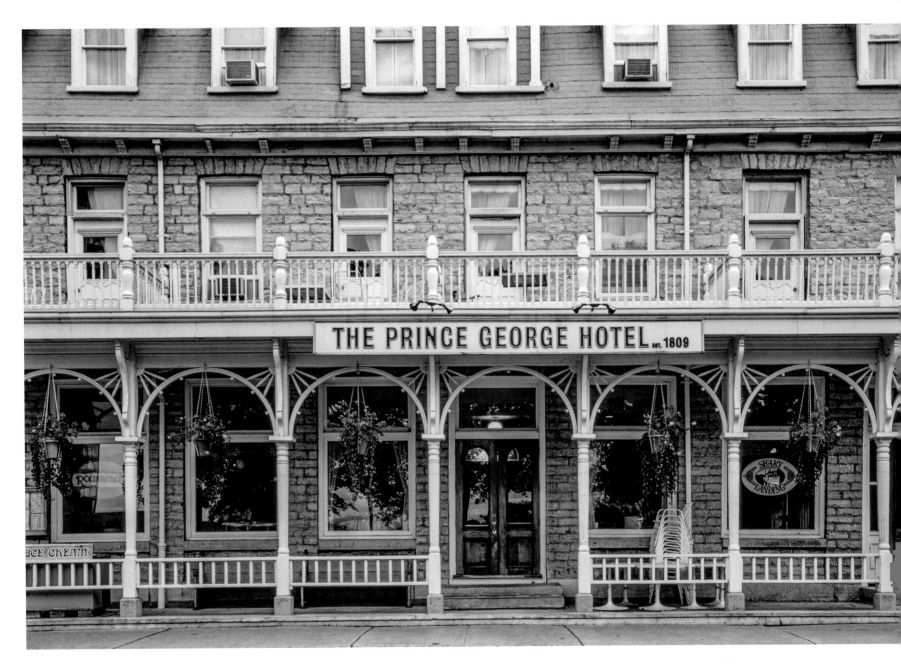

Historic Prince George Hotel in Kingston.

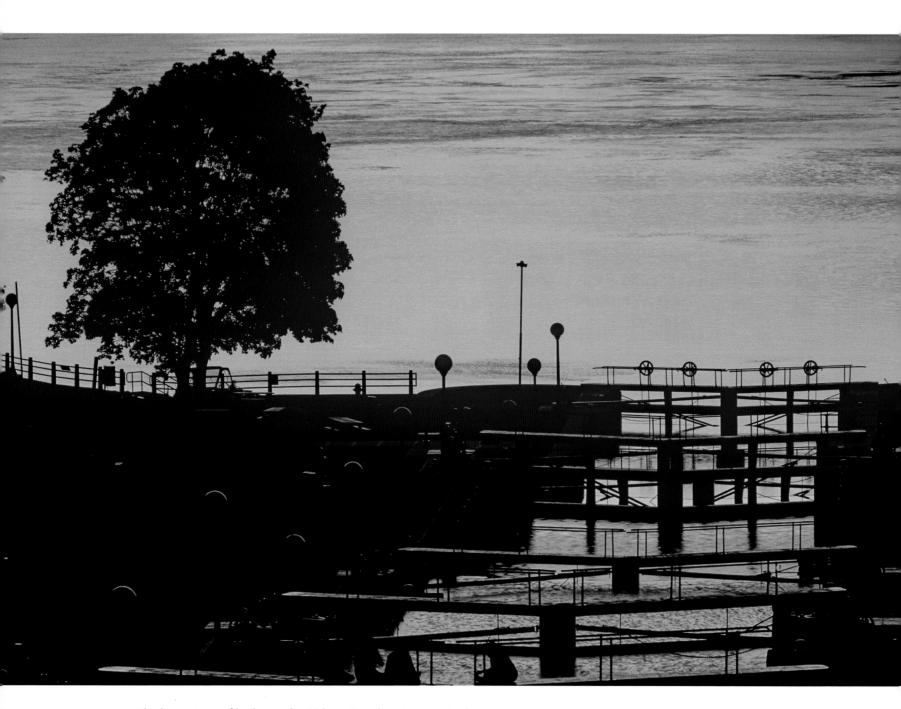

The largest set of locks on the Rideau Canal system are in the centre
of Ottawa, descending 24 metres from the canal to the Ottawa River.

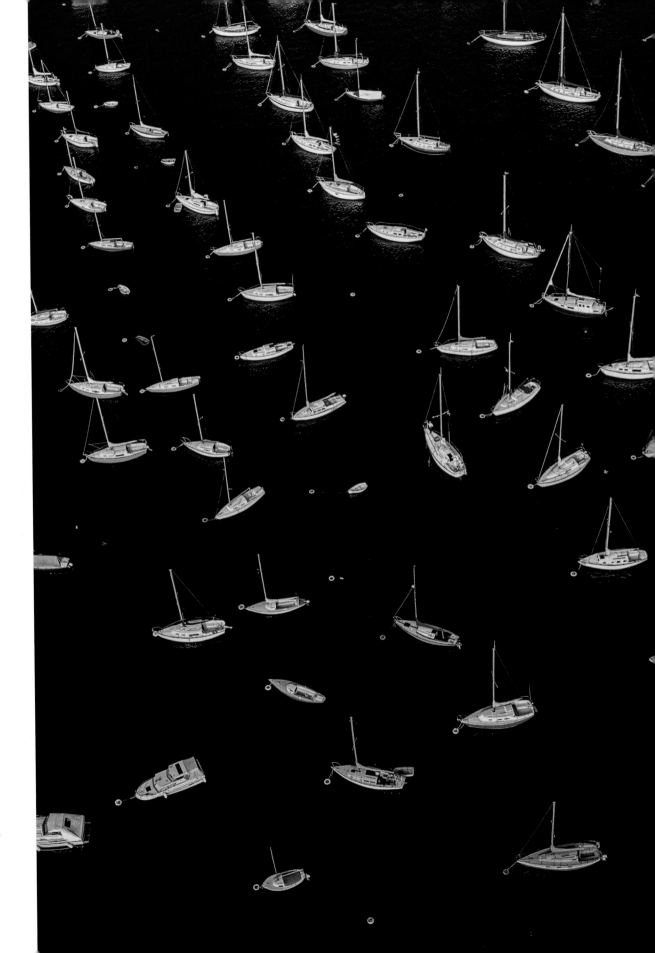

An aerial view of sailboats at the National Yacht Club next to Coronation Park in Toronto.

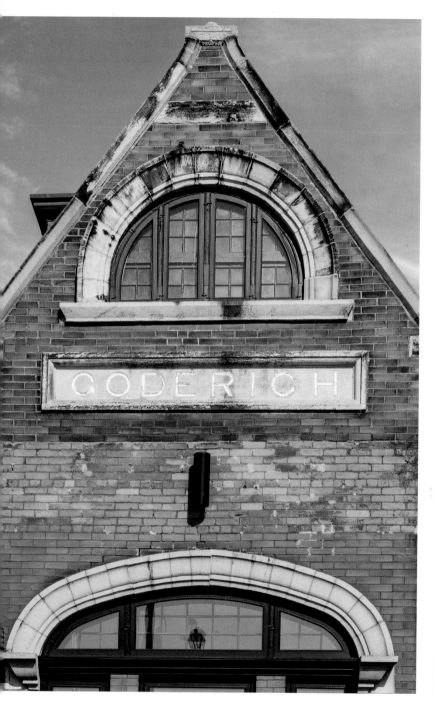

Window details in Goderich. The far left is the front of the former railway station, now a restaurant, the other three are located on Courthouse Square in the town centre.

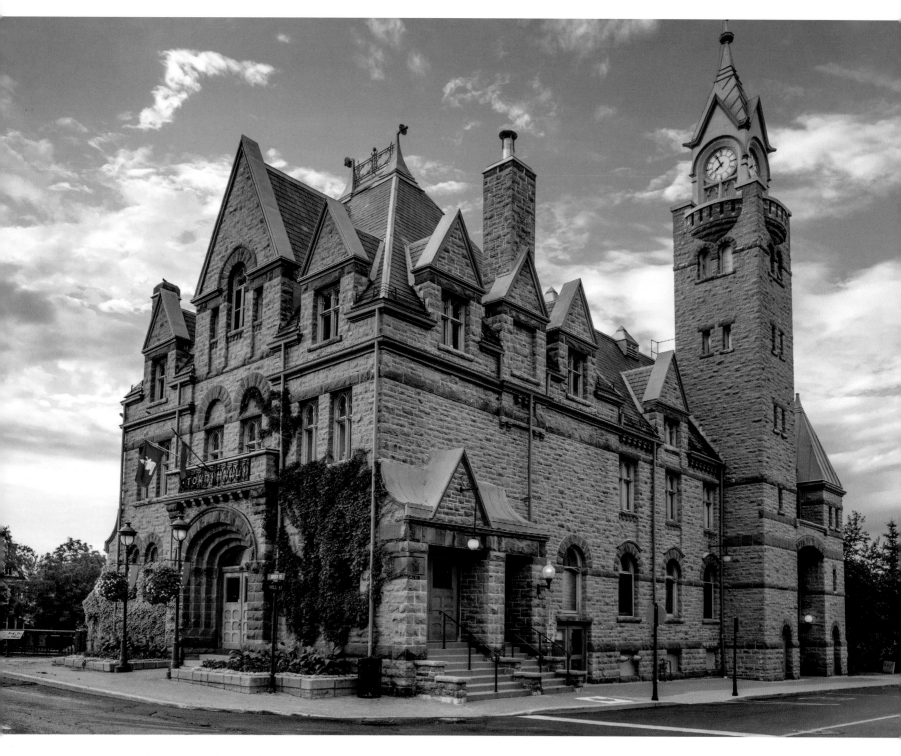

The Town Hall on Bridge Street, Carleton Place, southwest of Ottawa in Lanark County.

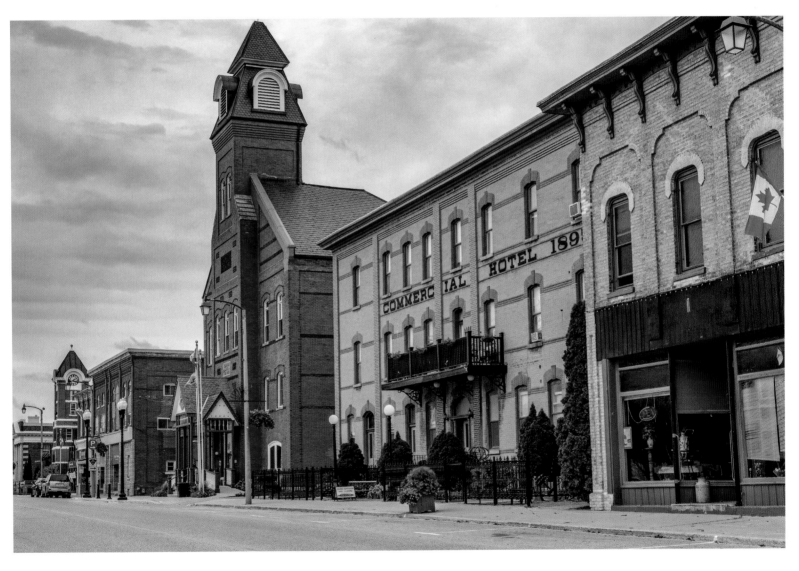

Main Street in Seaforth, Huron County, is one of Ontario's finest examples of commercial architecture from the 19th Century.

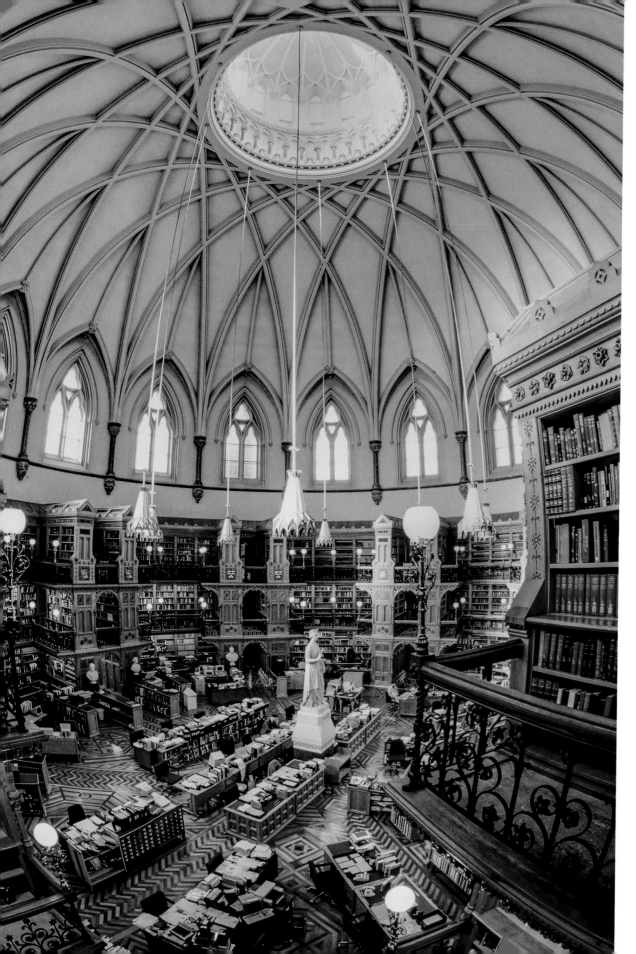

Ottawa's first statue of Queen Victoria stands at the centre of the circular gothic revival Library of Parliament.

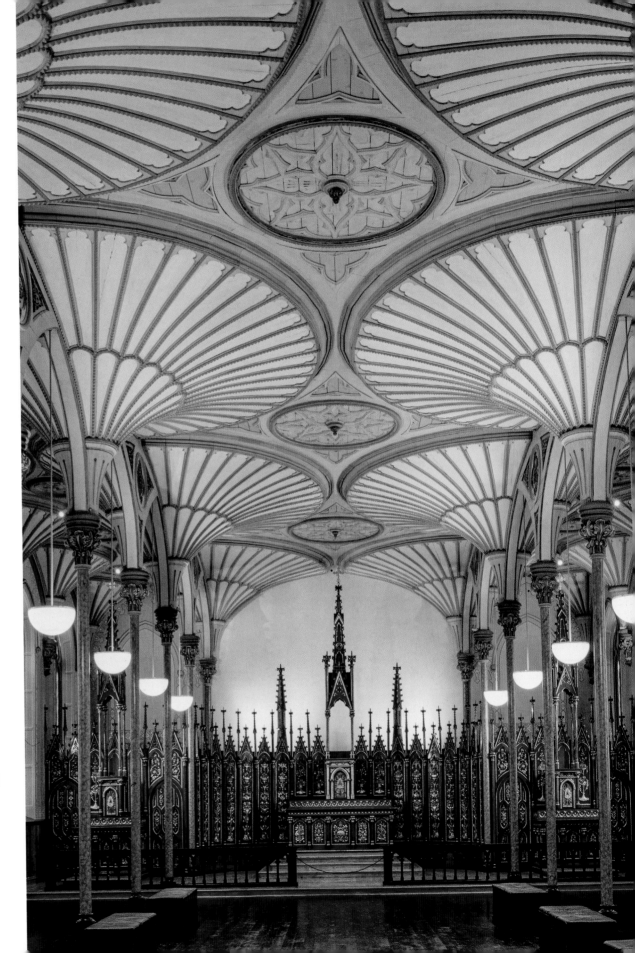

The Rideau Street Convent Chapel with its fan-vault ceiling was dismantled in 1972 and rebuilt inside the National Gallery of Canada in Ottawa.

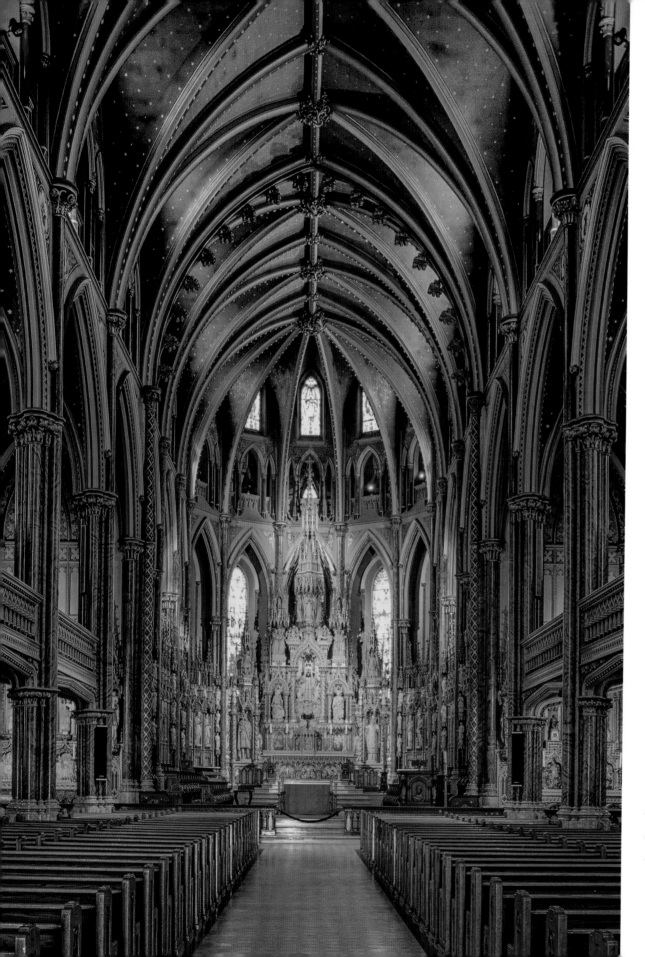

The interior of the Notre Dame Cathedral Basilica, the oldest and largest church in Ottawa.

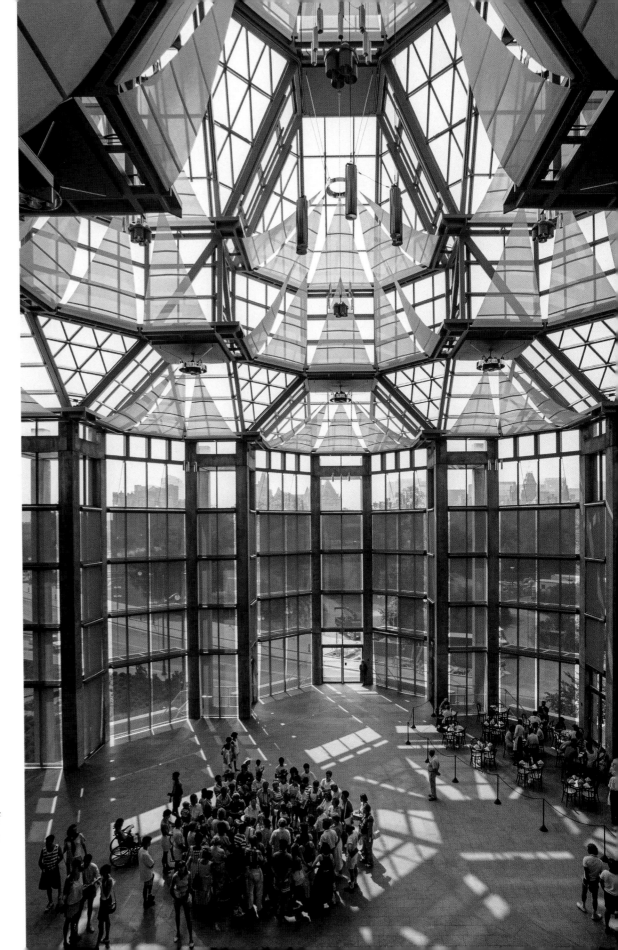

Tall windows and a ceiling of glass create the soaring luminous space of the Great Hall in the National Gallery of Canada, Ottawa.

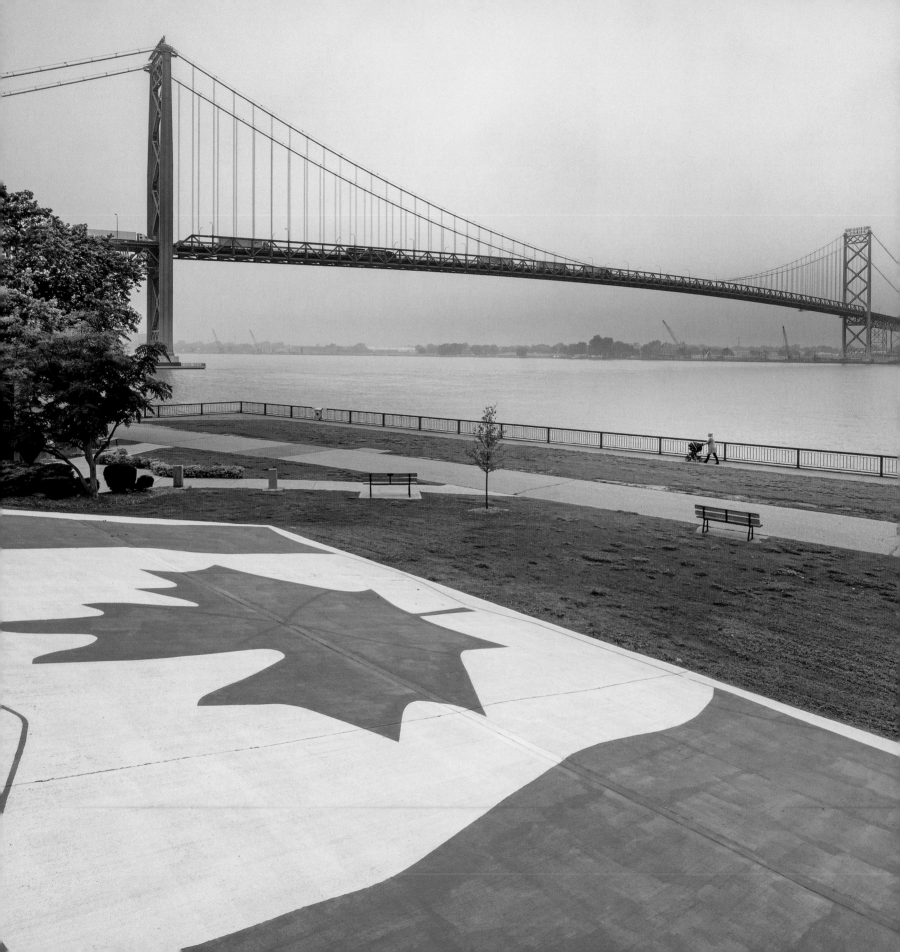

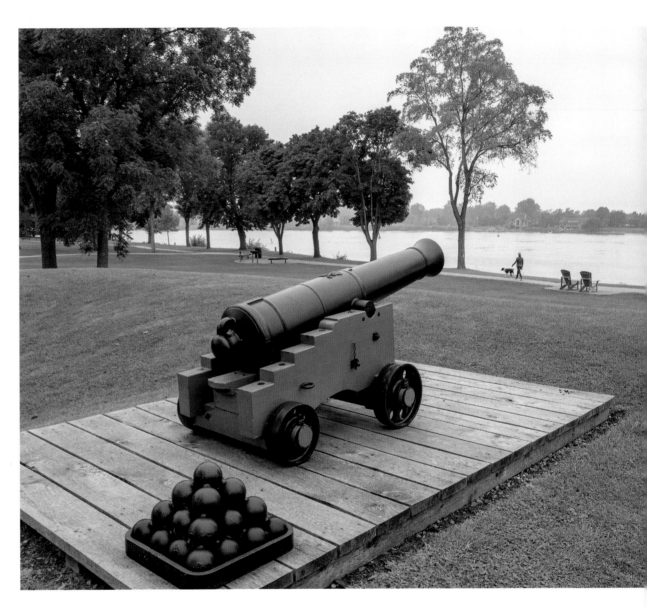

A cannon points across the Detroit River at Fort Malden National Historic Site in Amherstburg, south of Windsor.

The Ambassador Bridge seen from Dieppe Gardens in Assumption Park along the Riverfront Trail, Windsor. A quarter of all commercial trade between Canada and the United States crosses this bridge over the Detroit River.

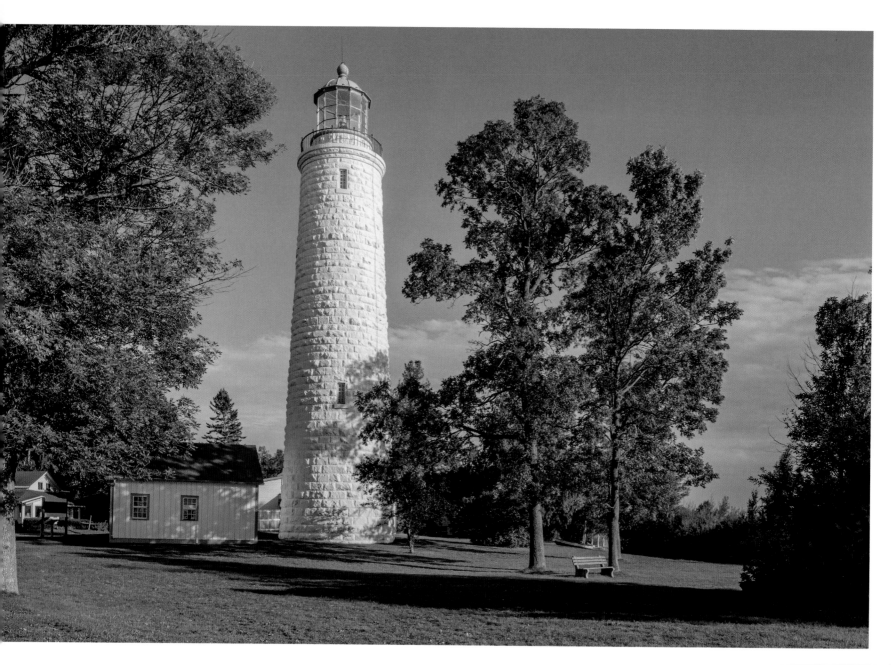

The 34-metre-tall limestone block tower and lightkeeper's cabin of the Point Clark Lighthouse, a National Historic Site in the Township of Huron-Kinloss on Lake Huron.

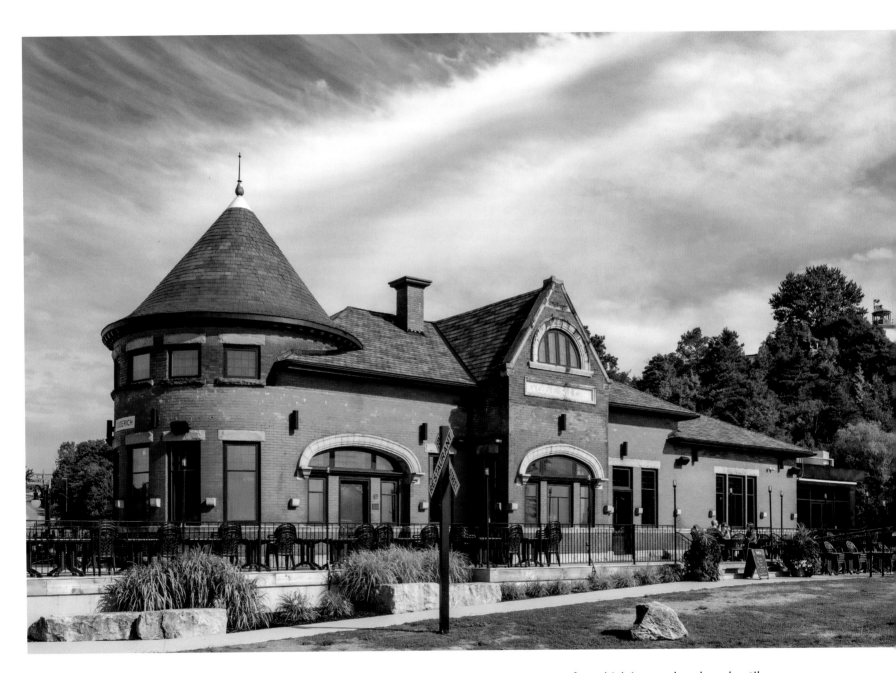

The last train left the Goderich train station in 1988, after which it was abandoned until an entrepreneur purchased the 400-ton building, moved it 250 metres to the edge of a beach on Lake Huron and renovated the interior into a stunning restaurant.

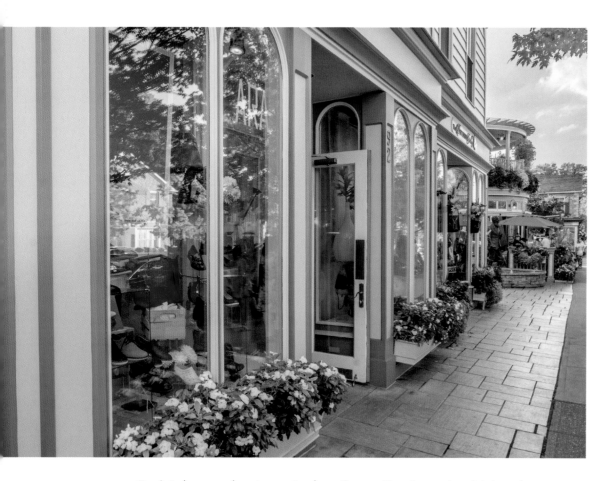

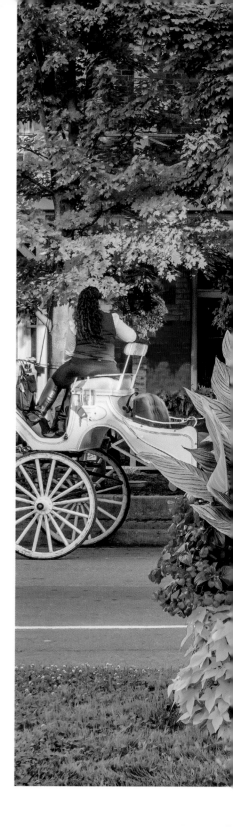

Quaint shops and restaurants along Queen Street are a tourist draw in Niagara-on-the-Lake, the first capital of the Province of Upper Canada, the predecessor of the Province of Ontario.

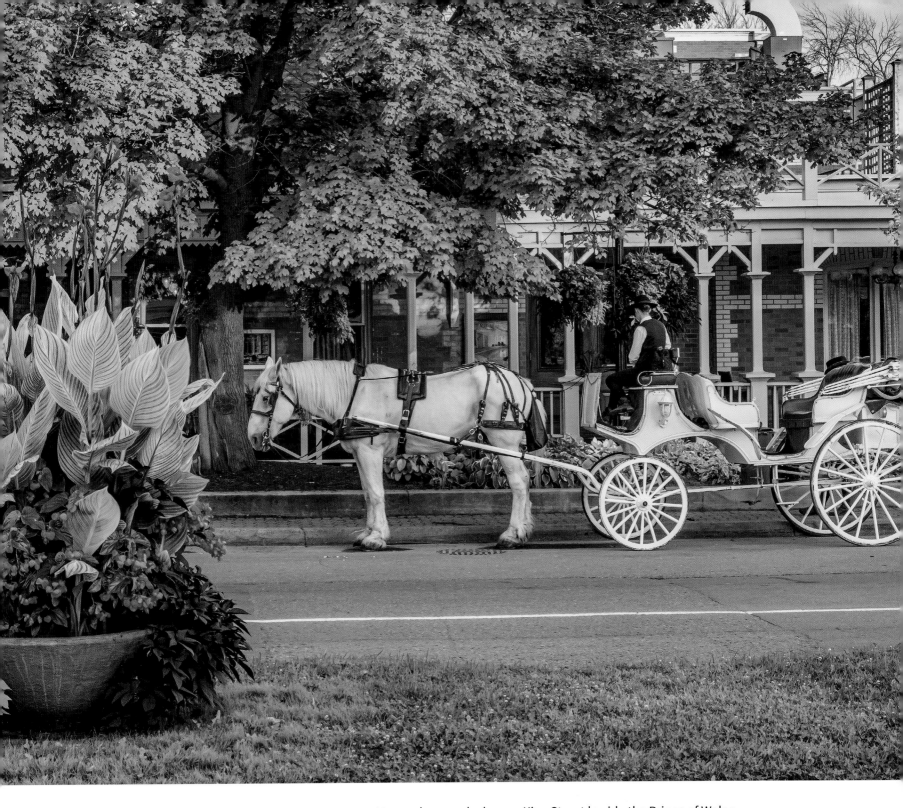

Horse-drawn caleches on King Street beside the Prince of Wales
Hotel, Niagara-on-the-Lake.

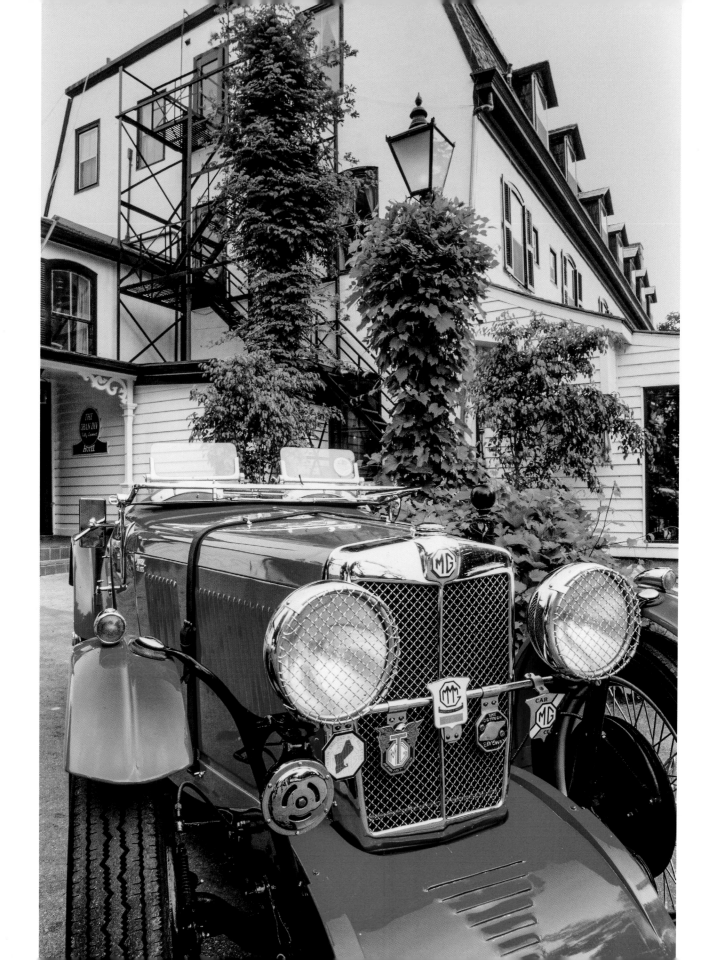

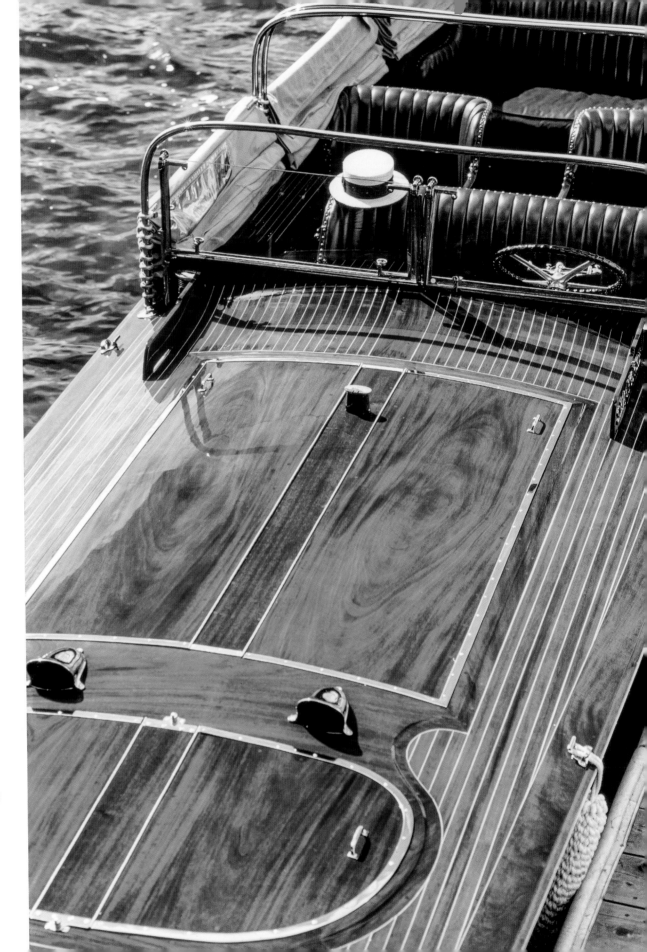

Upper-class elegance: an antique car in front of the Oban Inn in Niagara-on-the-Lake (left) and one of the famous wooden boats owned by cottagers and residents in Muskoka.

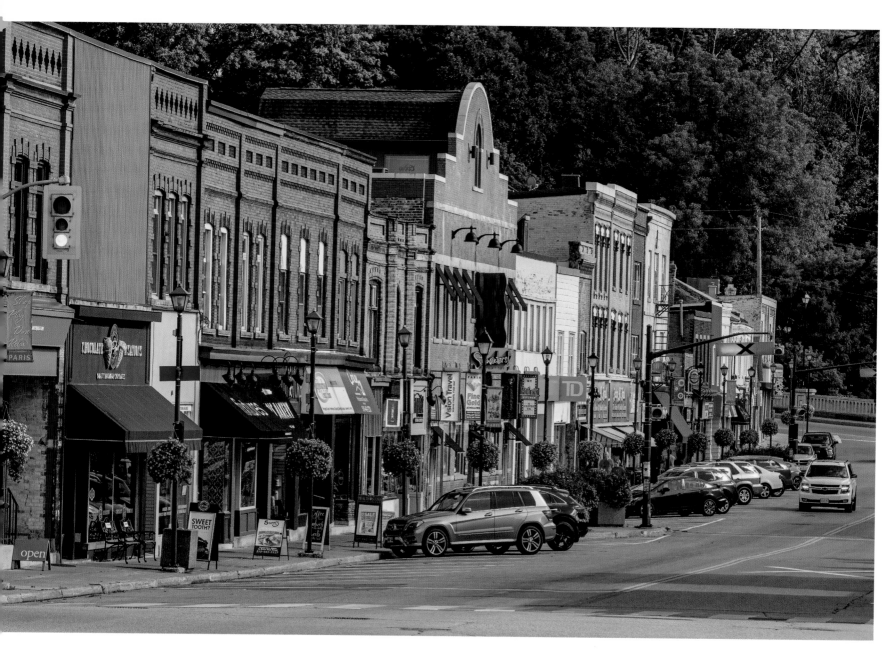

Grand River Street, the main street in Paris. The town is named for nearby deposits of gypsum, used to make plaster of paris.

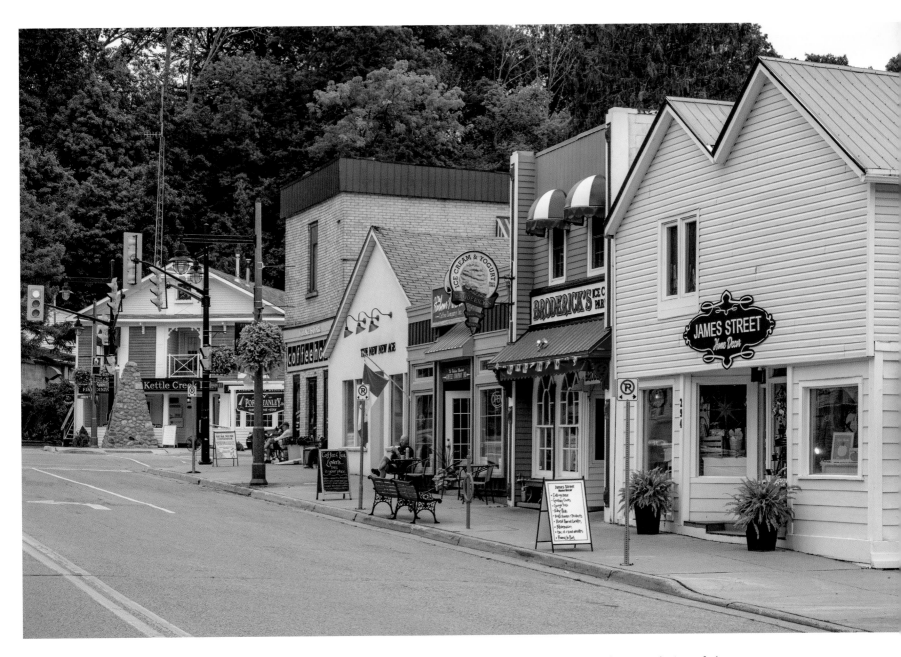

Bridge Street in Port Stanley. The community, with a population of about two thousand on Lake Erie, is named in honour of the father of Lord Stanley of Preston, Governor General of Canada and donor of the Stanley Cup.

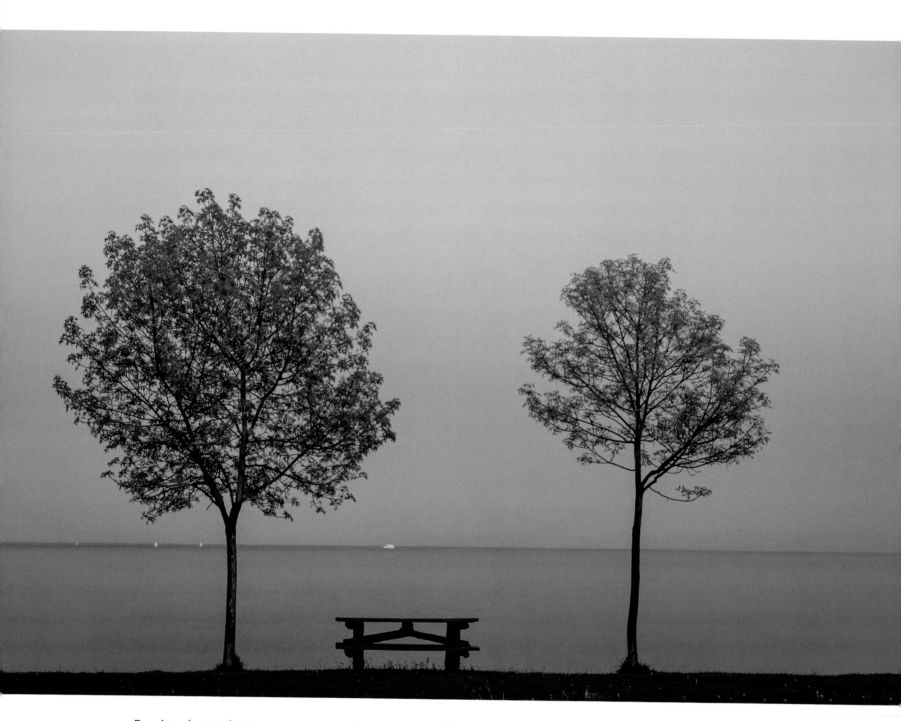

Evening along Lake Ontario at Humber Bay Park,
at the mouth of Mimico Creek, Etobicoke.

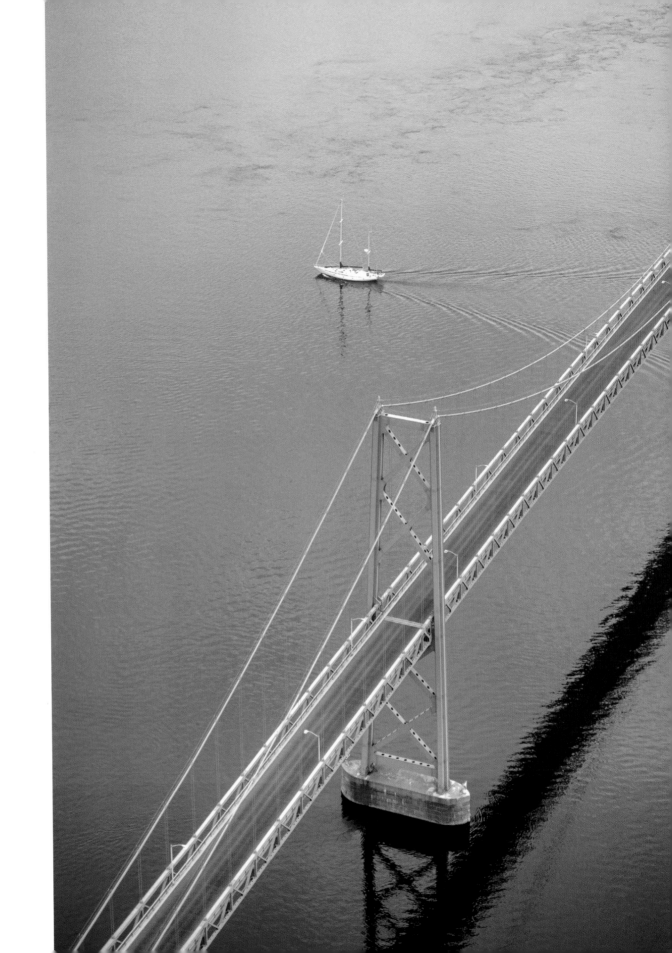

An aerial view of the Ogdensburg-Prescott International Bridge across the St. Lawrence River.

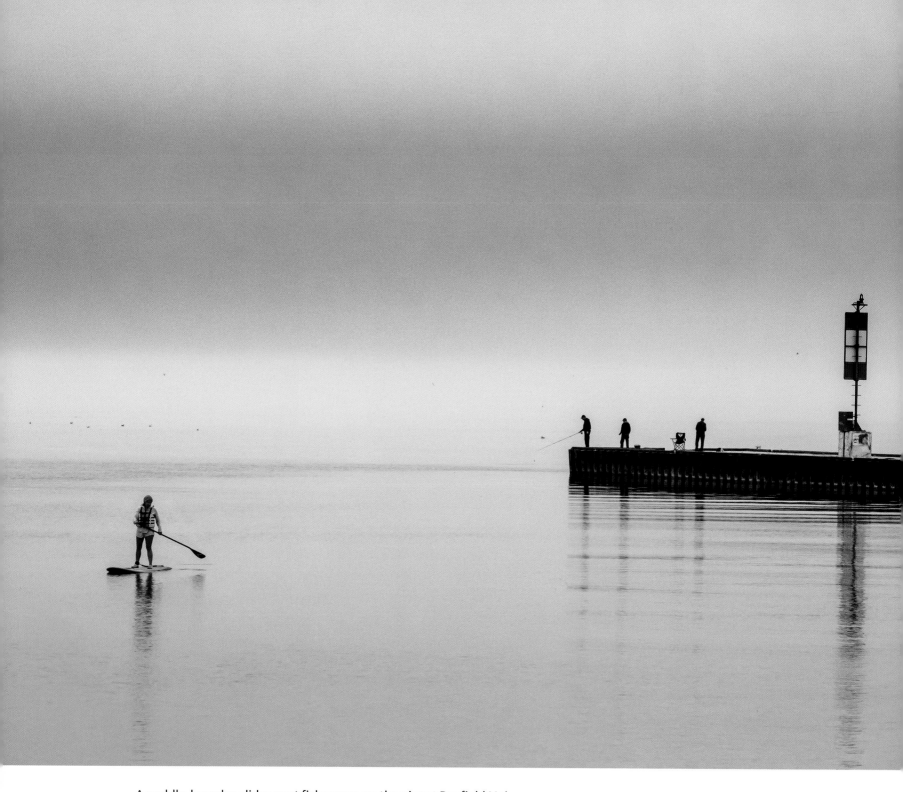

A paddle-boarder glides past fishermen on the pier at Bayfield Main Beach, Lake Huron at Bayfield.

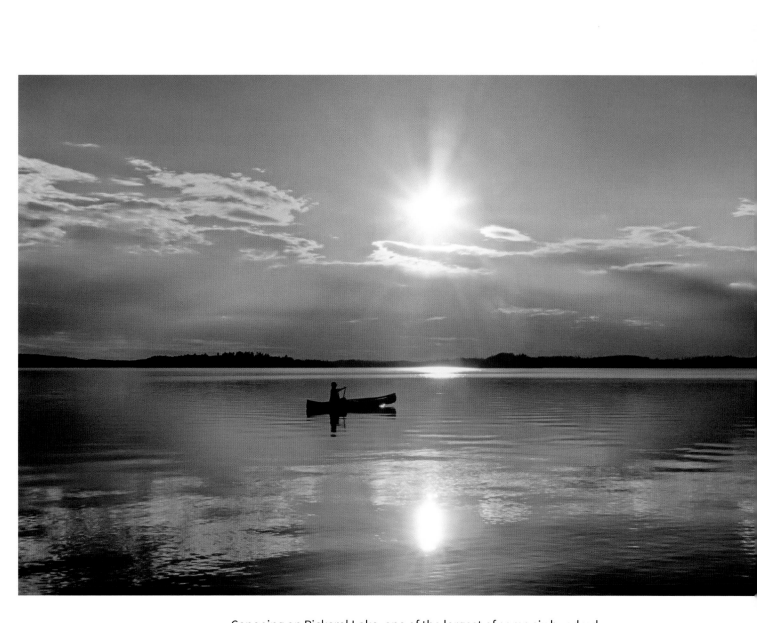

Canoeing on Pickerel Lake, one of the largest of some six hundred wilderness lakes in five-thousand-square-kilometre Quetico Provincial Park.

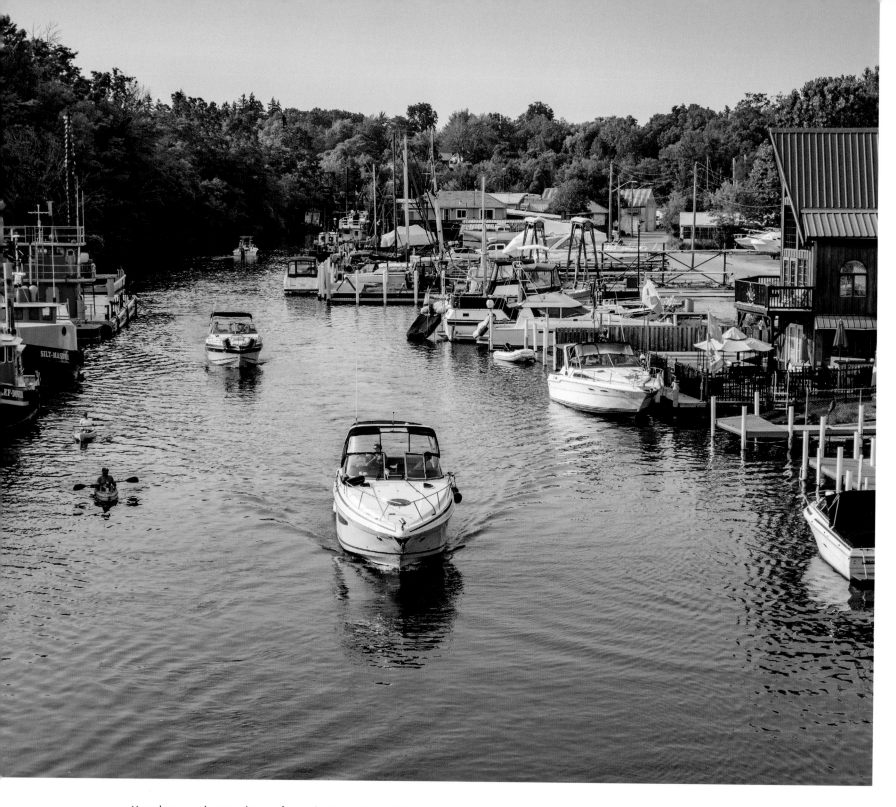

Kayakers and motorboats from the Lynn River Lift Bridge in Port Dover, Norfolk County, on the north coast of Lake Erie.

Houseboats and power yachts moored for the night above Lock 34 at Fenelon Falls on the historic Trent-Severn Waterway.

NEXT SPREAD: Boathouses along the Trent-Severn Waterway at Fenelon Falls.

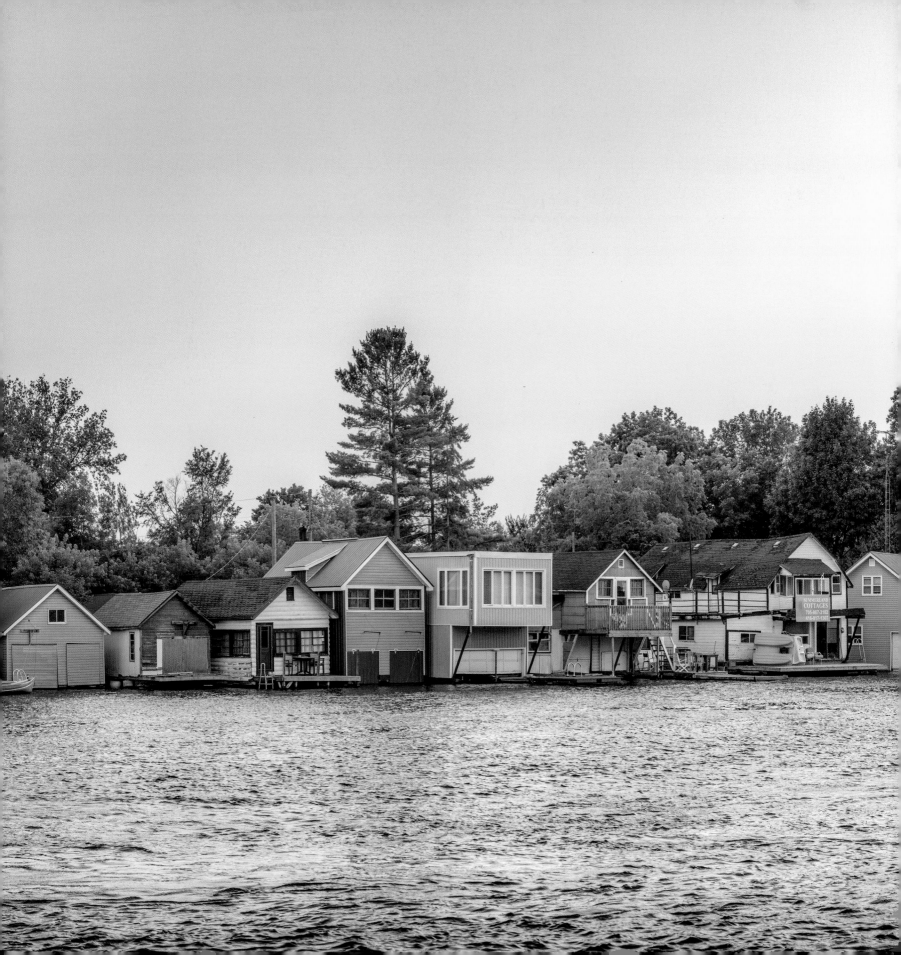

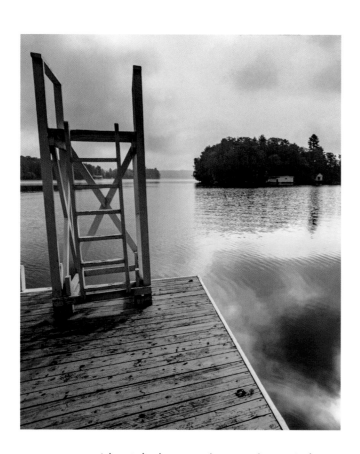

A boat dock on a quiet morning on Lake Joseph, one of the three main Muskoka Lakes along with Lake Rosseau and Lake Muskoka.

A footbridge across the Du Fond River at the outlet to Moore Lake in Samuel de Champlain Provincial Park east of North Bay.

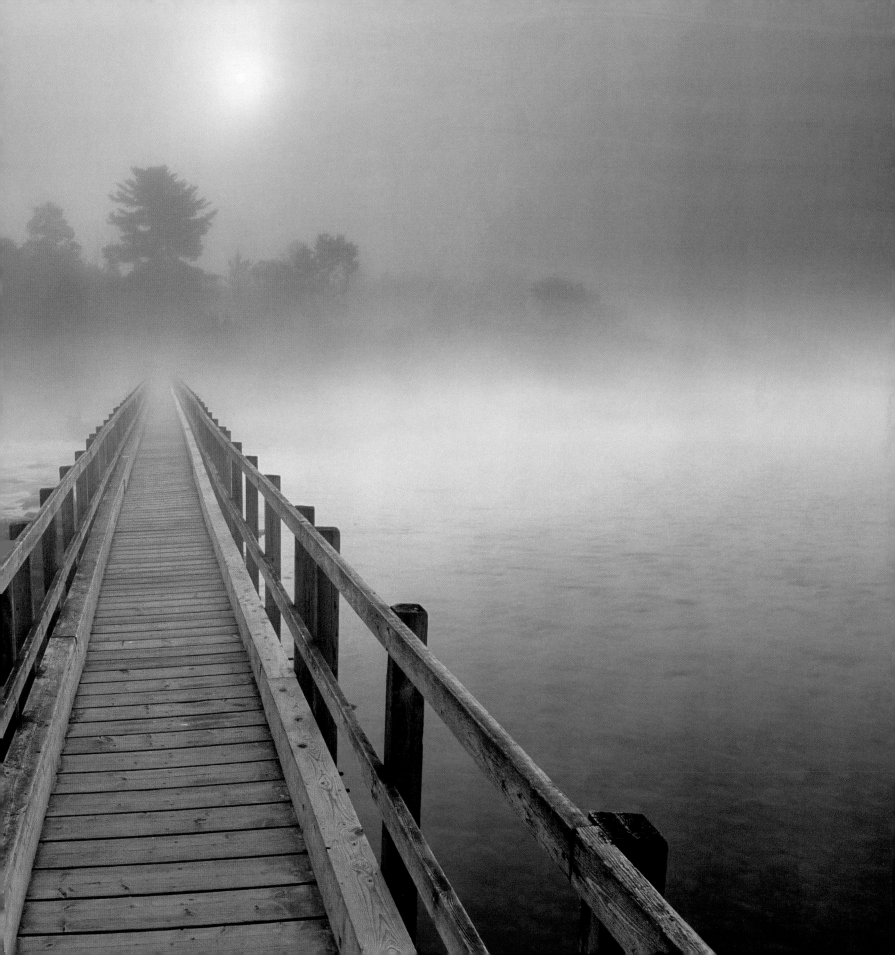

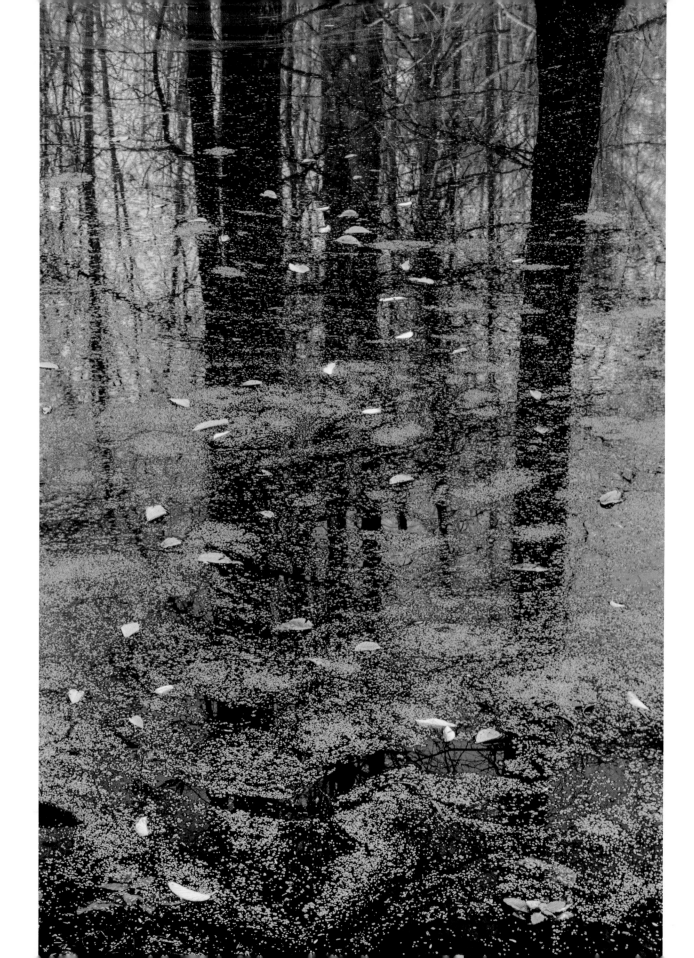

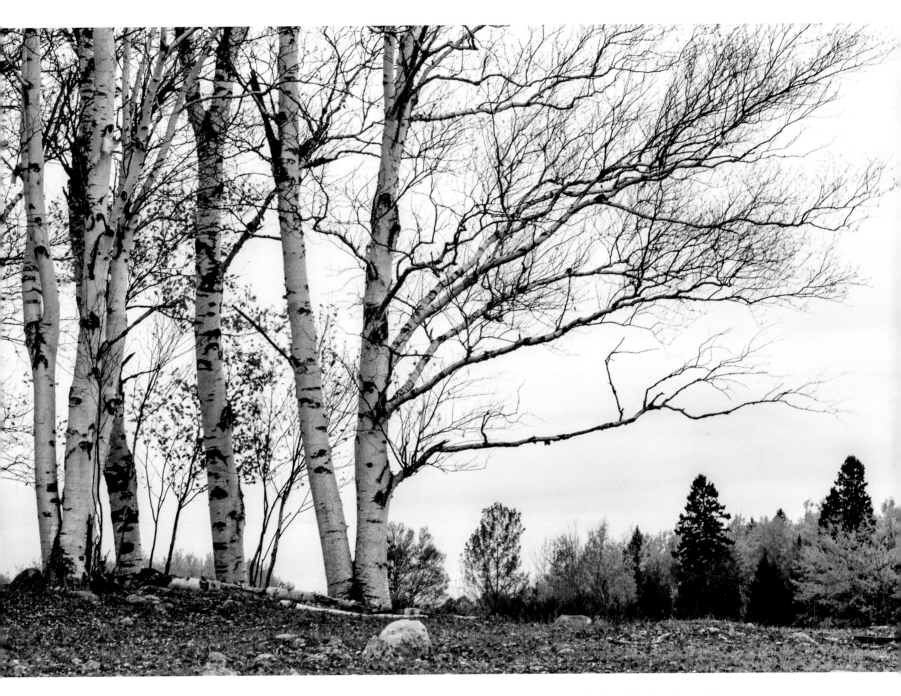

Autumn leaves, algae and the reflections
of trees on a pond in Muskoka.

Birch trees in the fall on St. Joseph Island in the channel between
Lake Superior and Lake Huron, south of Sault Ste. Marie.

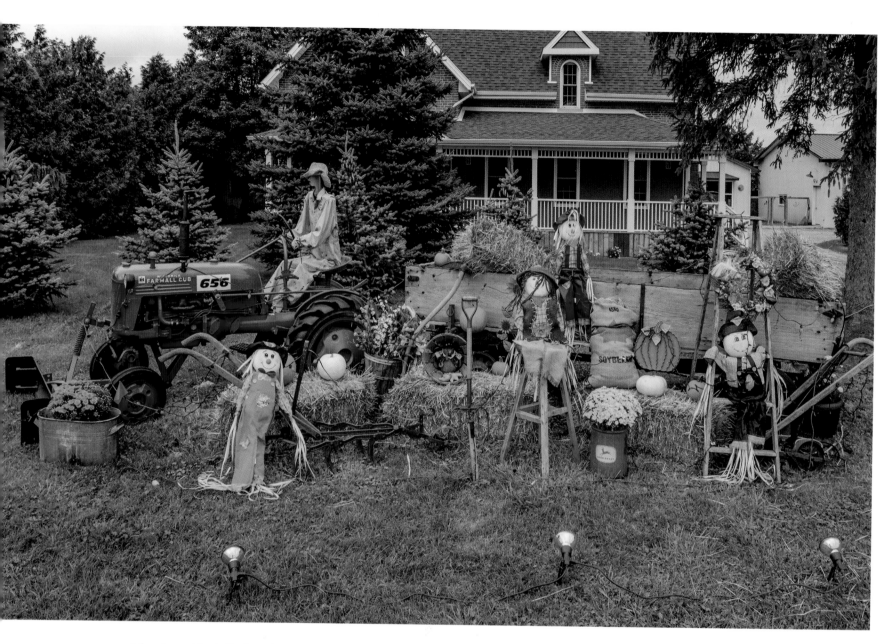

A front yard installation along Bear Line Road in Chatham-Kent County erected as a salute to the International Plowing Match, the largest outdoor agriculture and rural expo in North America, held annually in a different location, in this case in nearby Pain Court.

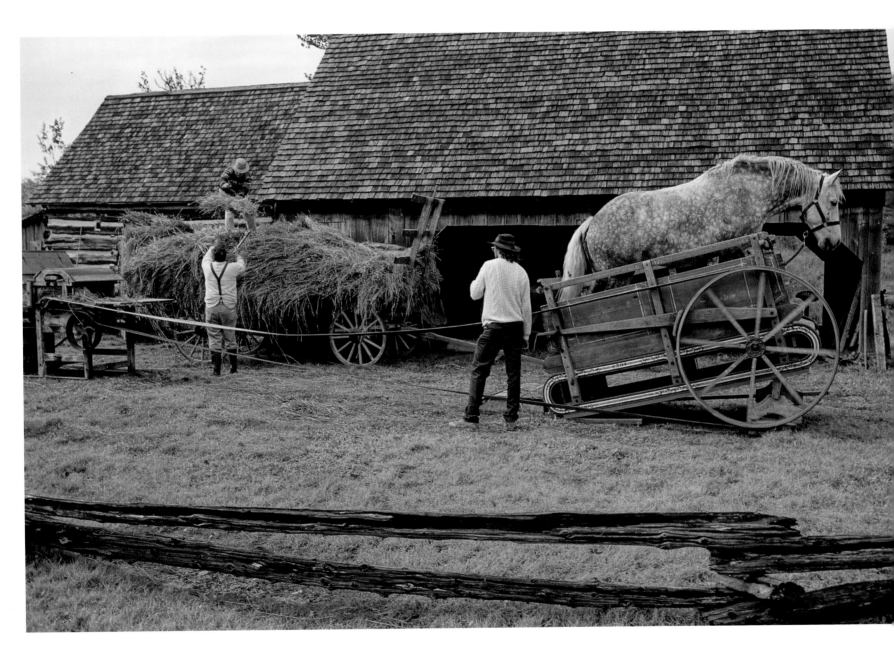

A demonstration of threshing grain using horsepower at the Log Farm in Nepean, where numerous reenactments of pioneer life are exhibited.

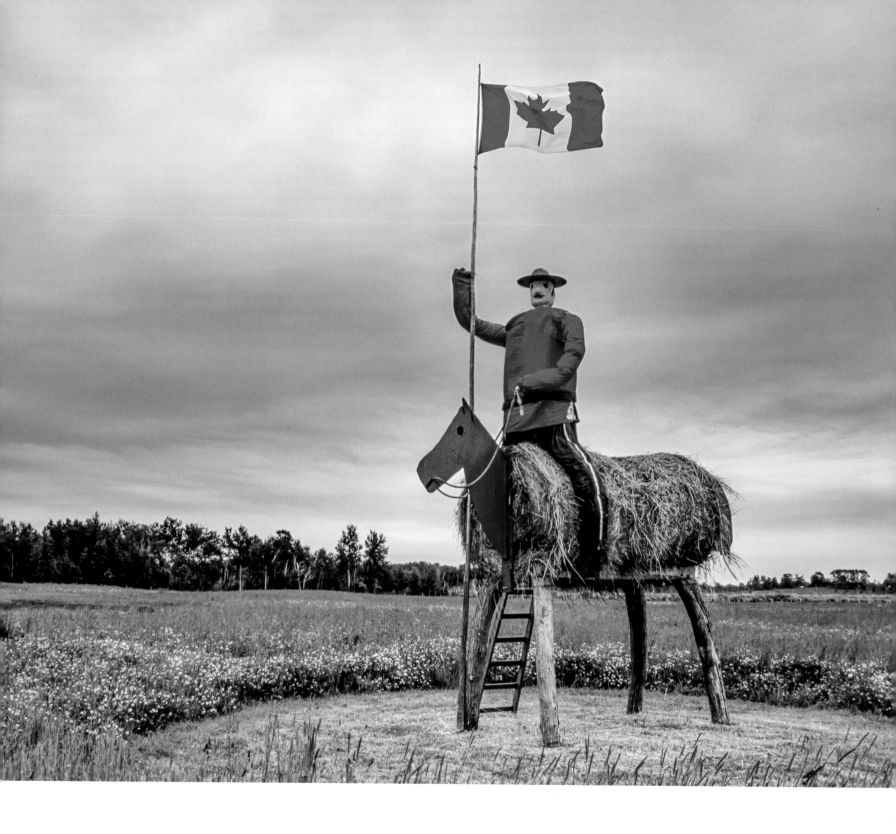

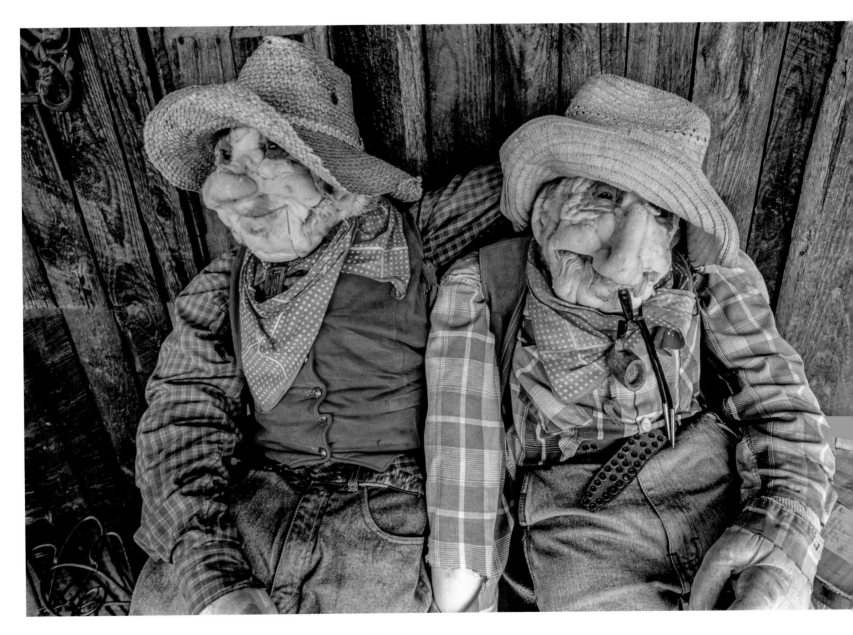

Rural folk art sculpture. A Mountie rides a straw horse on Manitoulin Island (left) and two characters sit outside a store in Wawa.

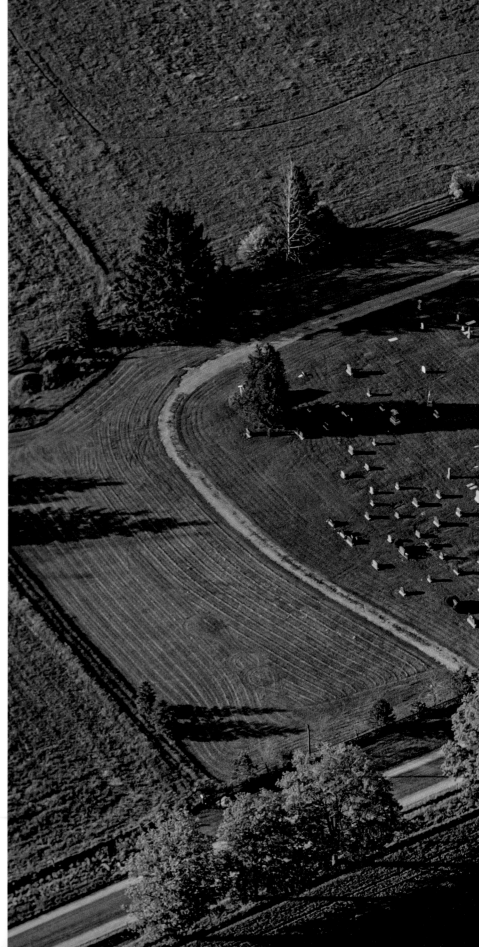

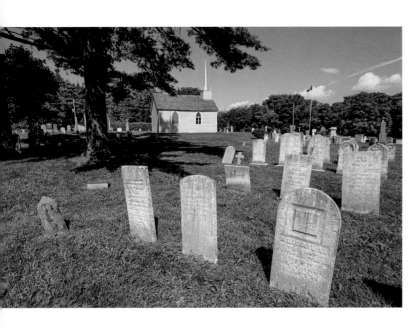

Old gravestones next to the Blue Church in
Prescott.

An aerial view of St. John's Church & Cemetery
in the township of New Tecumseth, County
Simcoe.

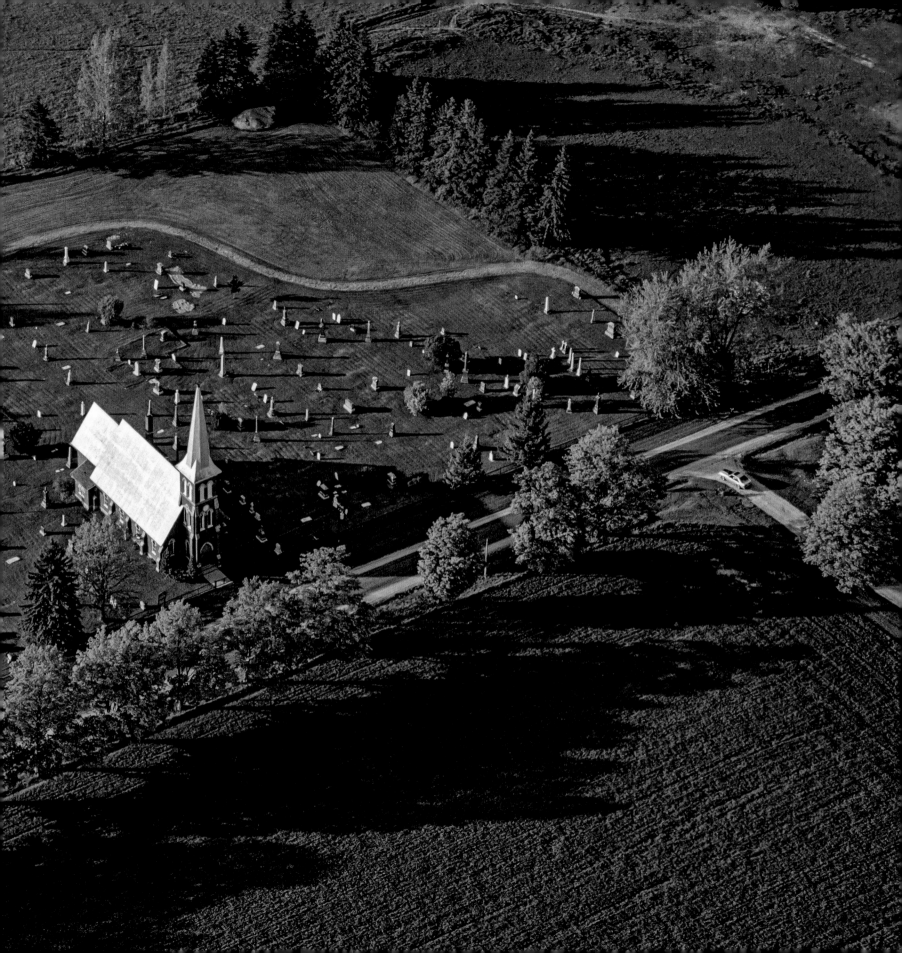

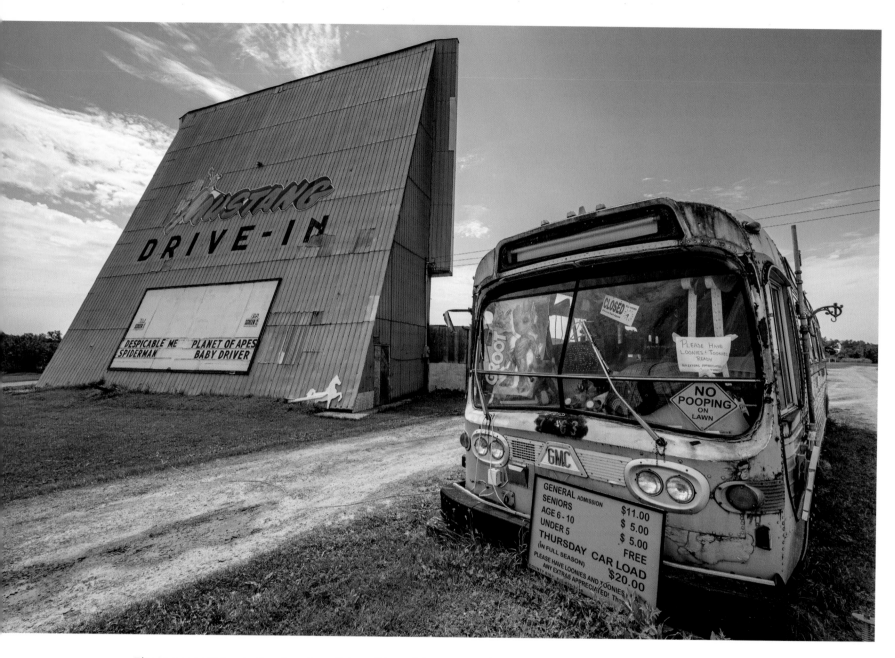

The Mustang Drive-In theatre along Prince Edward County Road 1 near Bloomfield.

After sunset on Robinson Street, Port Burwell. The Port Burwell Lighthouse, now a museum, was built in 1840 and is Canada's oldest wooden lighthouse.

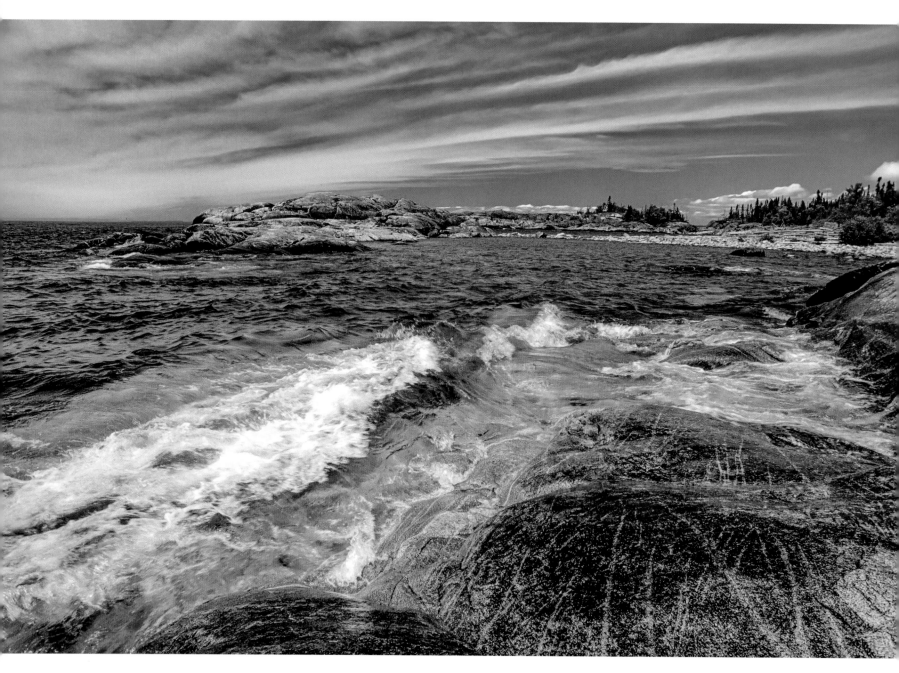

The waters of Lake Superior wash over ancient bedrock, in places nearly three billion years old, in Pukaskwa National Park.

Floating maple leaves and pine needles on Beausoleil Island, Georgian Bay Islands National Park.

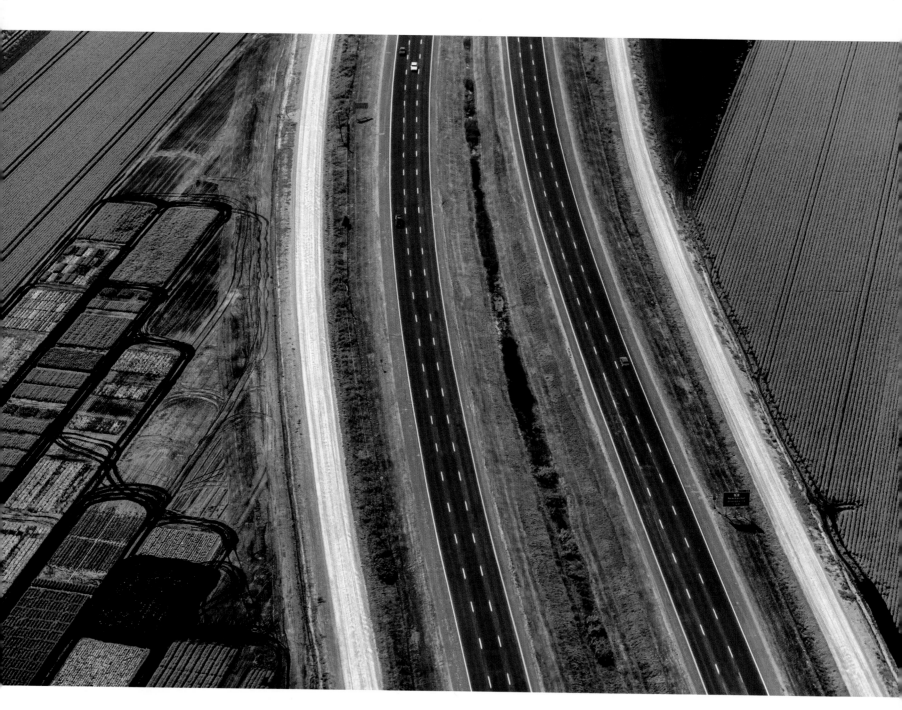

Highway 400 from above cuts through the Holland Marsh in spring.
The fertile organic soil on either side of the highway is ideal for
growing market-garden crops.

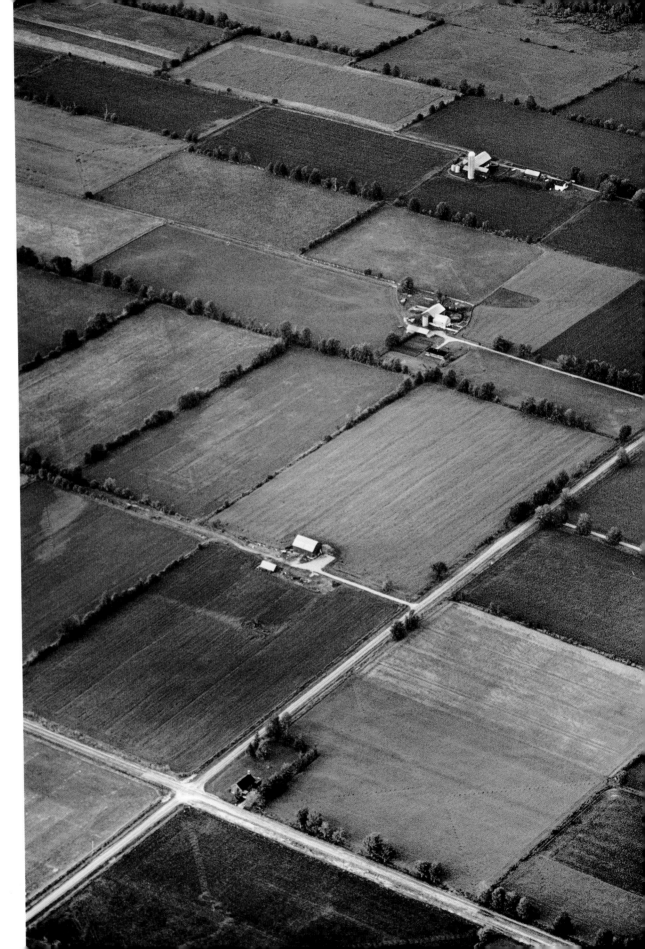

An aerial view of farmland north of Barrie.

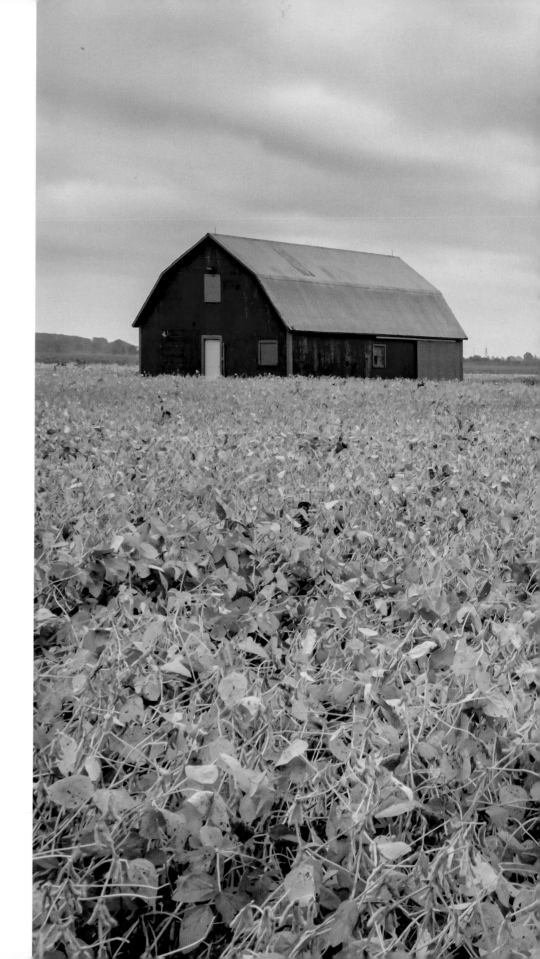

Barns and a field of soybeans in September beside Riverview Line Road and the Thames River west of Chatham-Kent.

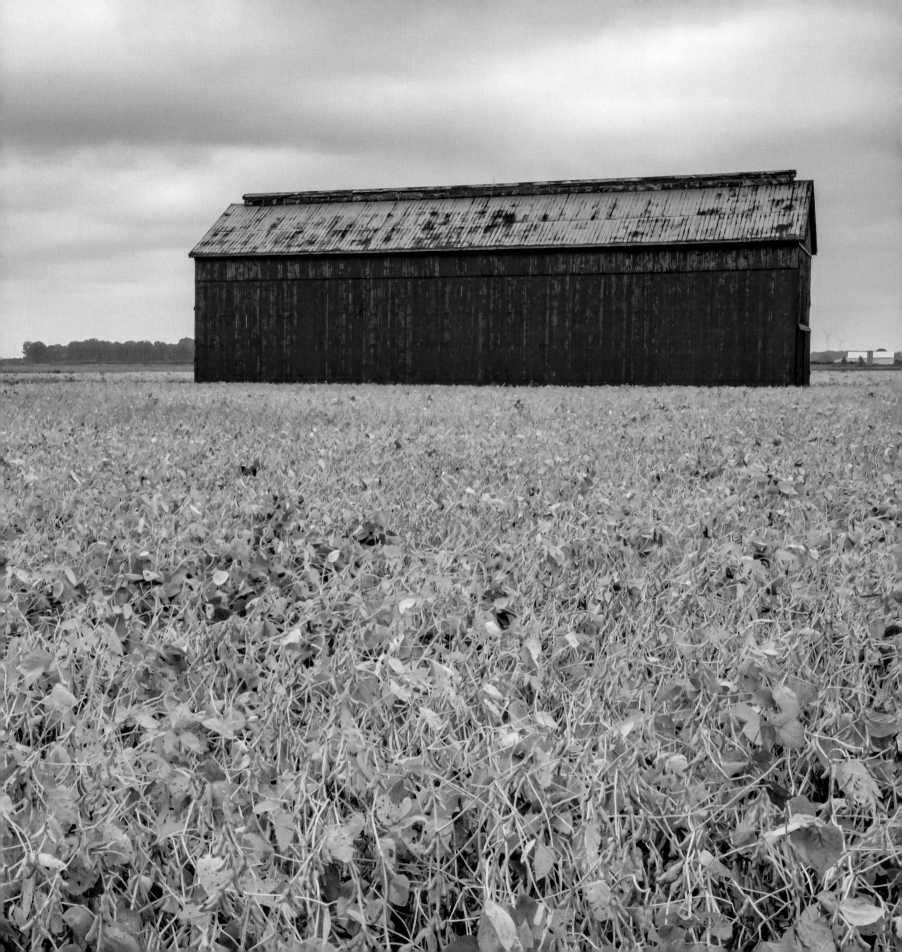

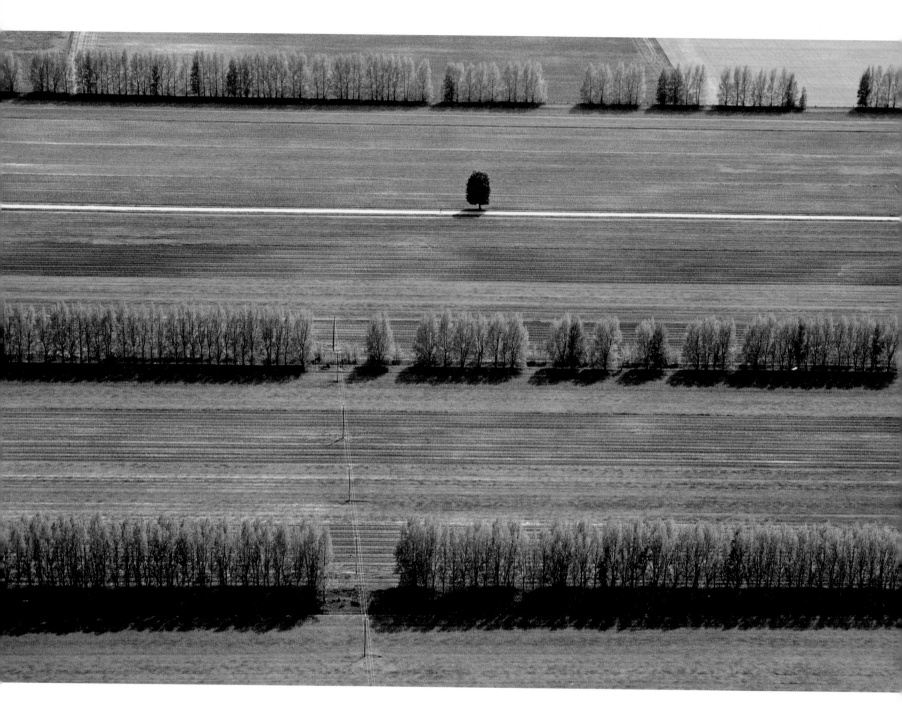

Aerial views of rows of poplar trees serving as windbreaks for farm fields near Port Elgin (above) and of a barn and orchard near Port Hope.

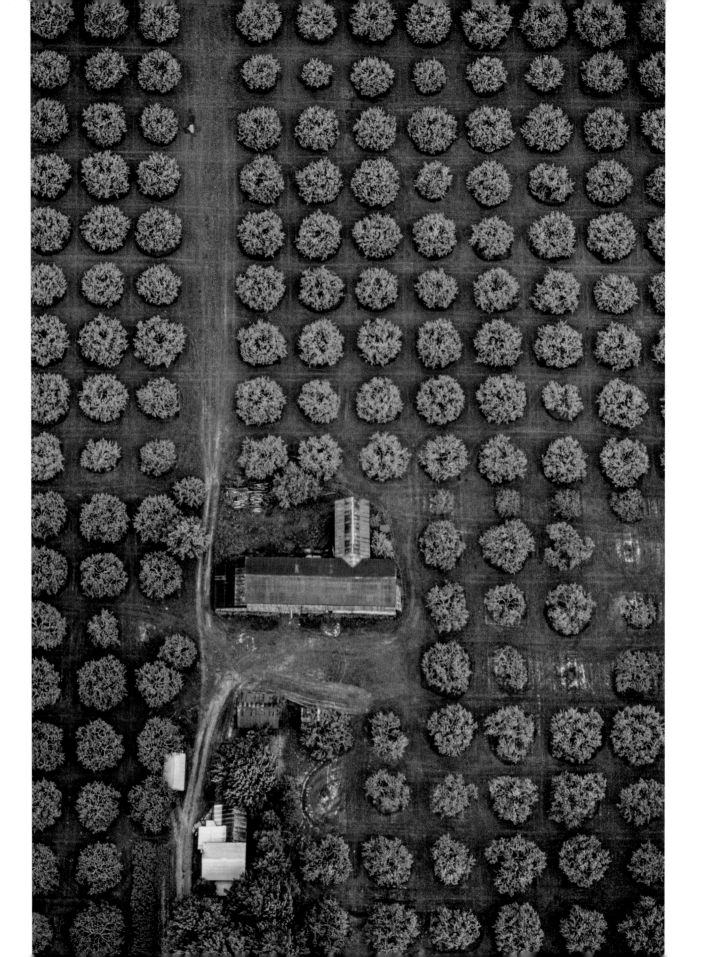

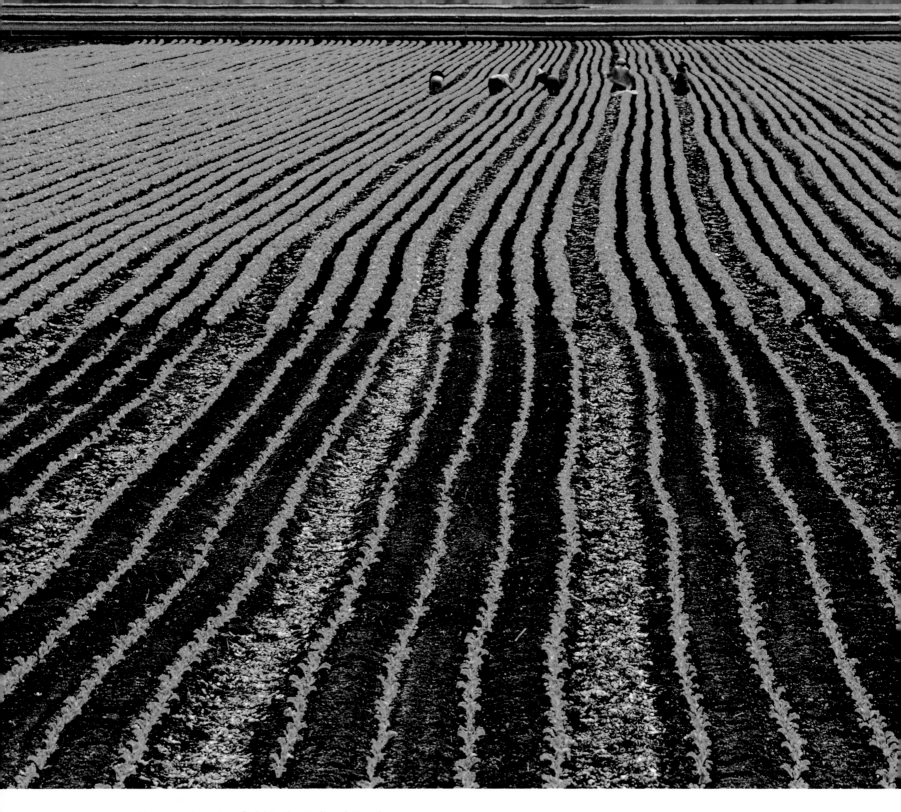

Farm workers in a field in the Holland Marsh.

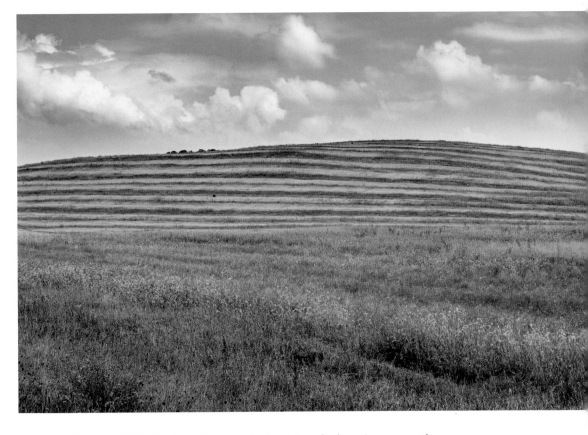

A furrowed hillside along the Londesboro Road where it crosses the South Maitland River, Huron County.

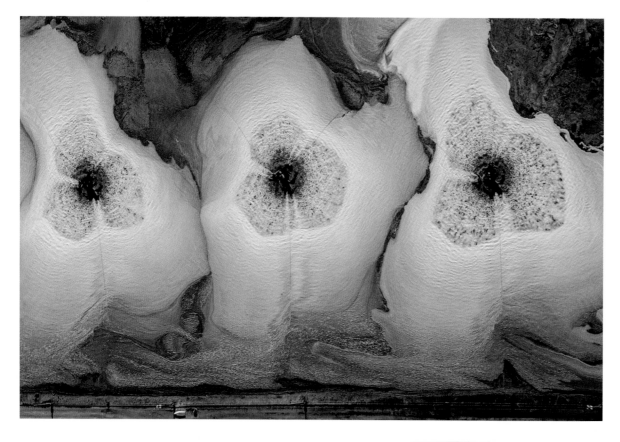

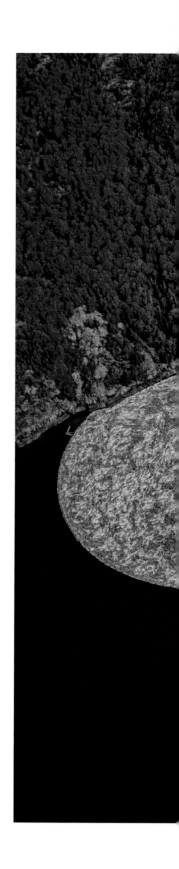

Aerial views of the pulp and paper industry. Mill effluent aeration ponds near Fort Frances (above) and log booms in Beatty Cove on Lake Superior near Marathon.

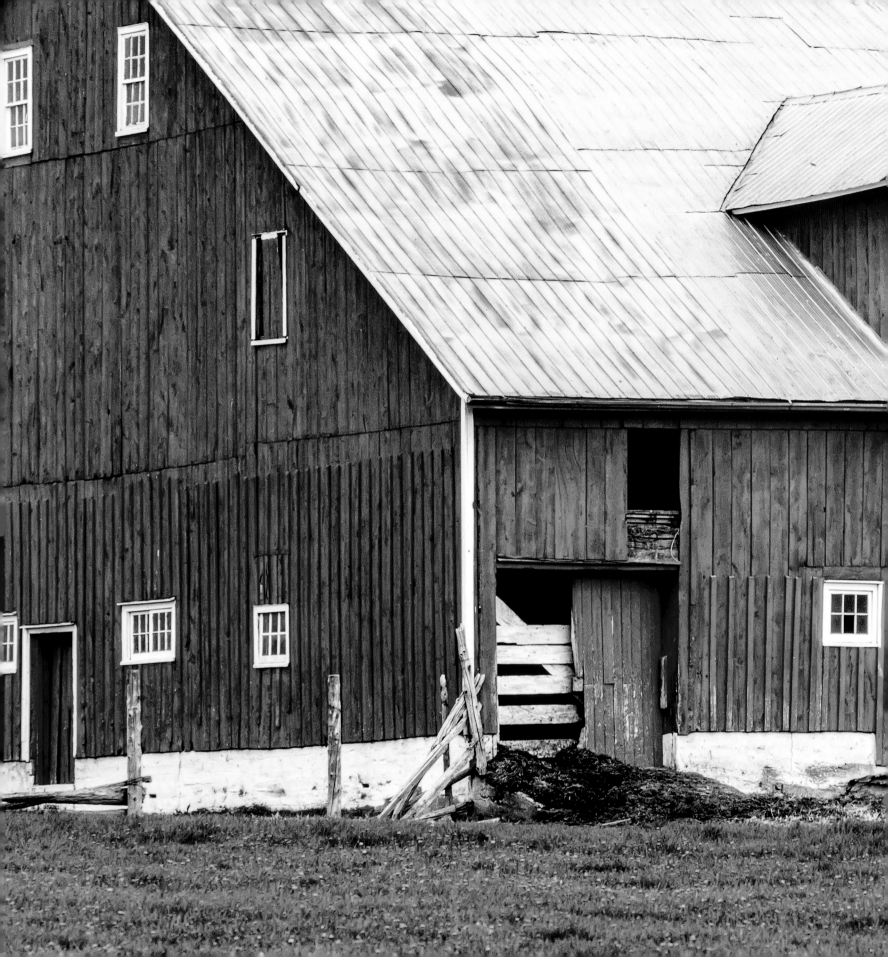

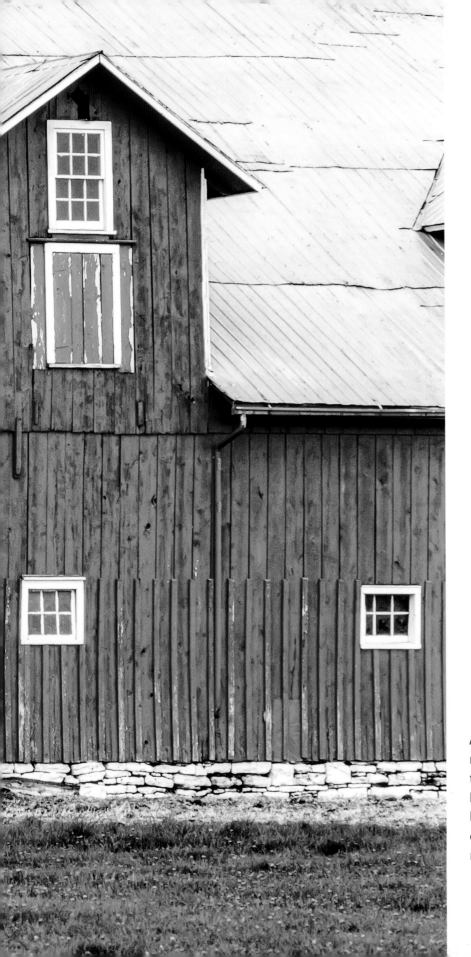

A barn near Napanee. The reason many barns are red is partly economic, for a long time red paint was the cheapest, and partly traditional. Before paint, barns were commonly coated with combinations of linseed oil and rust. The rust was toxic to fungi and other wood-decaying organisms and imparted a reddish colour to the walls.

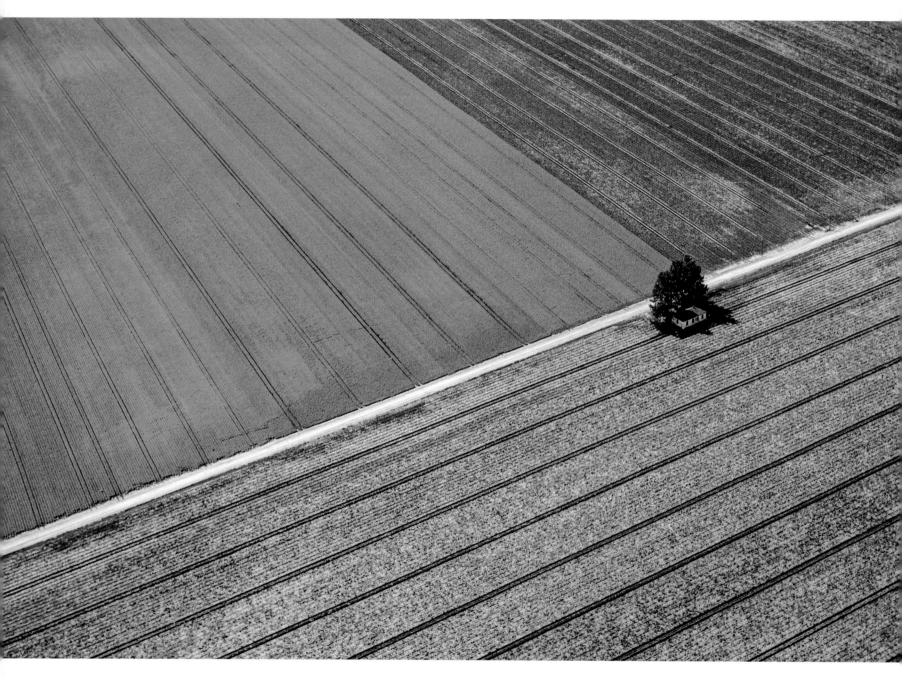

An aerial view of Holland Marsh.

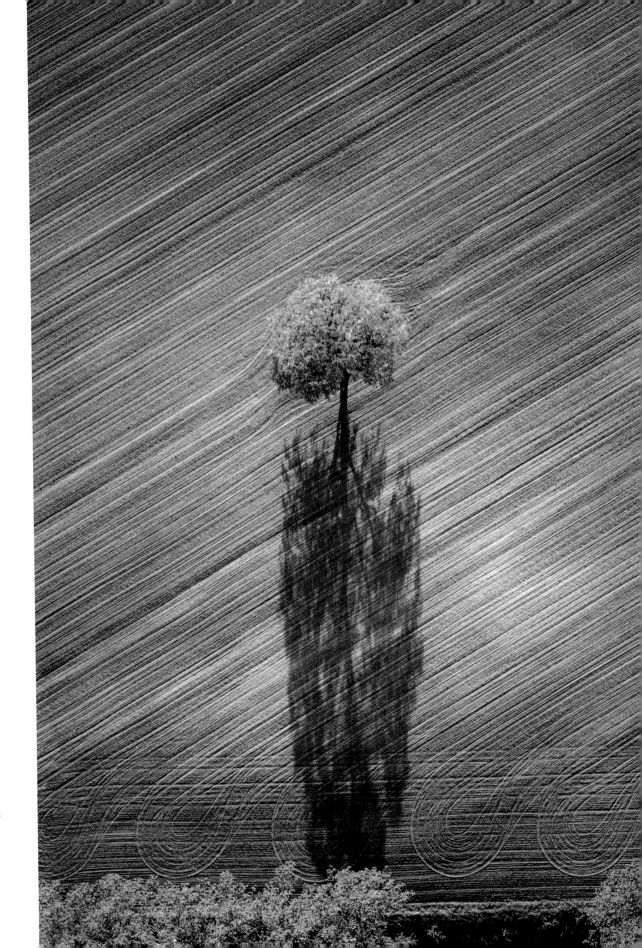

An overhead view of a tree in a farm field near Newmarket. The apparent trunk is actually its shadow.

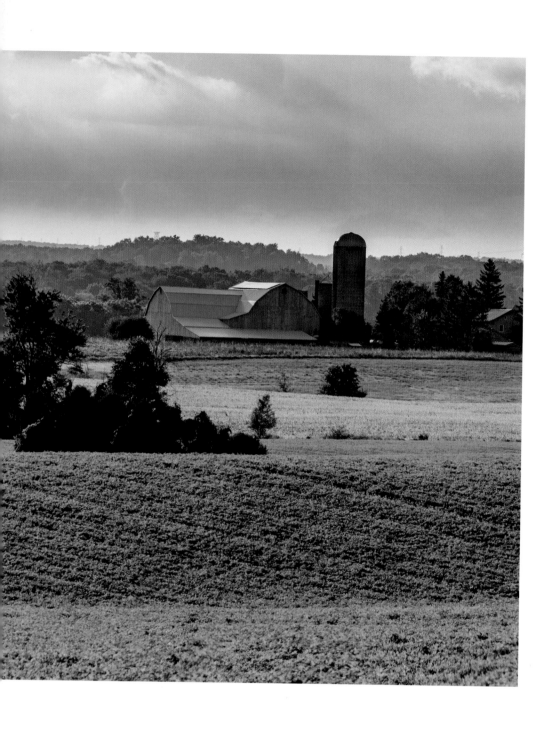

Barns with their associated silos storing silage to feed livestock through the winter are ubiquitous in the rural landscape throughout southern Ontario, here between Pinehill Road and Huron Road in Wilmot Township (above) and near Plainfield in Hastings County.

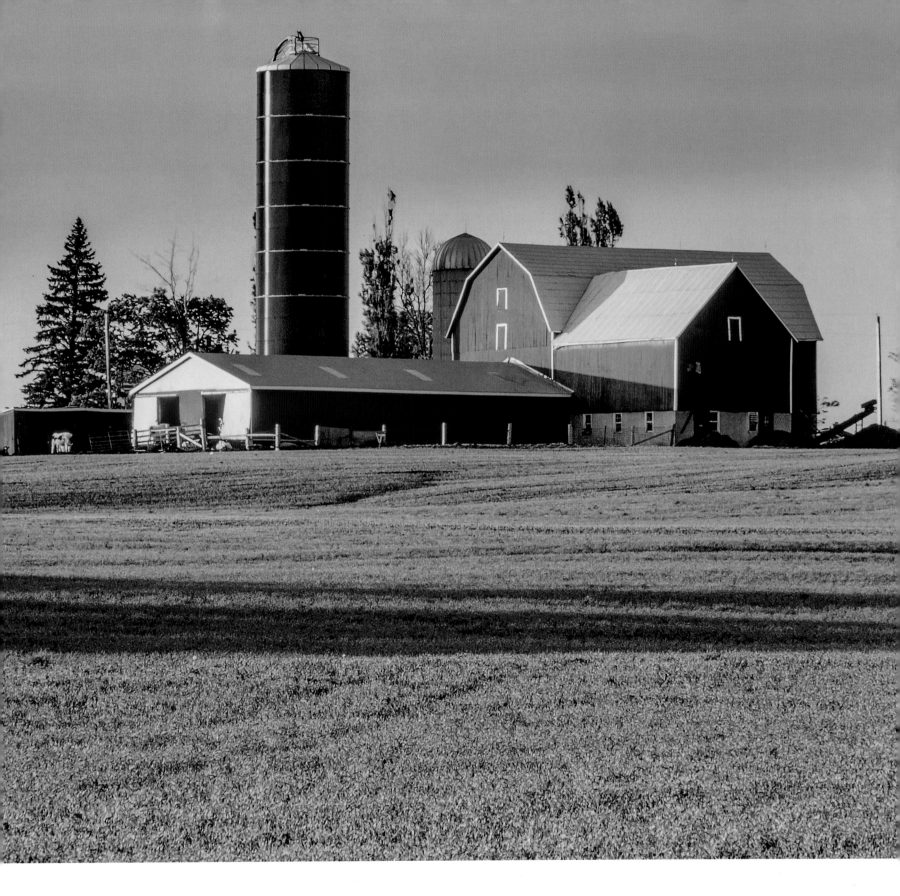

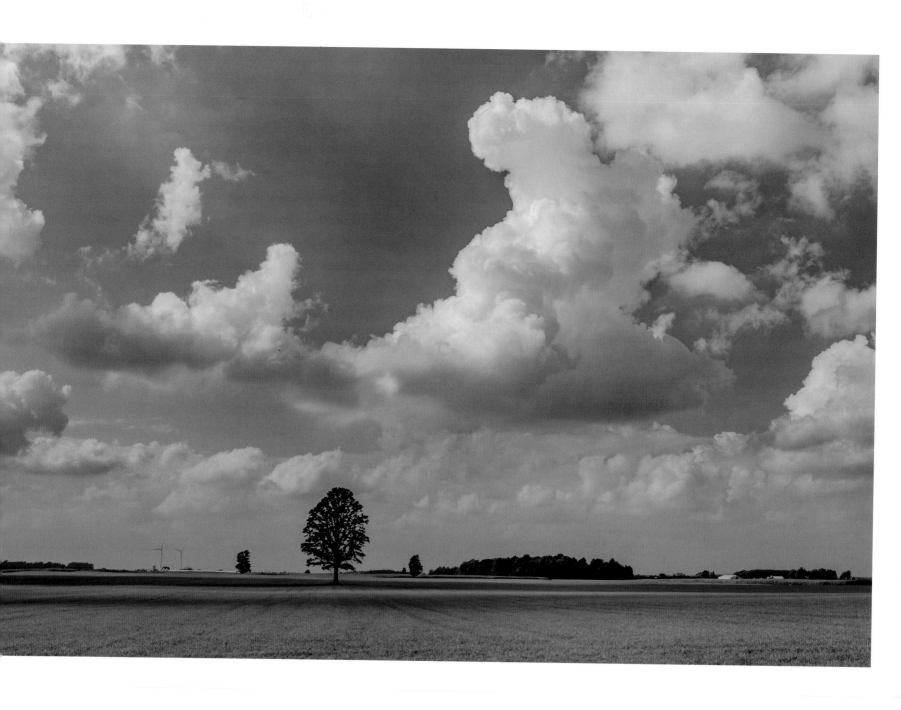

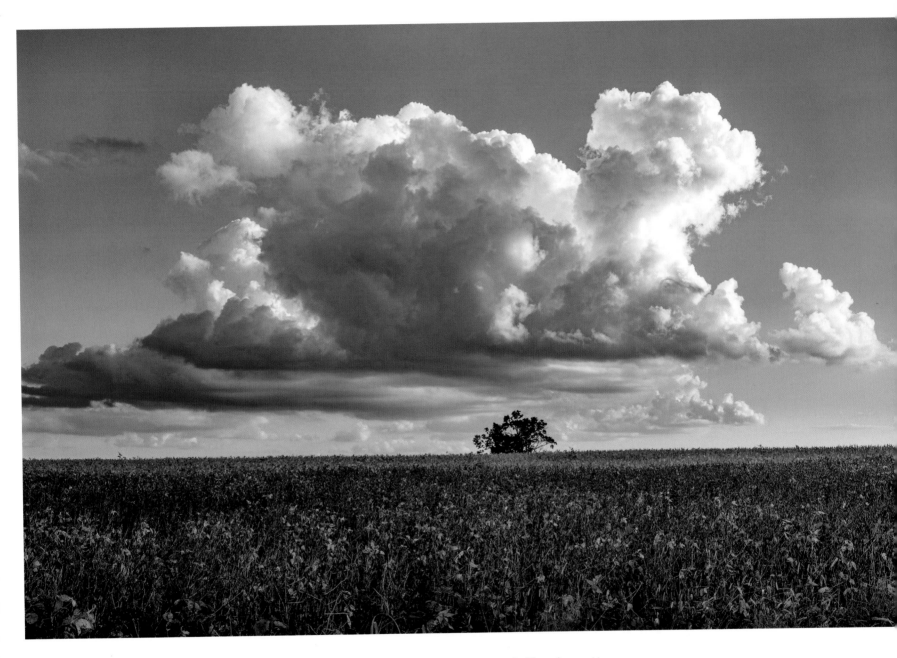

Cumulus clouds in late summer over farmland near Brodhagen, Perth County (left) and near New Dundee in the Regional Municipality of Waterloo. There are several possible reasons why single trees are sometimes left in farm fields, but the most common one is to provide shade during breaks from working under a hot summer sun.

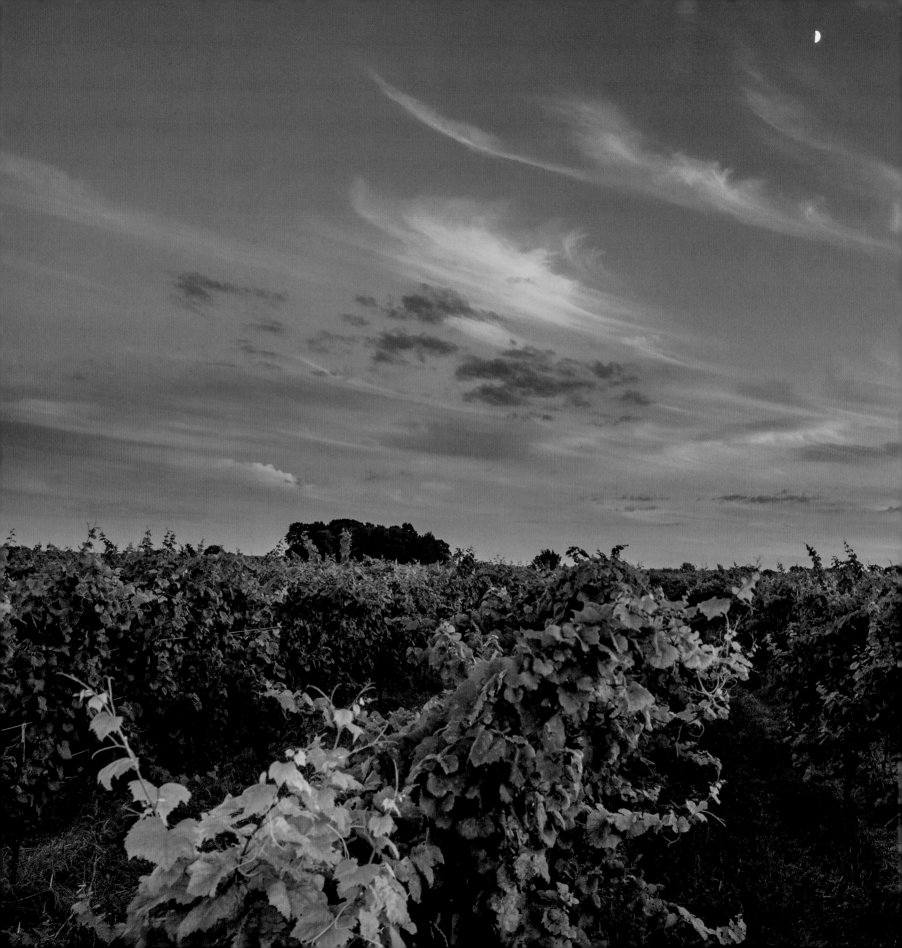

A half moon and sunset sky over one of the many vineyards on the Niagara Peninsula.

203

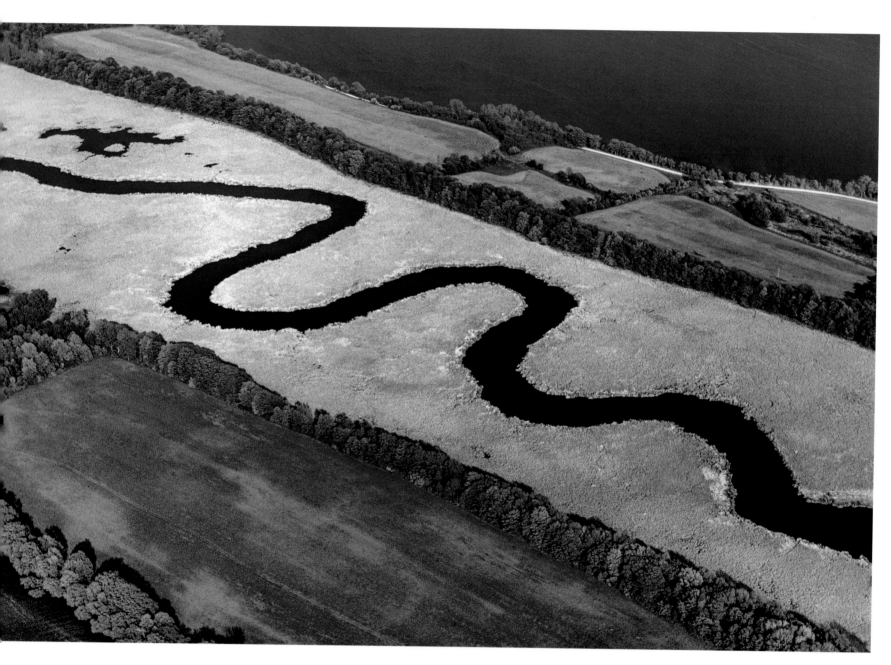

Aerial views of a meandering stream next to West Lake in Prince Edward County (above) and through the fertile market-garden fields of the Holland Marsh.

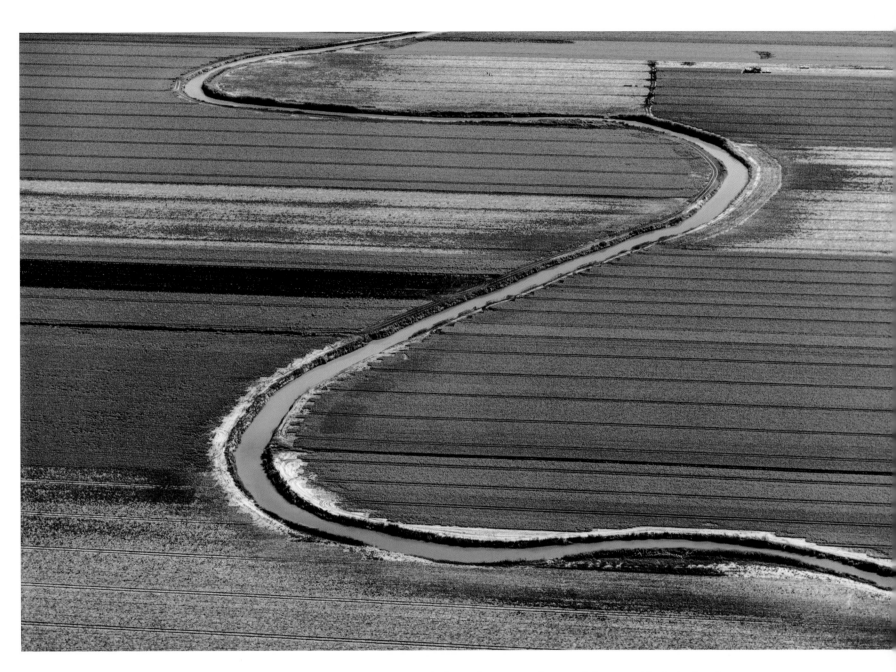

NEXT SPREAD: A sheep farm, one of several thousand in Ontario, at Pethericks Road and County Road 8 in Northumberland County on a stormy afternoon in mid-July.

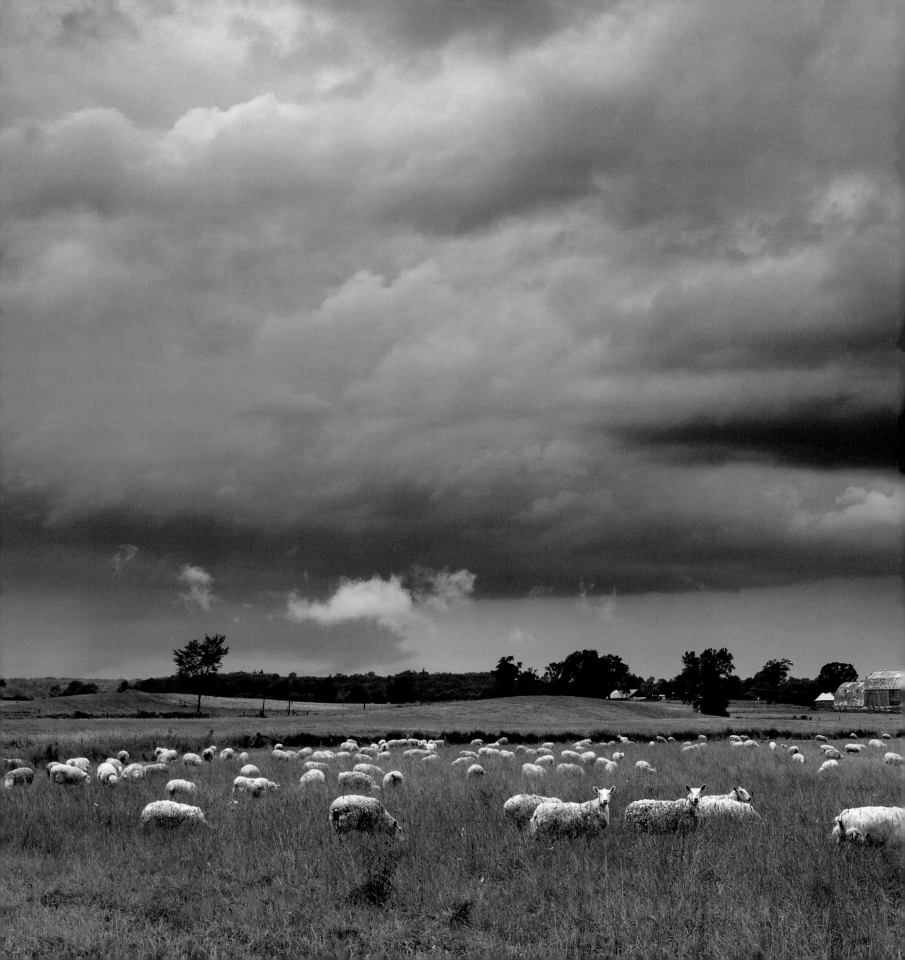

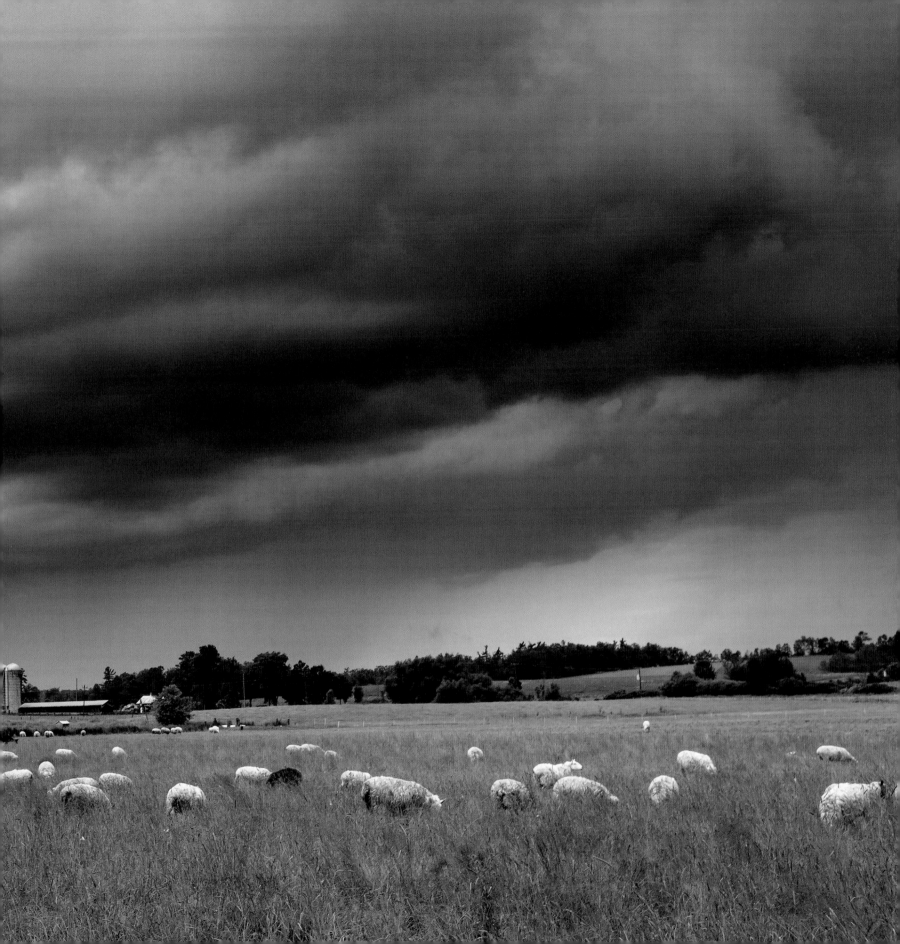

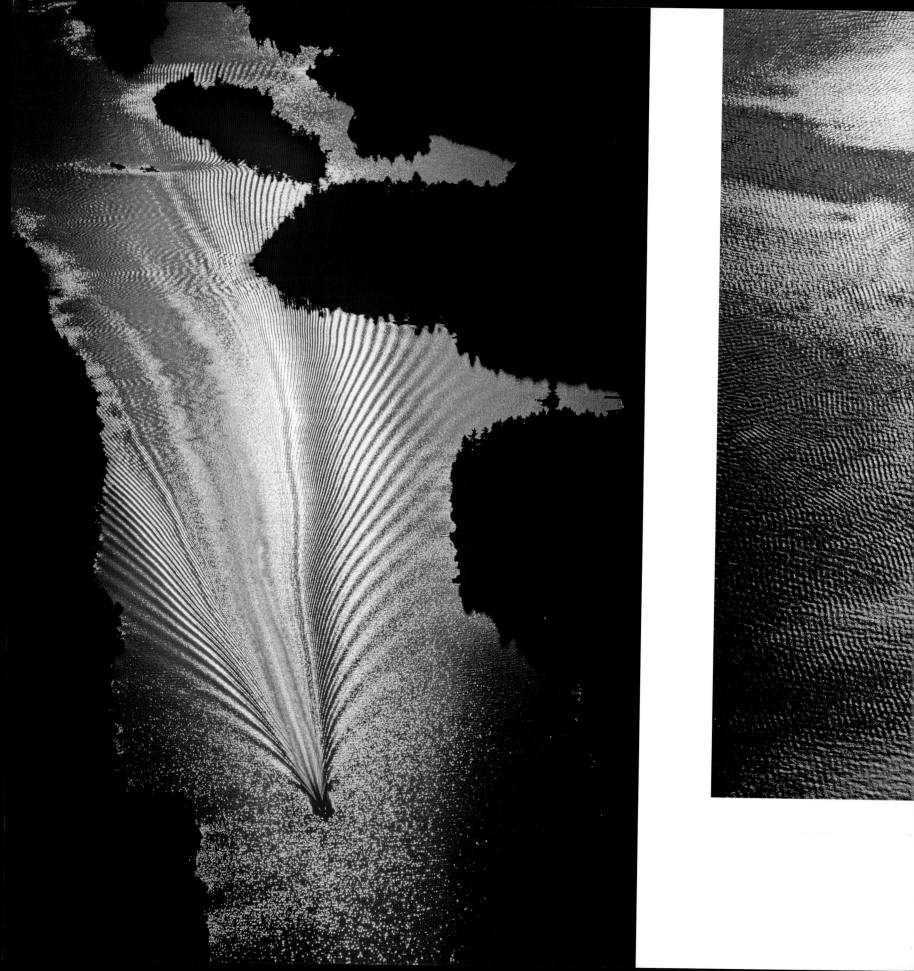

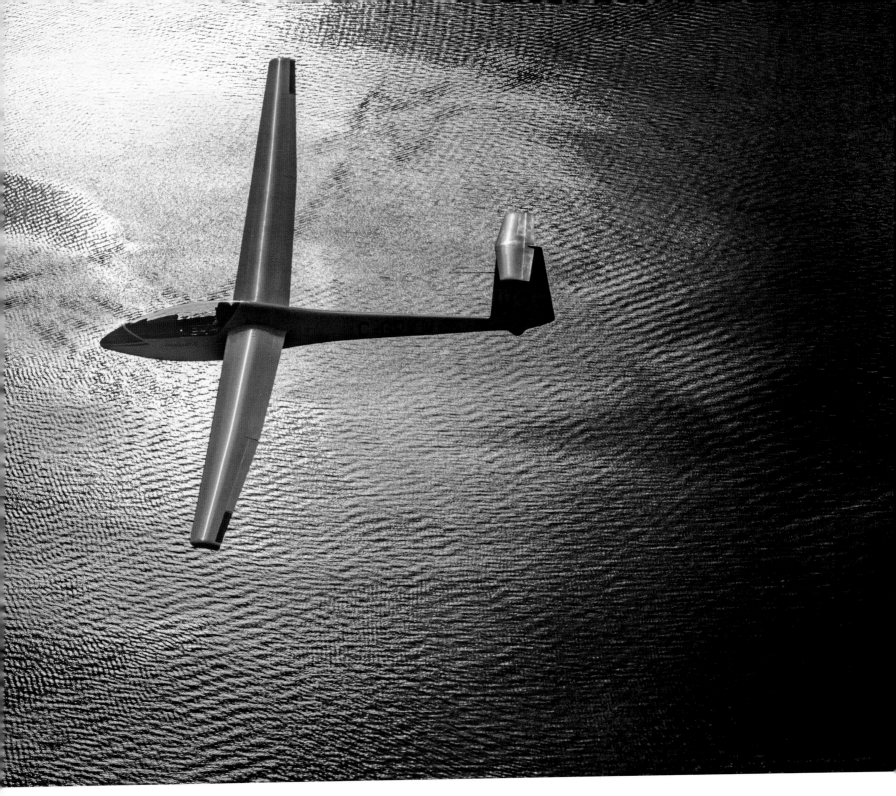

A motorboat zippers its wake in waters reflecting the late-day sun in one of innumerable passages through the Thirty Thousand Islands of Georgian Bay.

A sailplane silhouetted against the waters of the Ottawa River near Hawkesbury. Utilizing summertime thermal updrafts, a skilled pilot can stay aloft for hours.

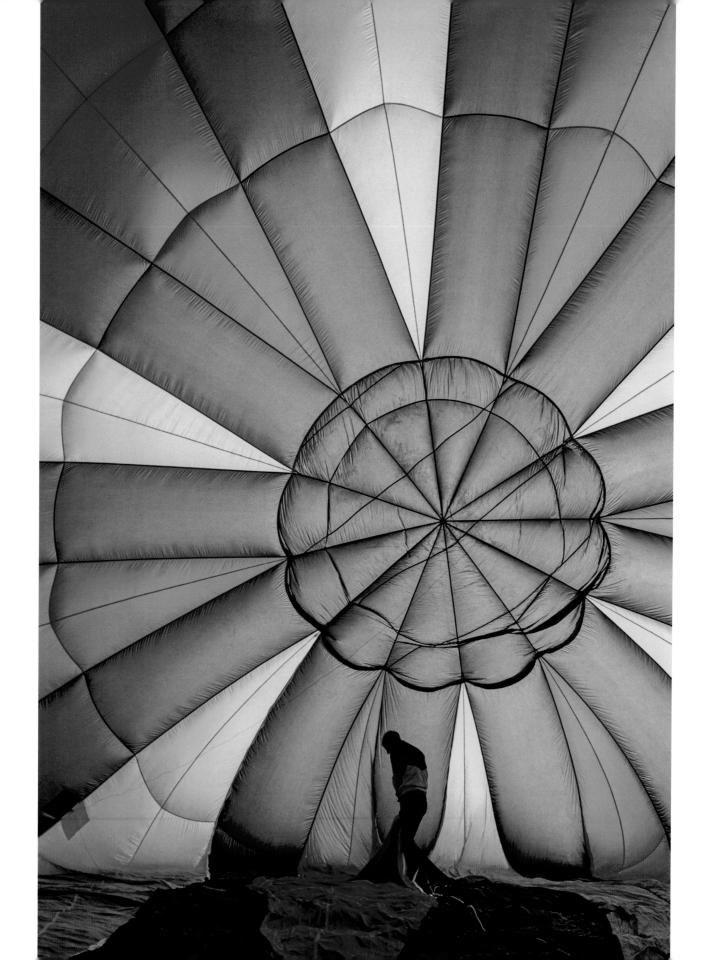

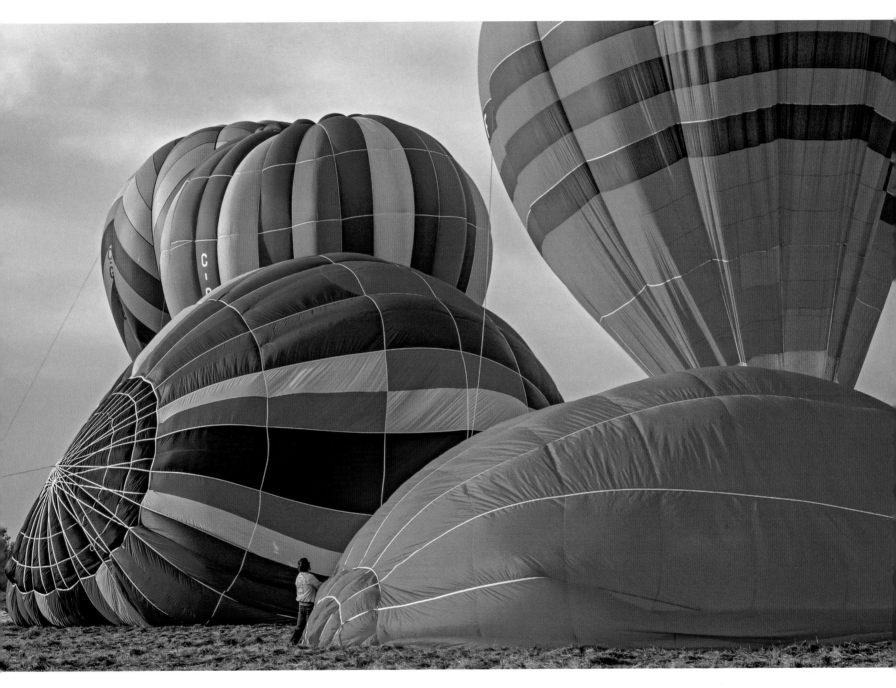

A balloonist inside a hot-air balloon near Orangeville prepares it for flight.

Preparing hot-air balloons for launch near Orangeville, Dufferin County.

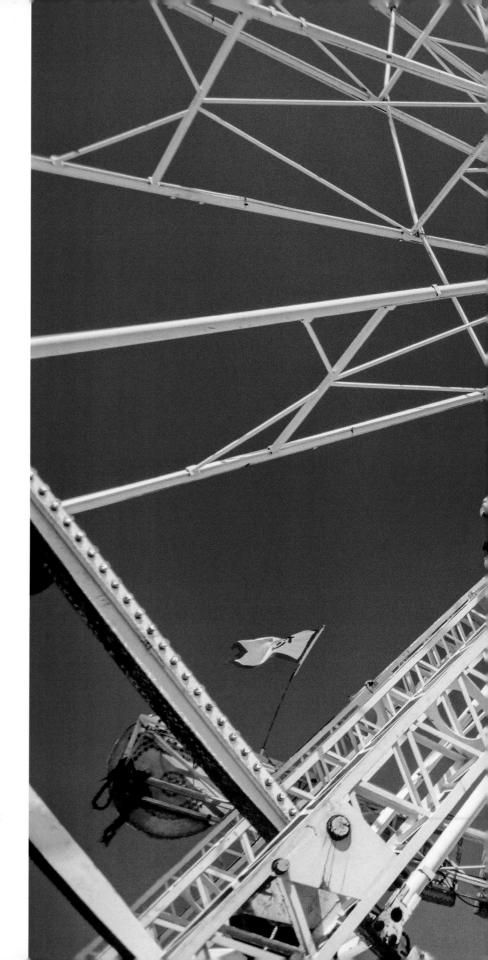

A carny part of the way up a giant Ferris wheel at the Canadian National Exhibition in Toronto.

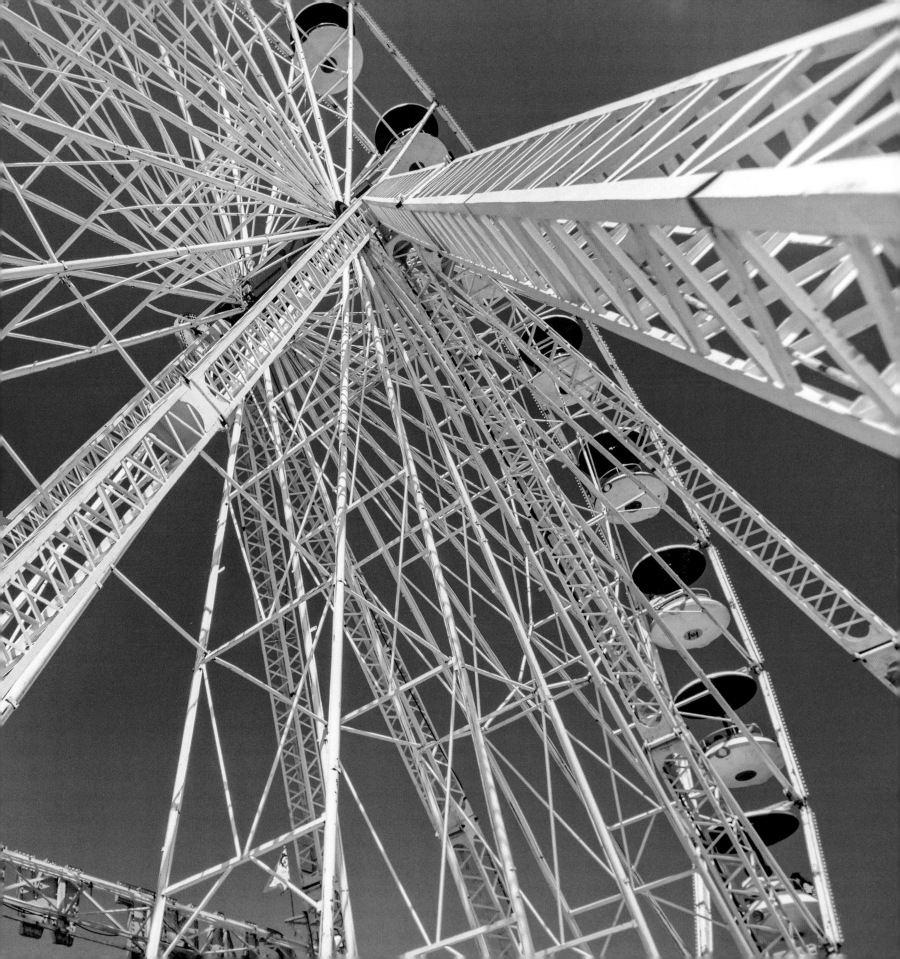

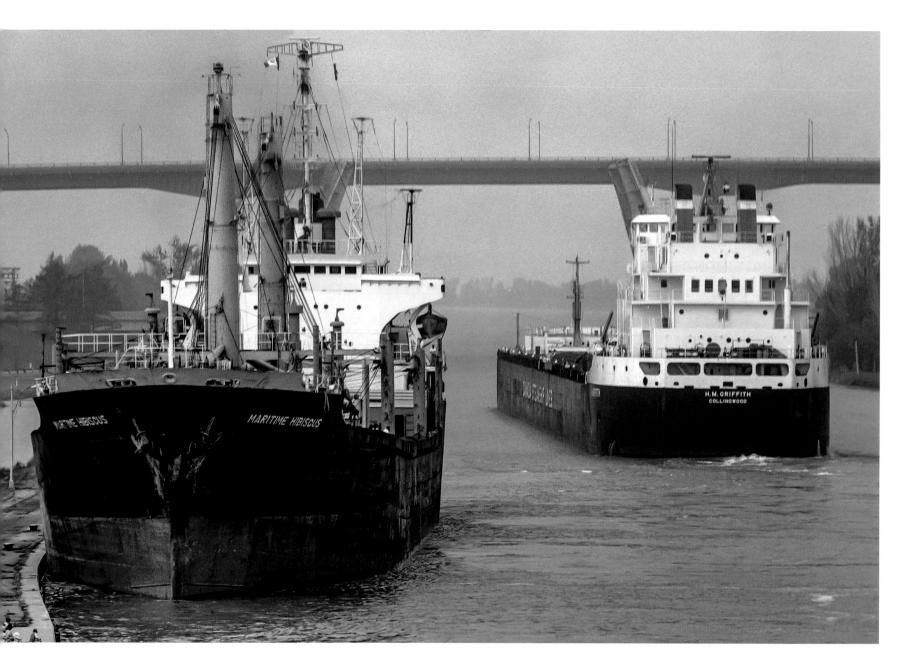

The same view from Lock 3 on the Welland Canal taken almost four decades apart. The H.M. *Griffith* (above) steaming towards the Garden City Skyway in 1980 is the same cargo ship as the *Rt. Hon. Paul J. Martin* in the photo to the right taken in 2018. The H.M. *Griffith* was completely rebuilt except for the original stern section and

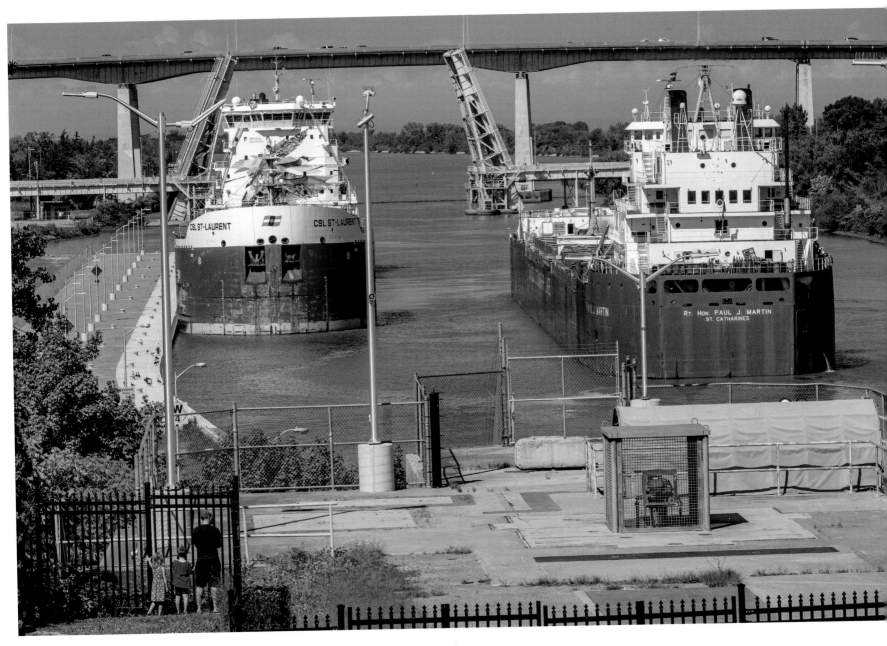

relaunched and rechristened the *Rt. Hon. Paul J. Martin*. The Maritime Hibiscus sank off the Papua New Guinea coast in 1991. The spectacular artwork on the forward facade of the CSL *St. Laurent* commemorates the 150th anniversary of Confederation and the 375th of the City of Montreal.

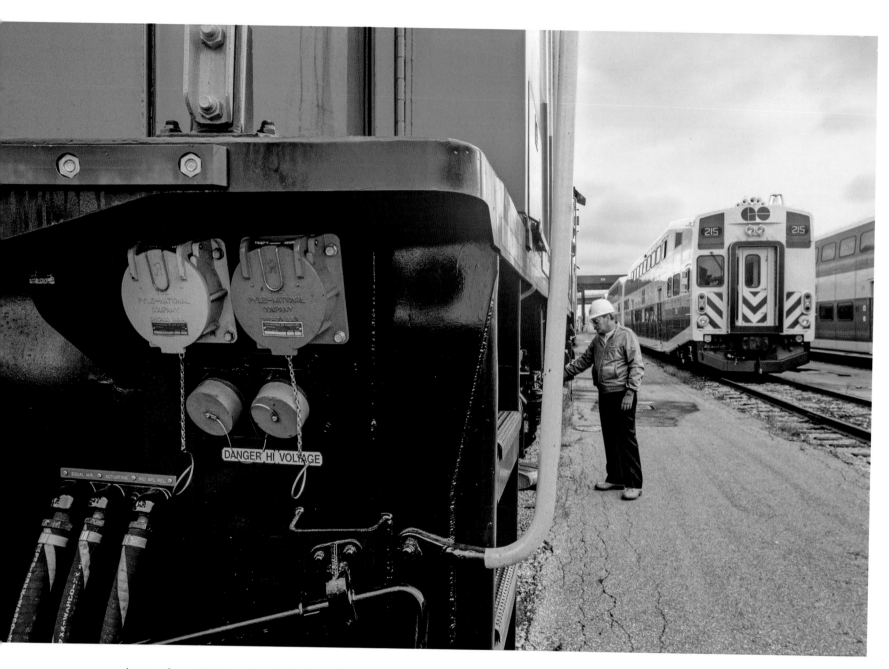

Inspecting a GO Transit train in the Willowbrook Yard in Toronto's west end.

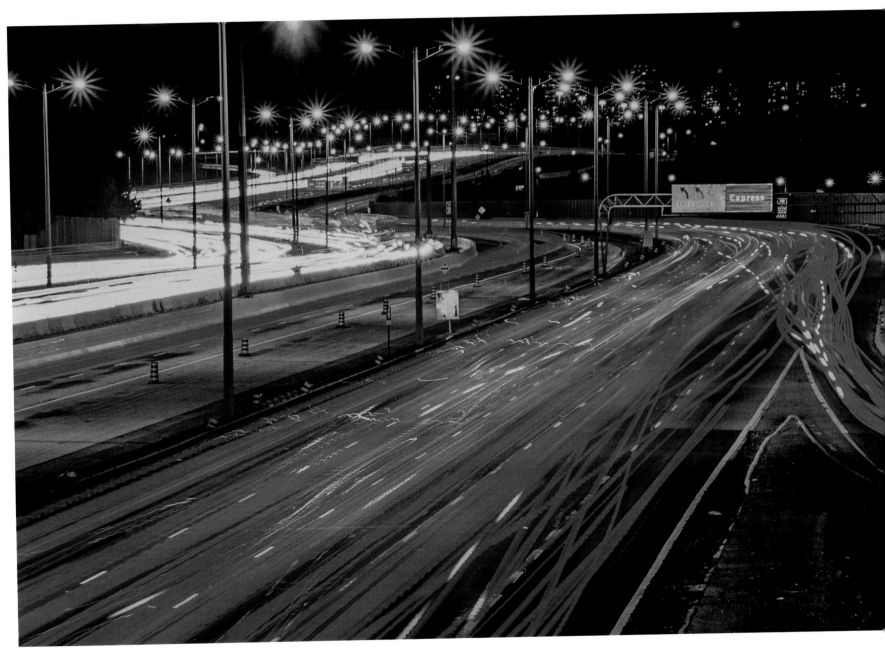

The 401 Expressway through Toronto at night, where the flow of traffic never stops.

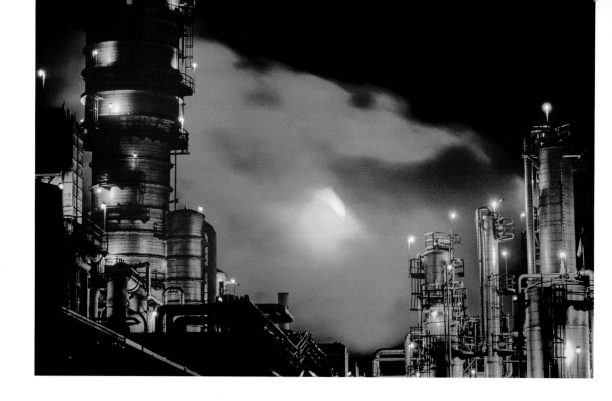

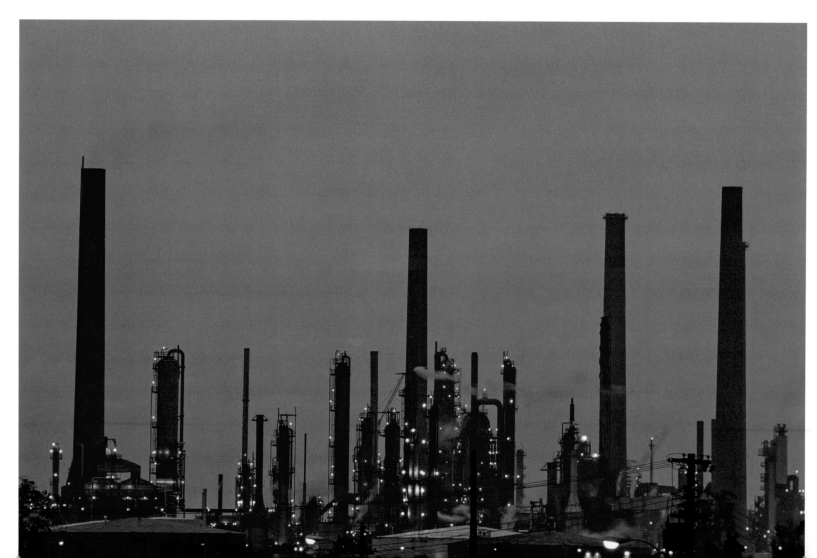

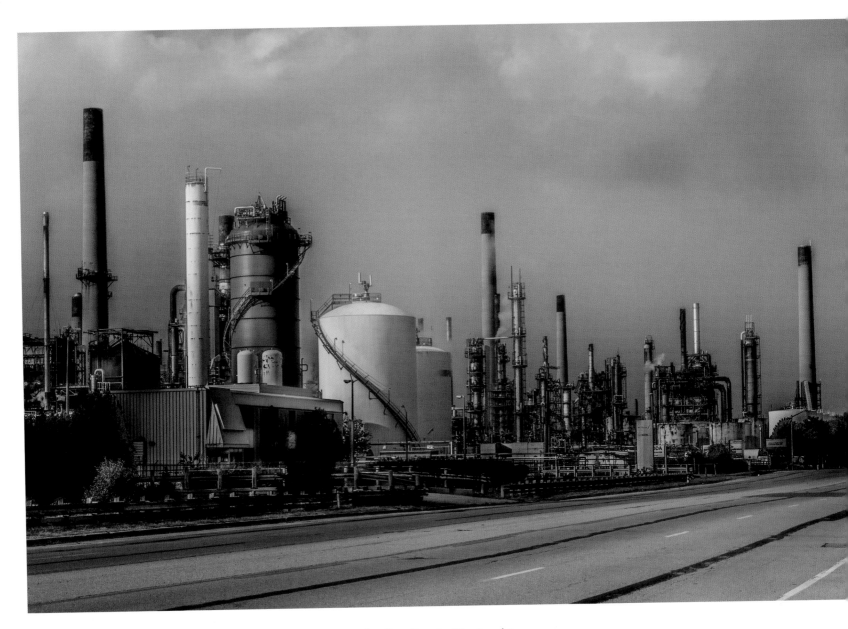

Part of the vast complex of oil and gas refineries in Chemical Valley, Sarnia. The Lambton County city became the centre of Canada's petrochemical industry after North America's first commercial oil well was drilled at Oil City, thirty kilometres to the southeast.

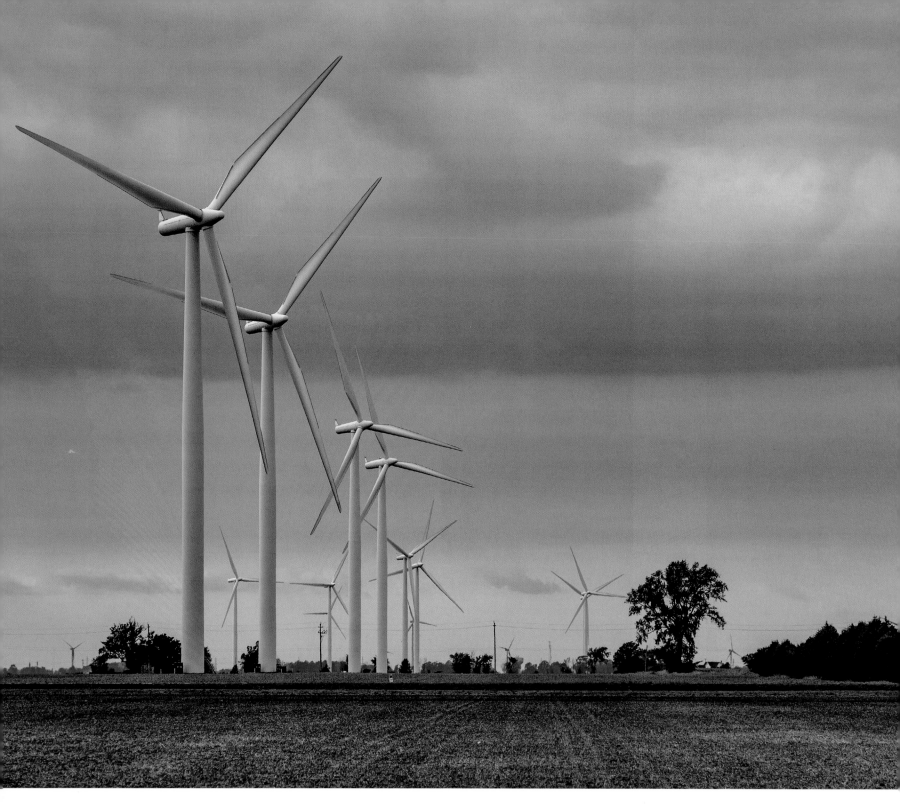

Towering wind turbines near Port Alma utilize the winds off Lake Erie. While
not without controversy, several thousand of these wind turbines supply
about a tenth of Ontario's power needs.

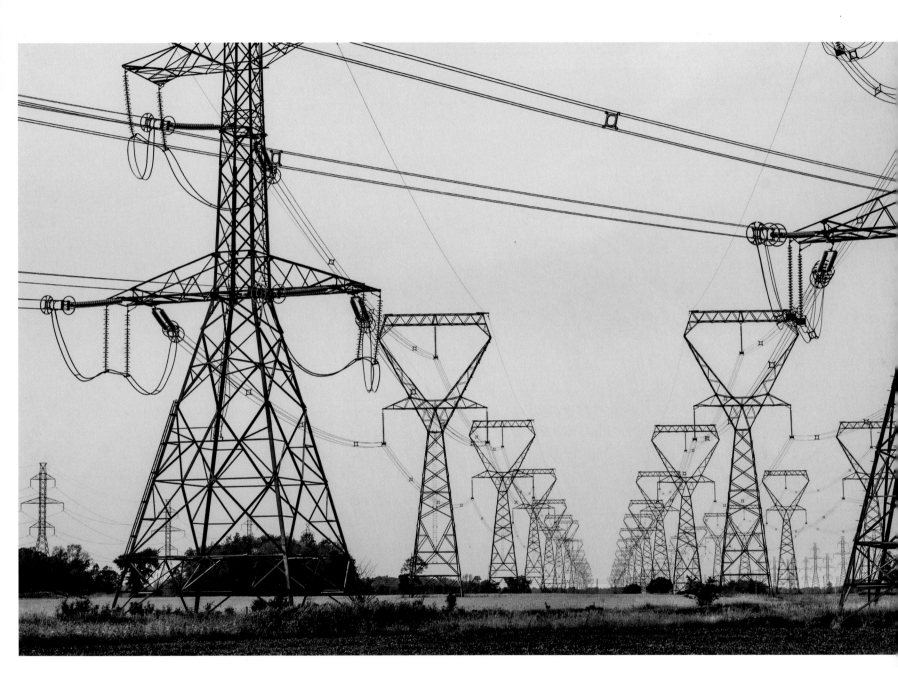

Massive hydro pylons in Haldimand county march northwards from Lake Erie.

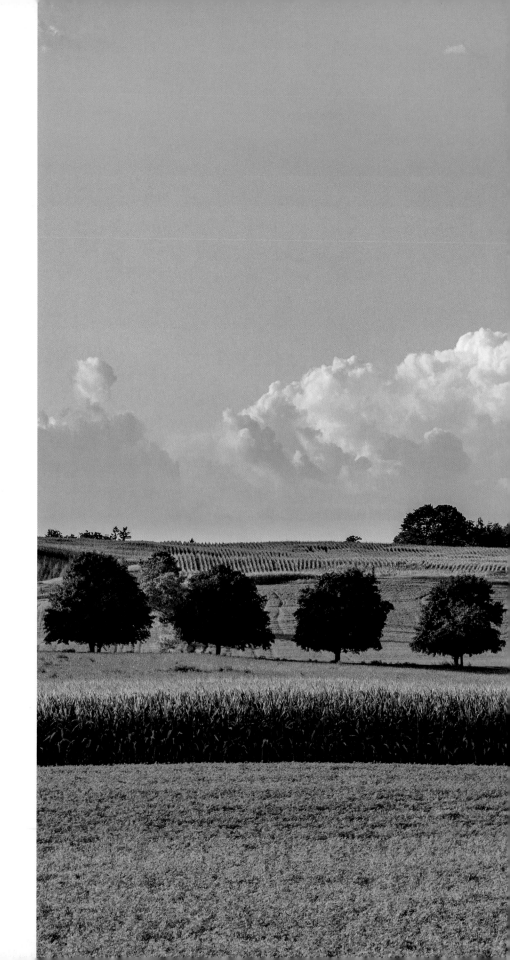

Corn and hay fields at Pinehill Road
and Bridge Street near Haysville in the
Waterloo Region.

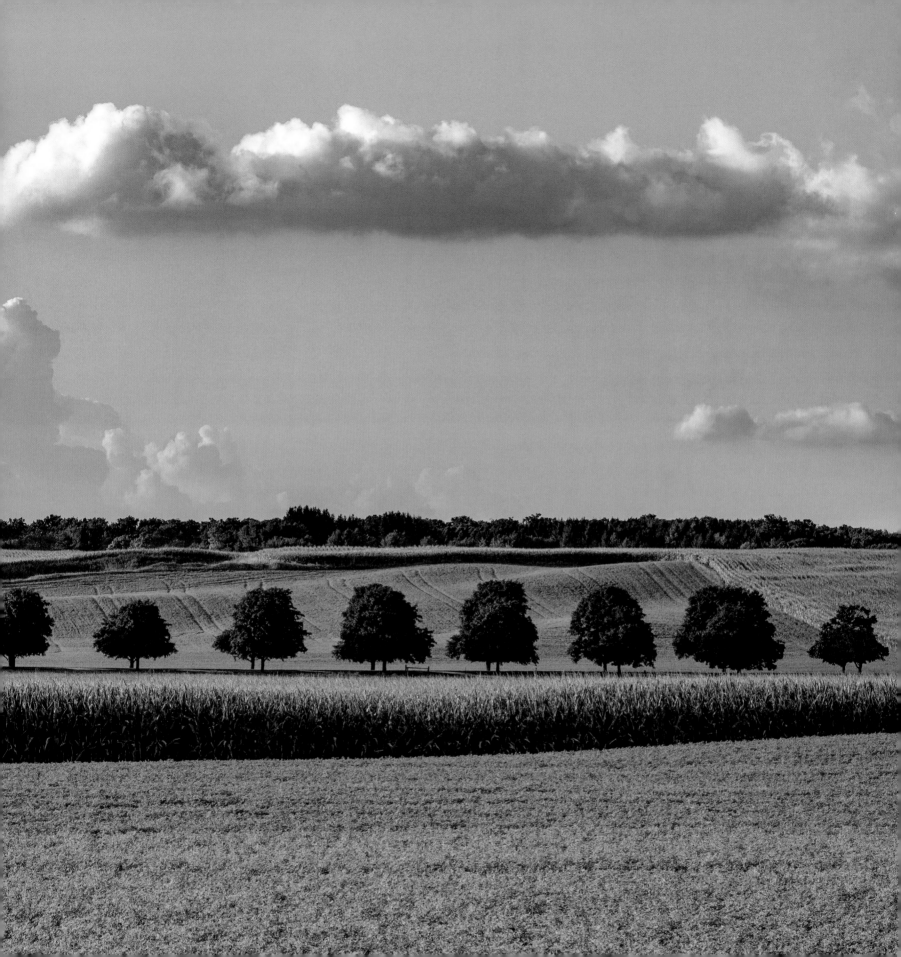

Index